SERGE
.
LUTENS

© Assouline, 1998
26 rue Danielle Casanova
75002 Paris (France)
assouline@imaginet.fr
Tel: +33 1 42 60 33 84
Fax: +33 1 42 60 33 85

Distributed to the U.S. trade by St. Martin's Press, New York
Distributed in Canada by McLelland & Stewart
Distributed in all other countries by Thames and Hudson (Distributors) Ltd,
London

ISBN: 2 84323 066 7

Translated from the French by Christopher Petkanas
© Assouline

Color separation: Gravor (Switzerland)
Printed and bound by Amilcare Pizzi (Italy)

·SERGE LUTENS·

Image pursued.

These images impose themselves on me, preceding me
more than they follow me.

The imaginary where finery and rupture distill.
Characters of precise contour, black essences,
calligraphy of bodies in downstrokes and in up-
strokes articulating their own words, of stone, of
heart.

Sketch of lace, bite of iron, blood of a fabric on a night
white or dark, ephemeral artifice, silken trap, ghostly
sorbet...

The shadow is black in any case for these beautiful
immortals in the shattered mirror.

Invisible disorder where everything becomes clear.
Setting up a game for which only I know the rules and
from which I come out both winner and loser, player
and played.

"Taking" pictures, what a fitting phrase in regard to me.

Serge Lutens

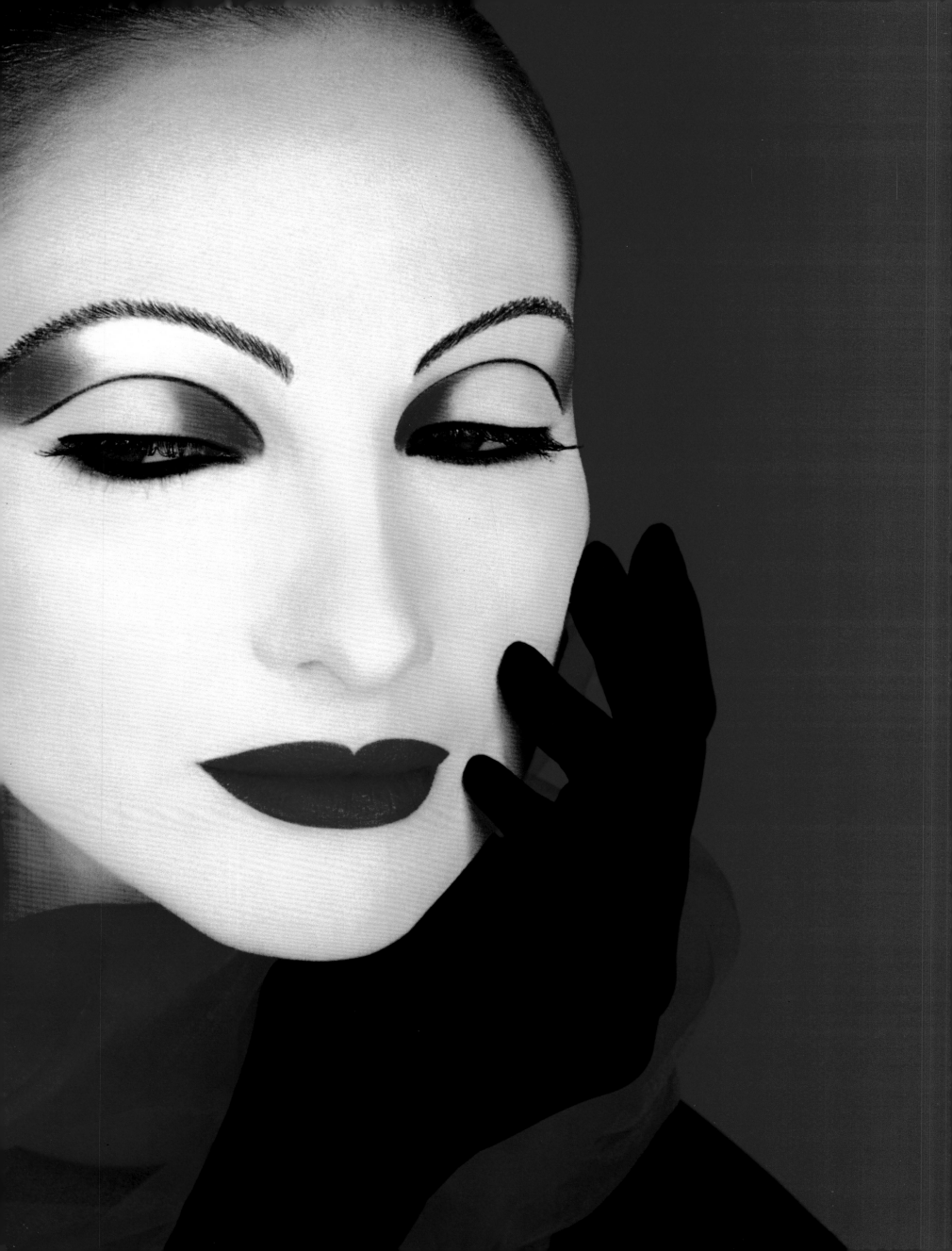

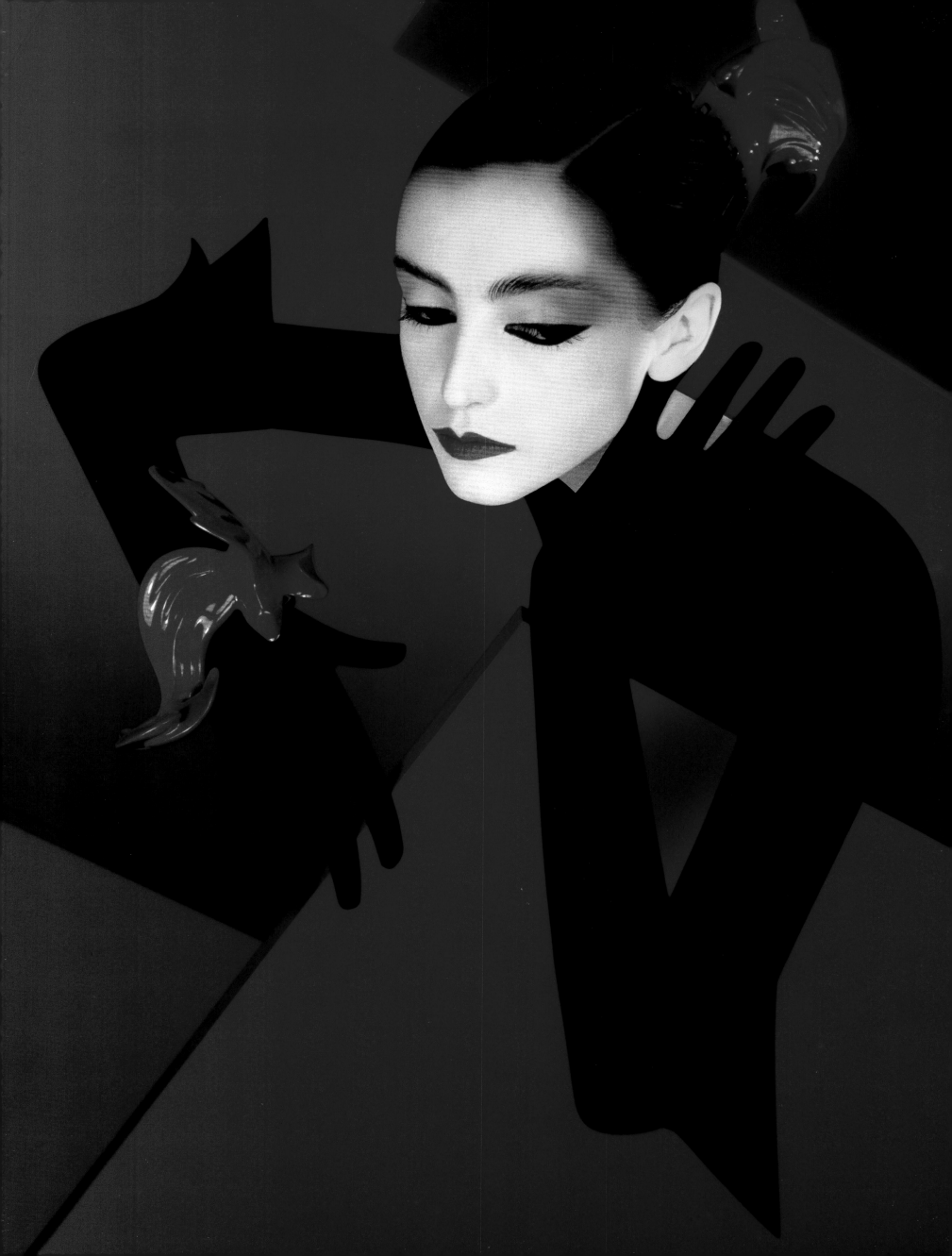

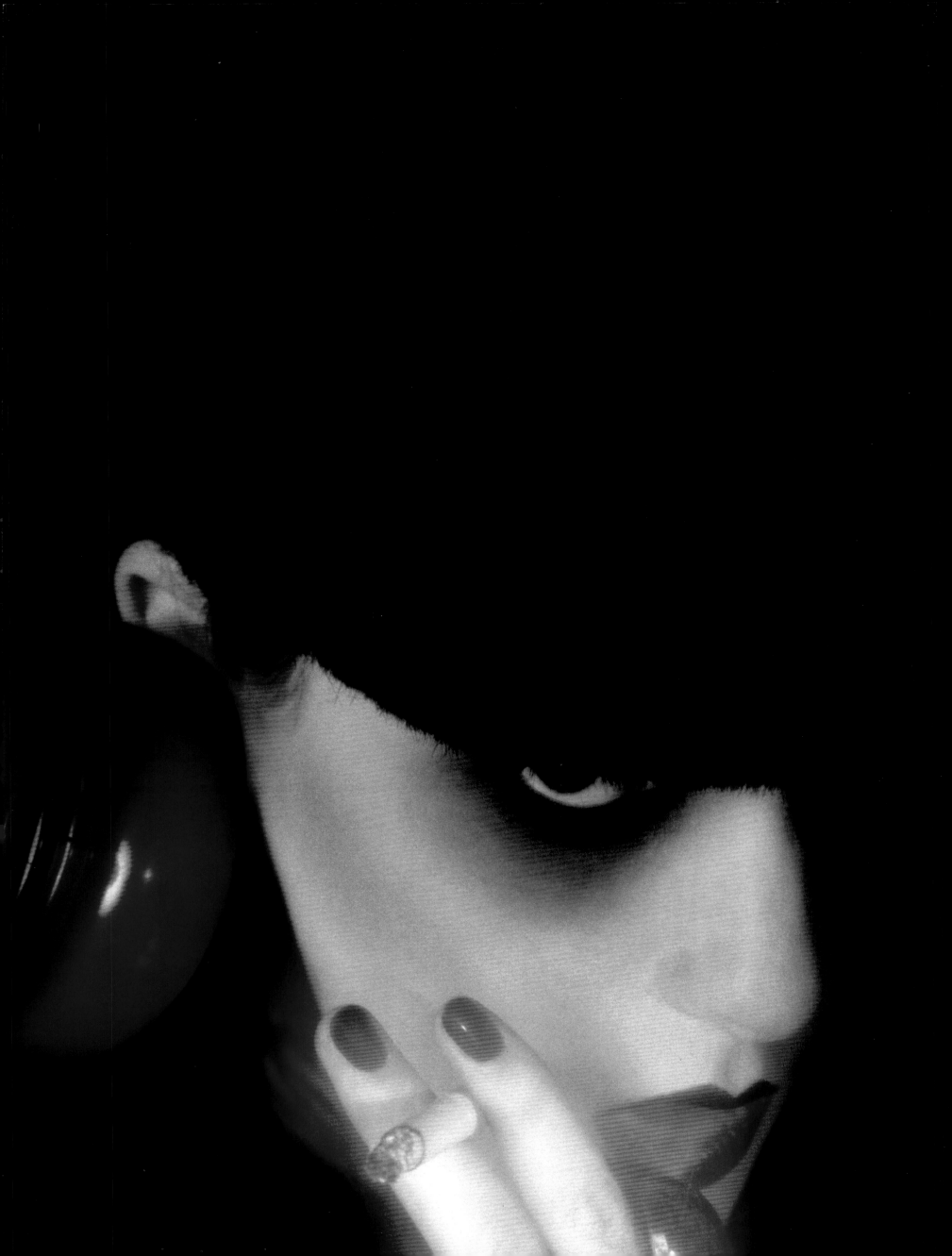

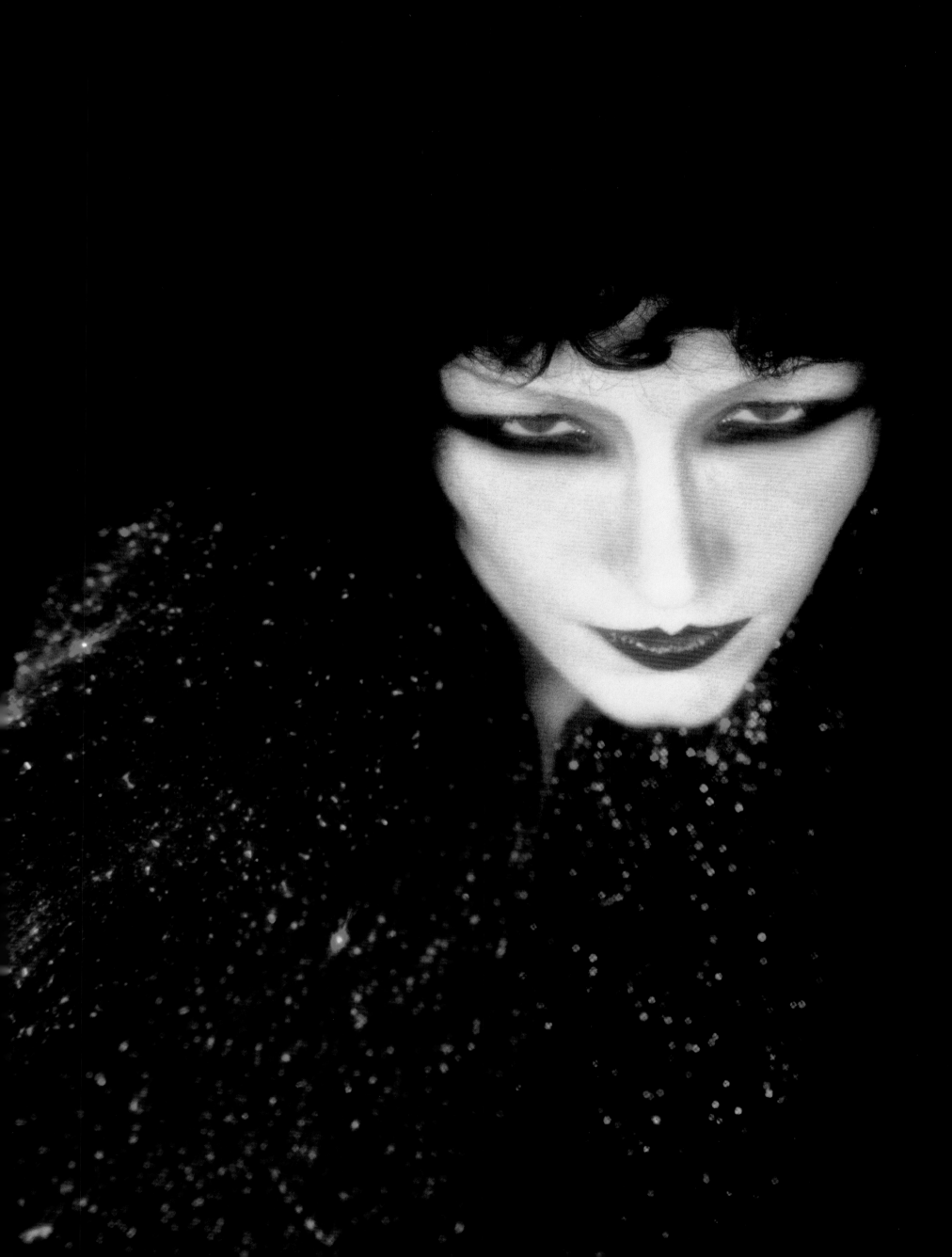

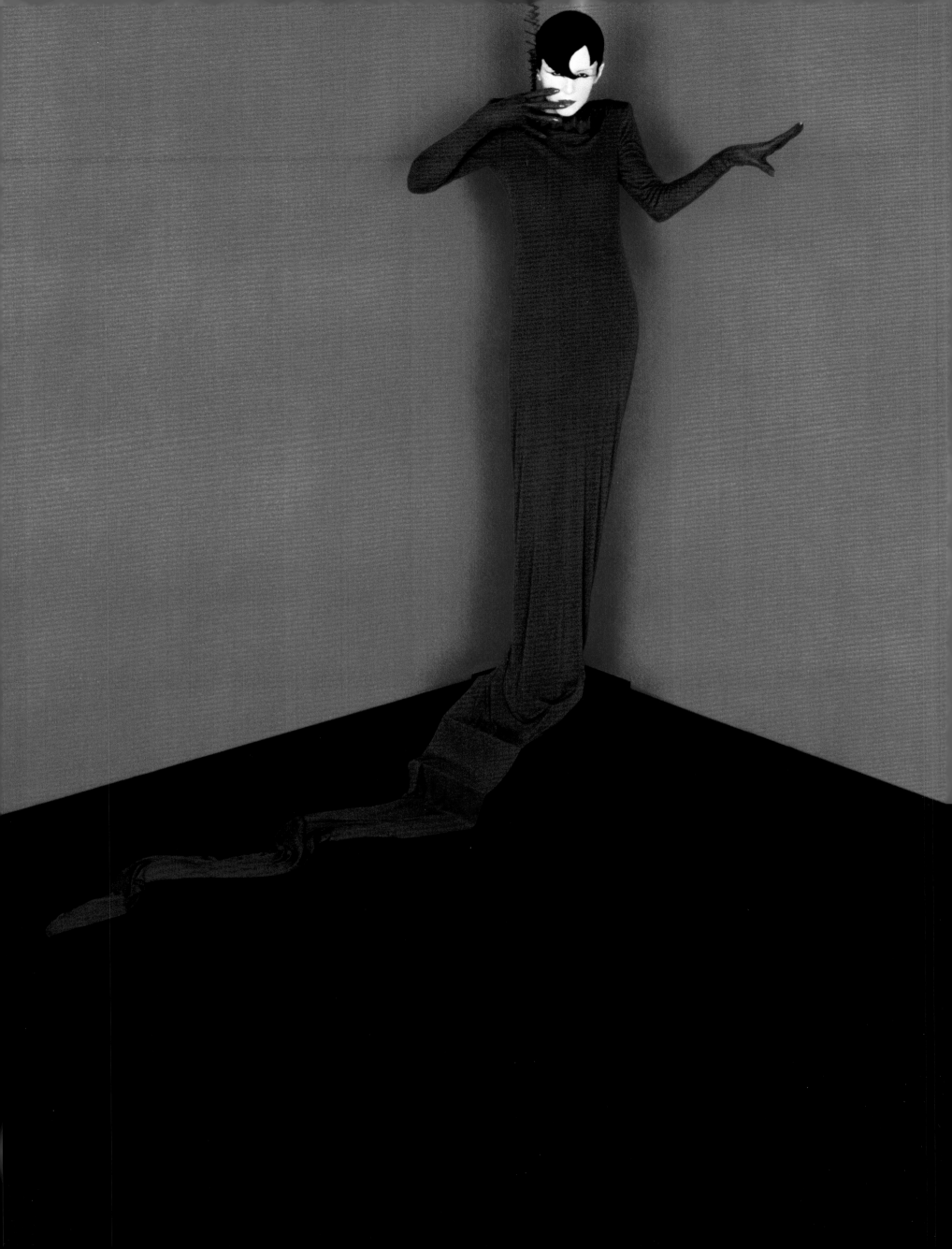

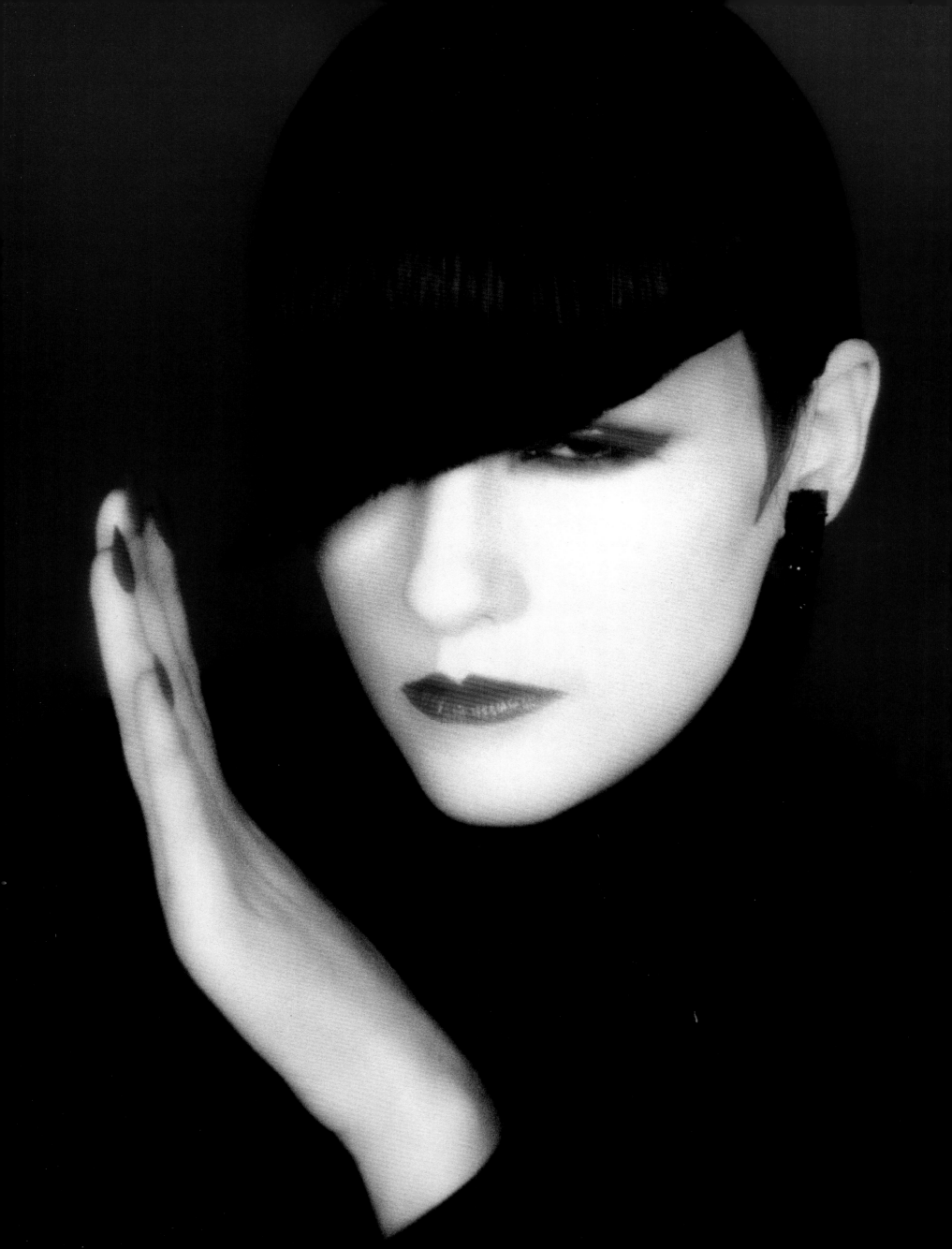

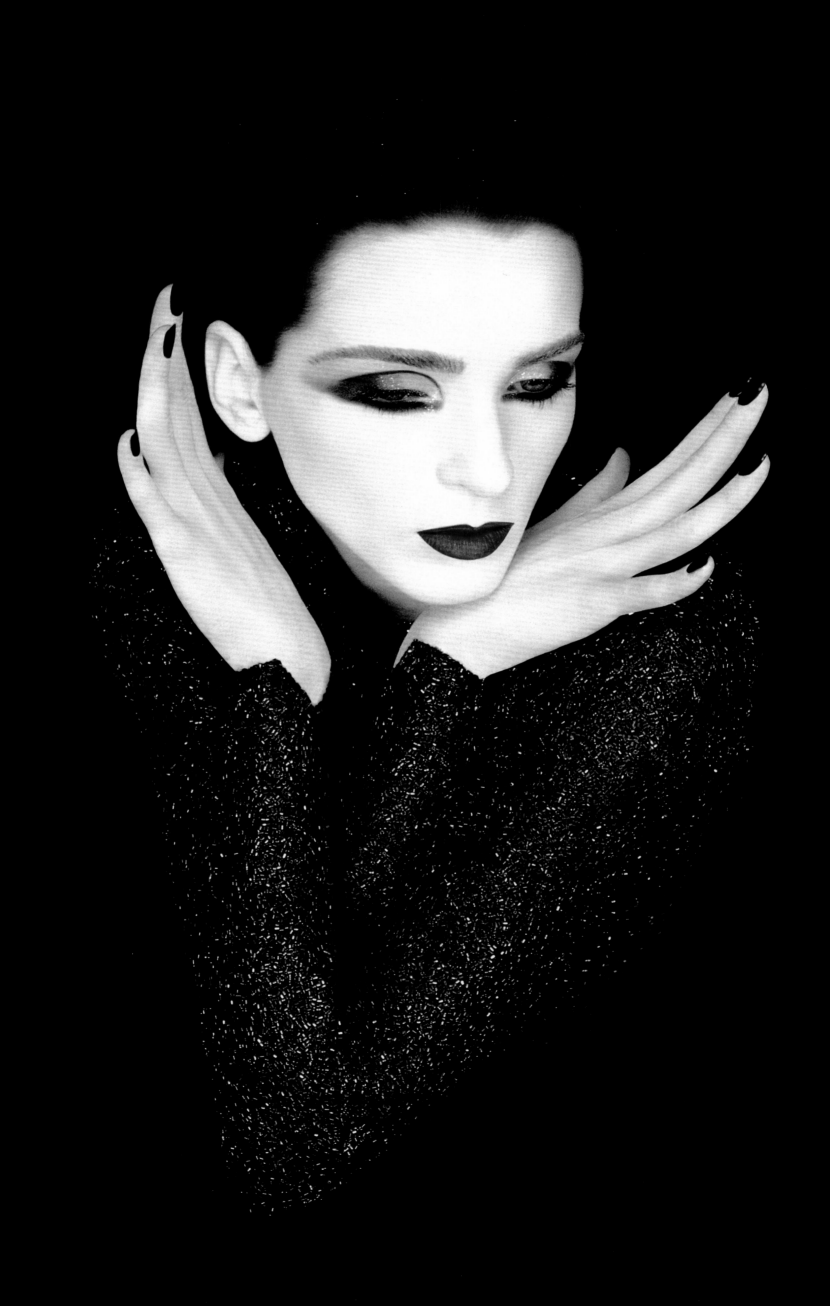

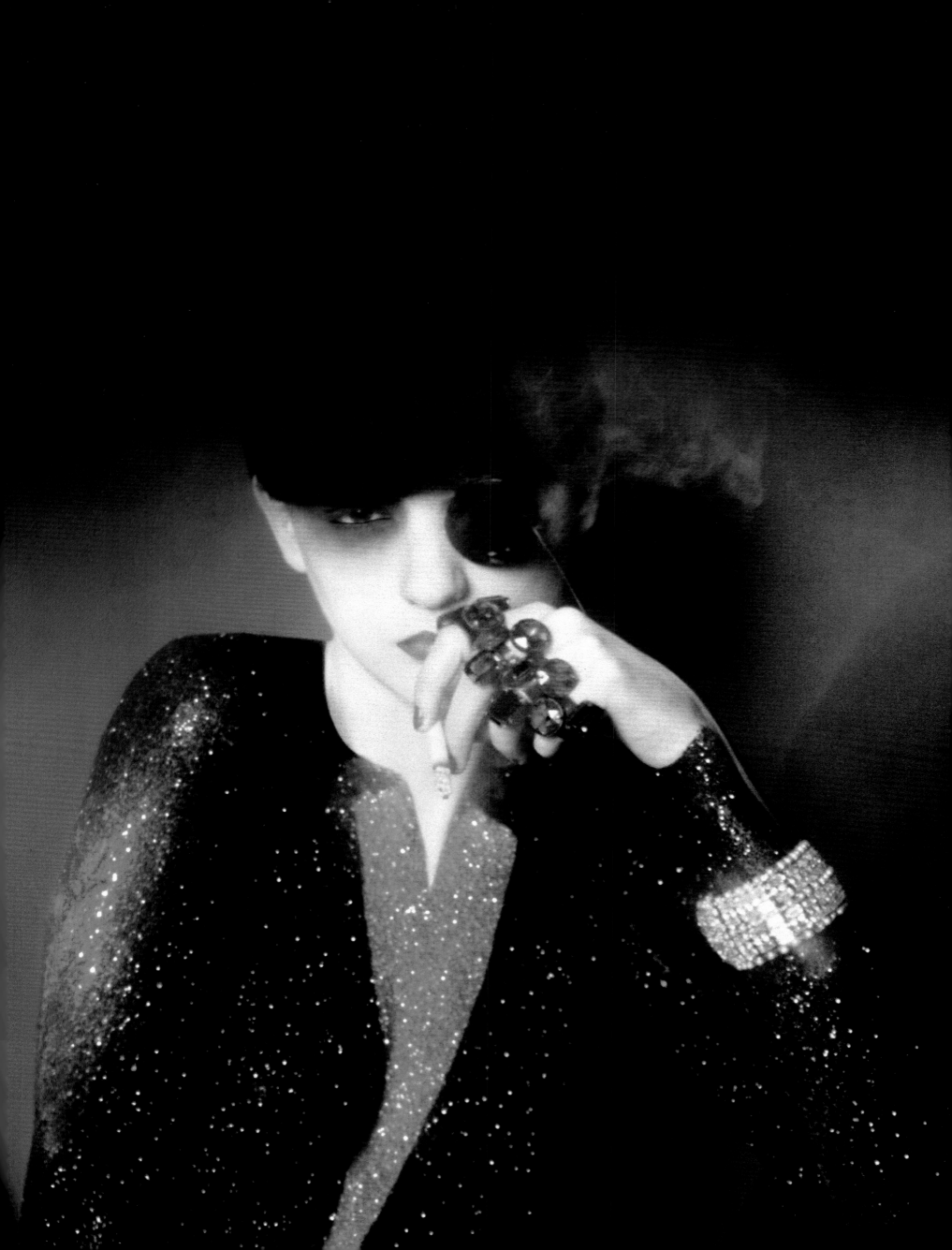

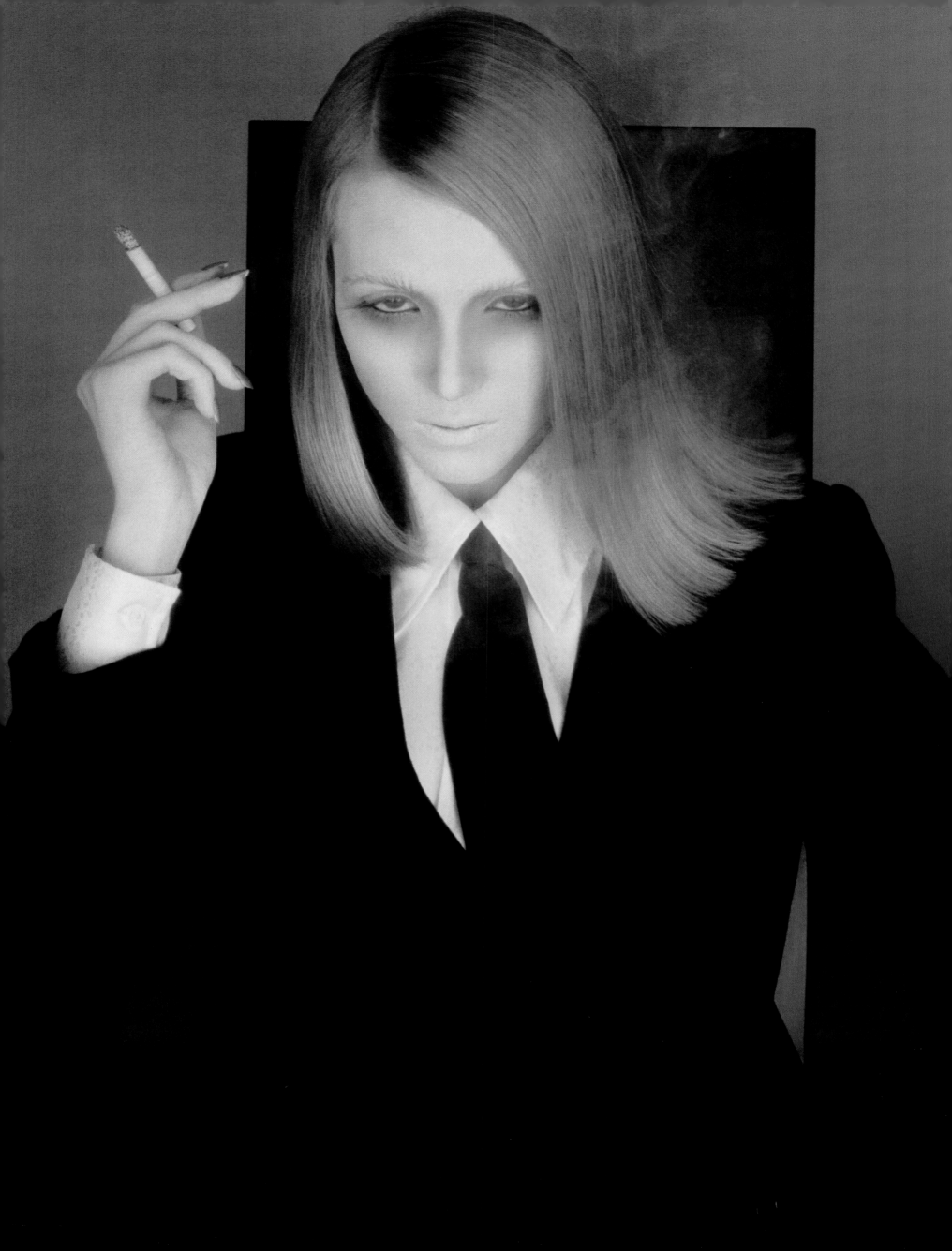

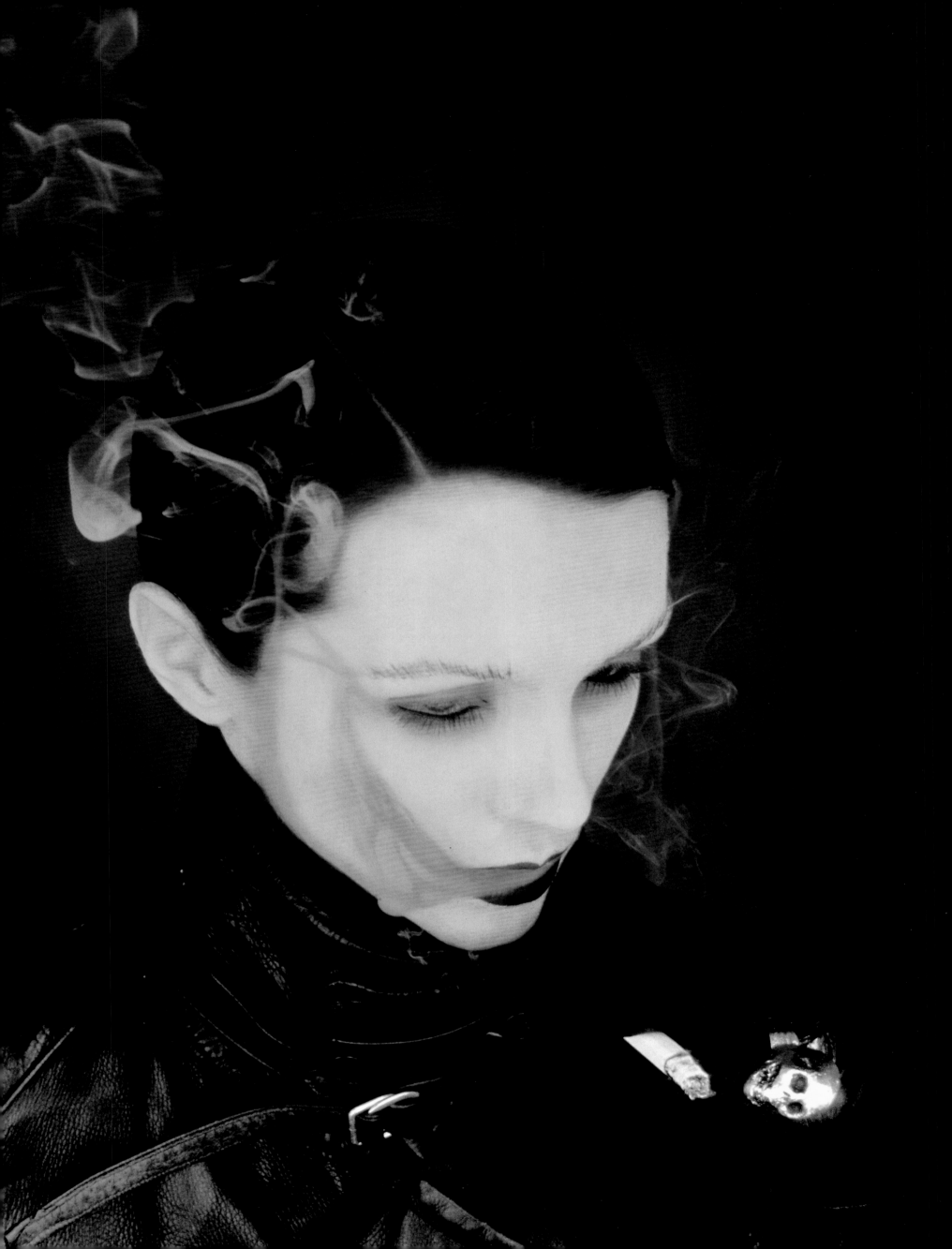

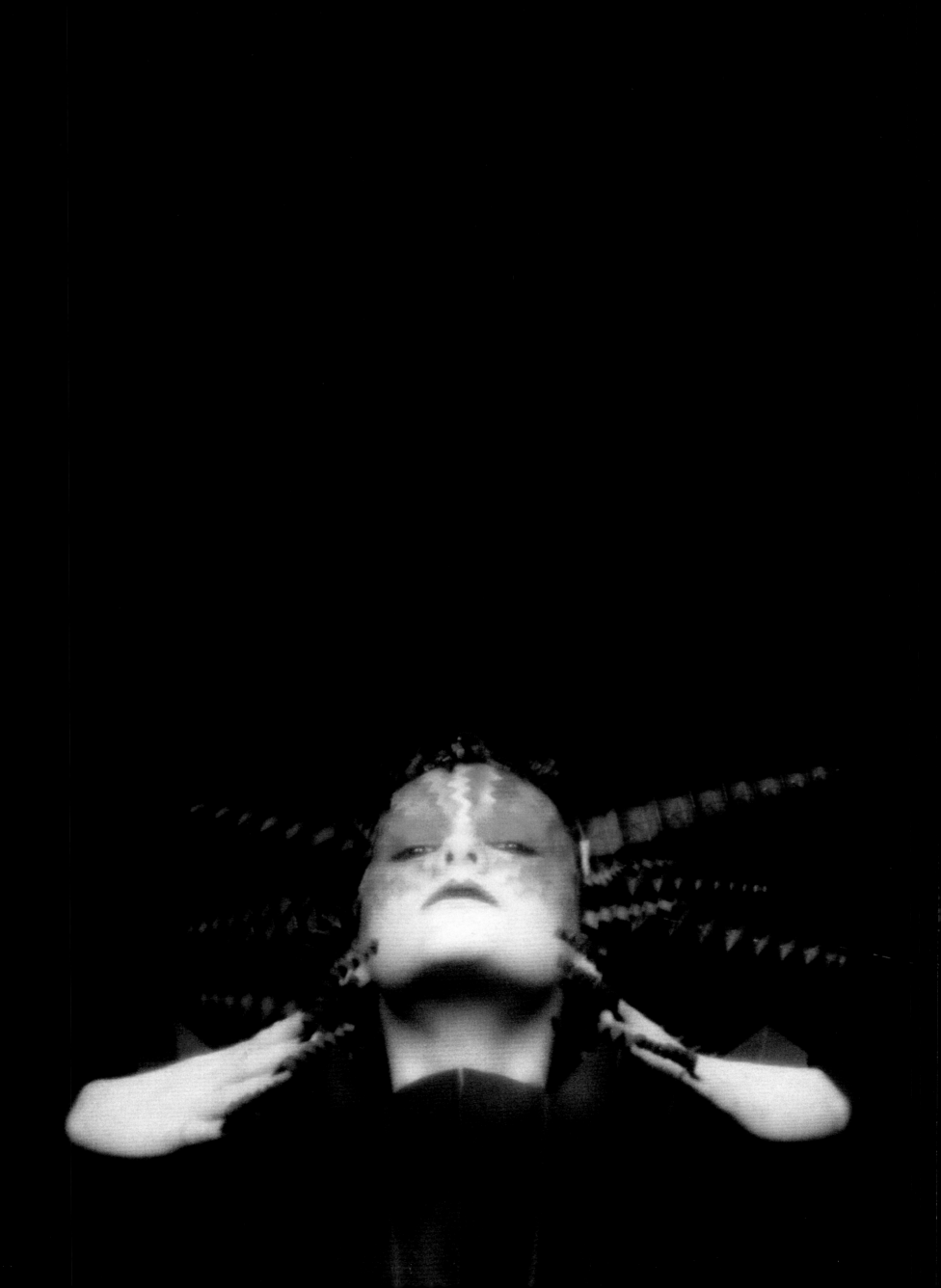

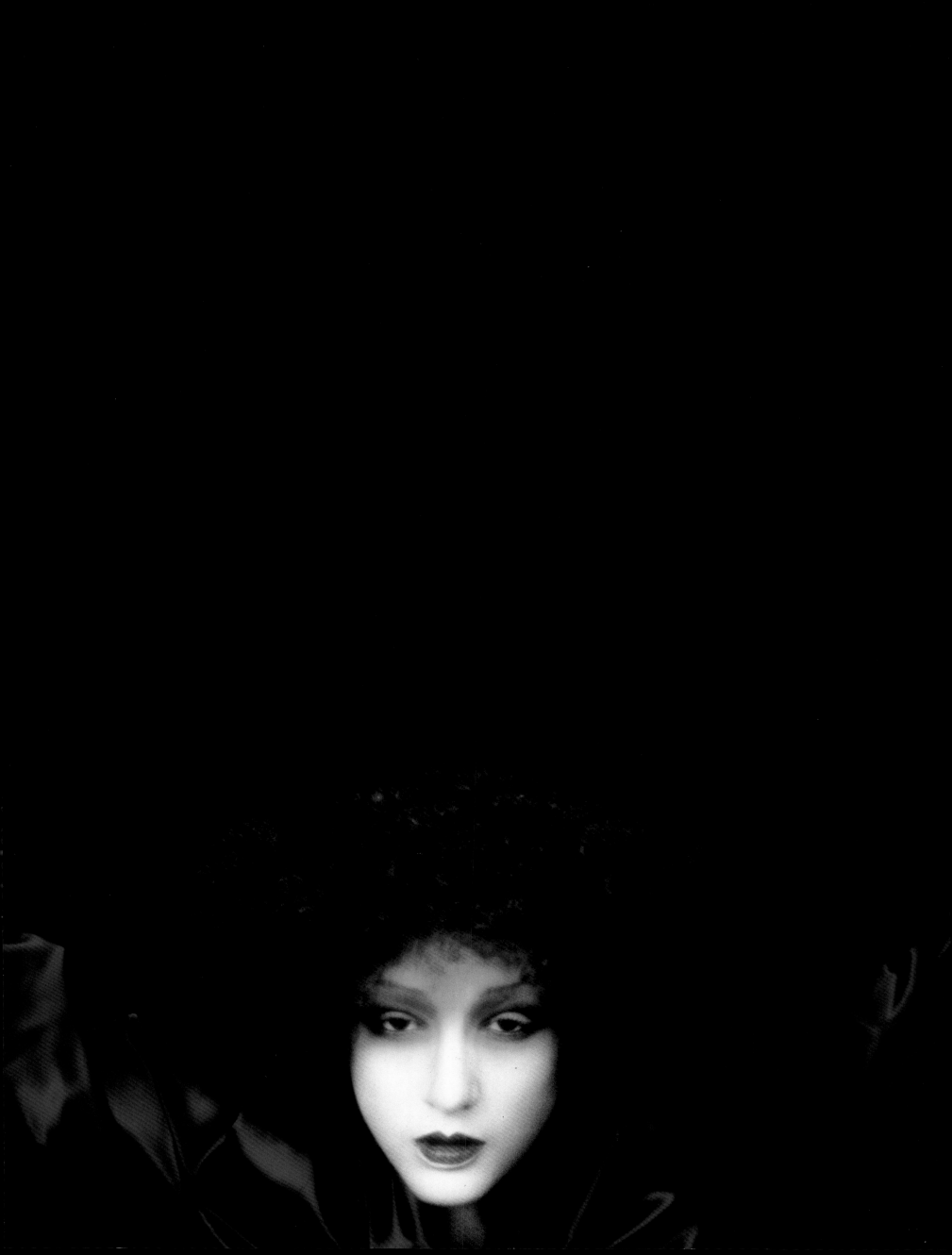

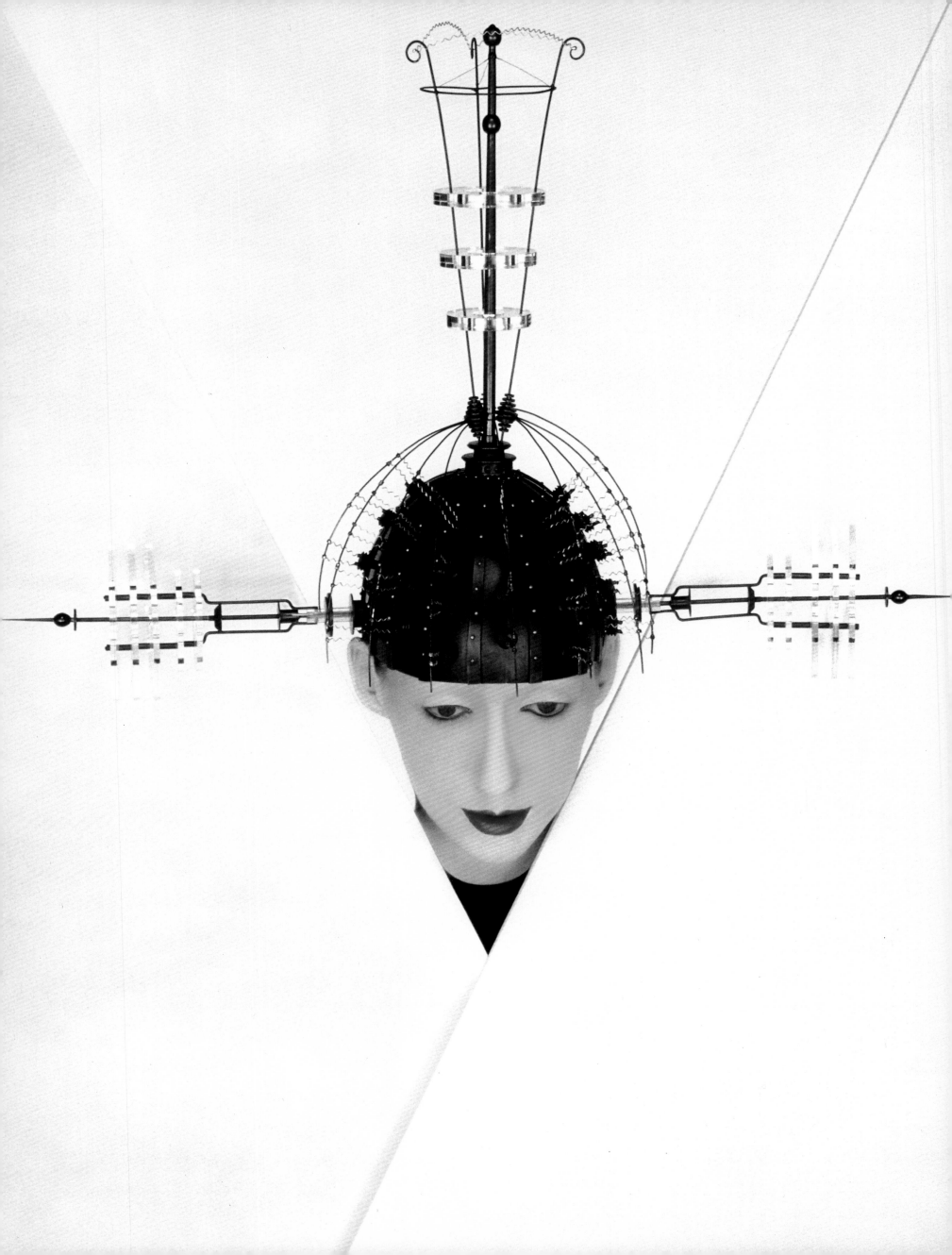

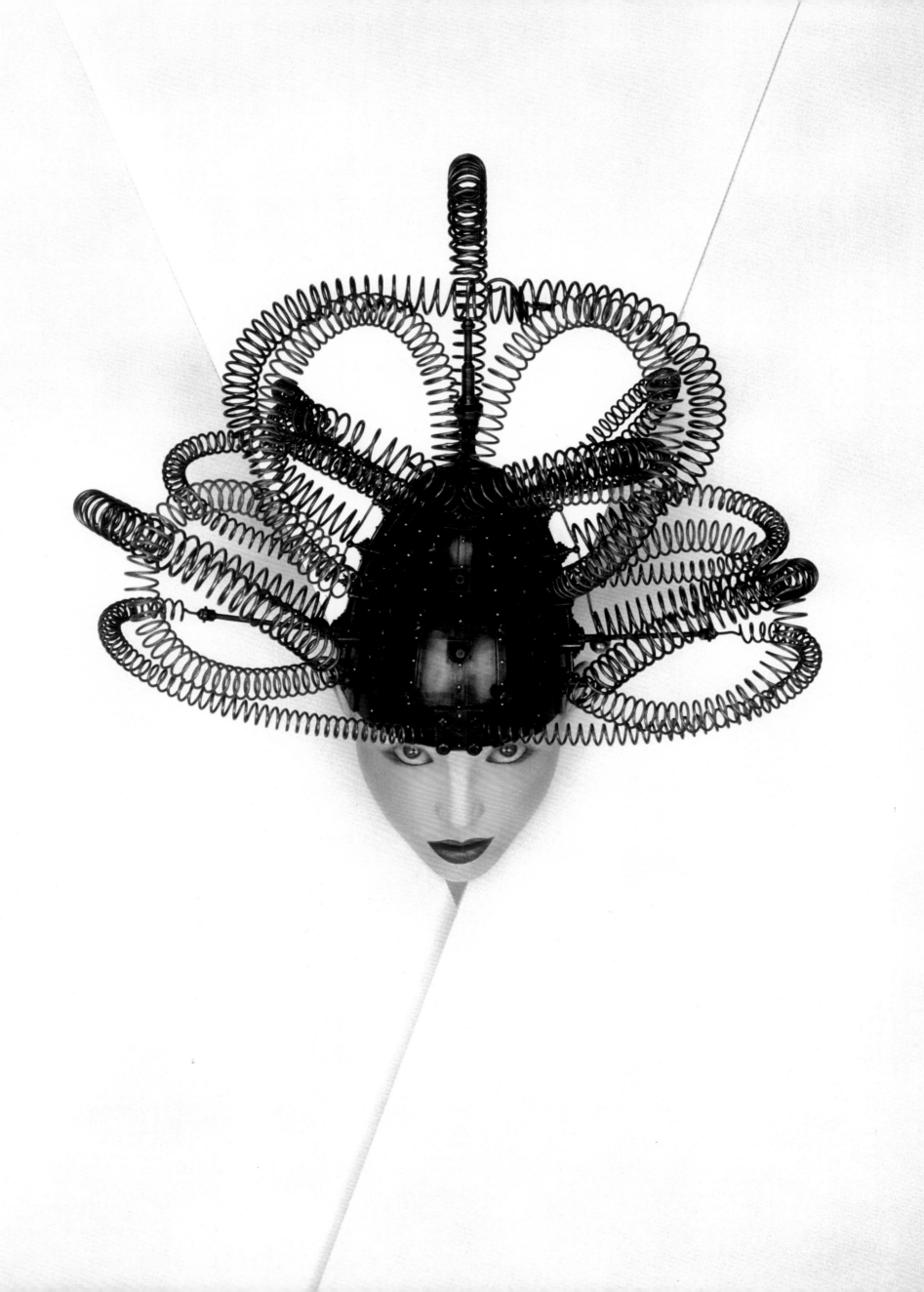

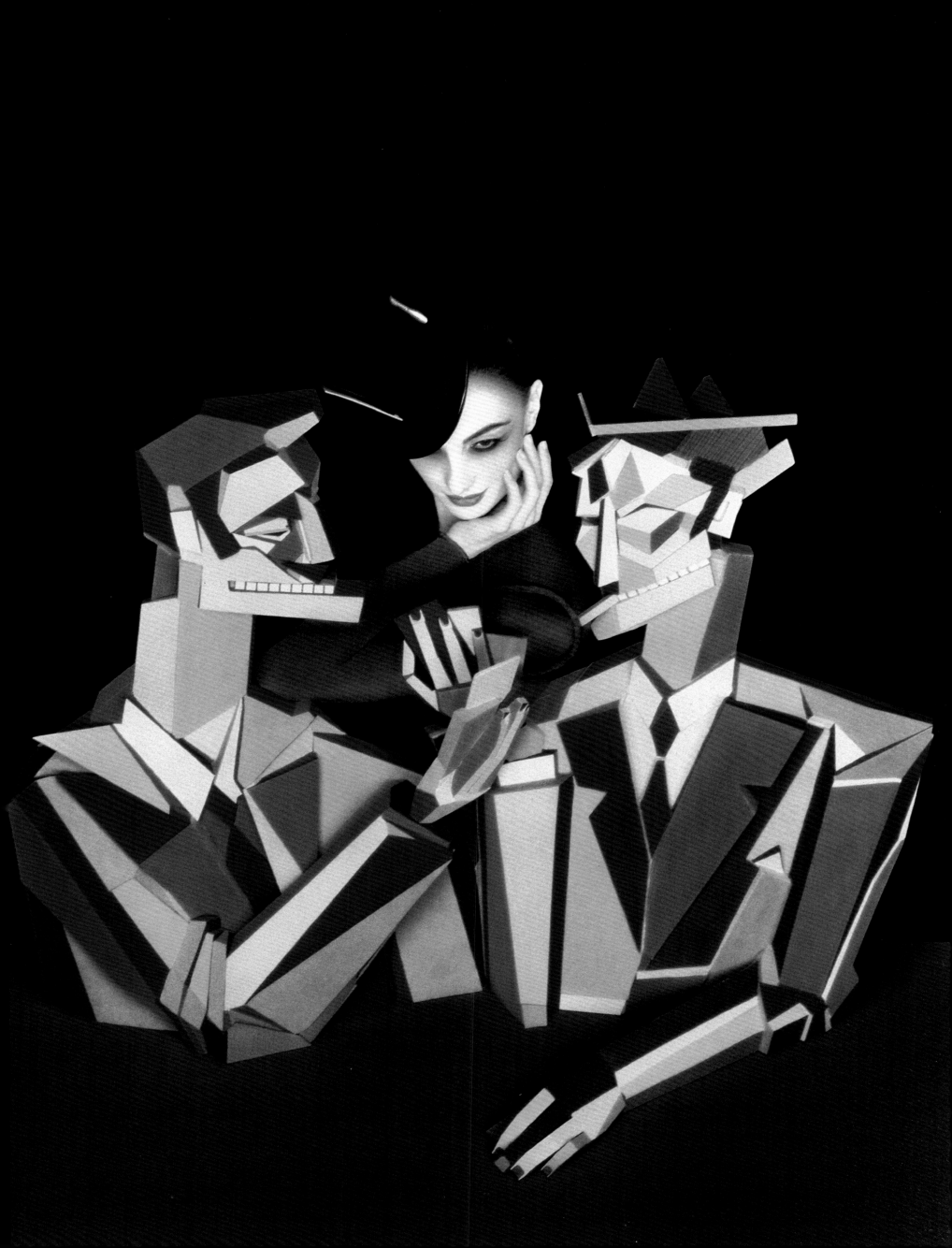

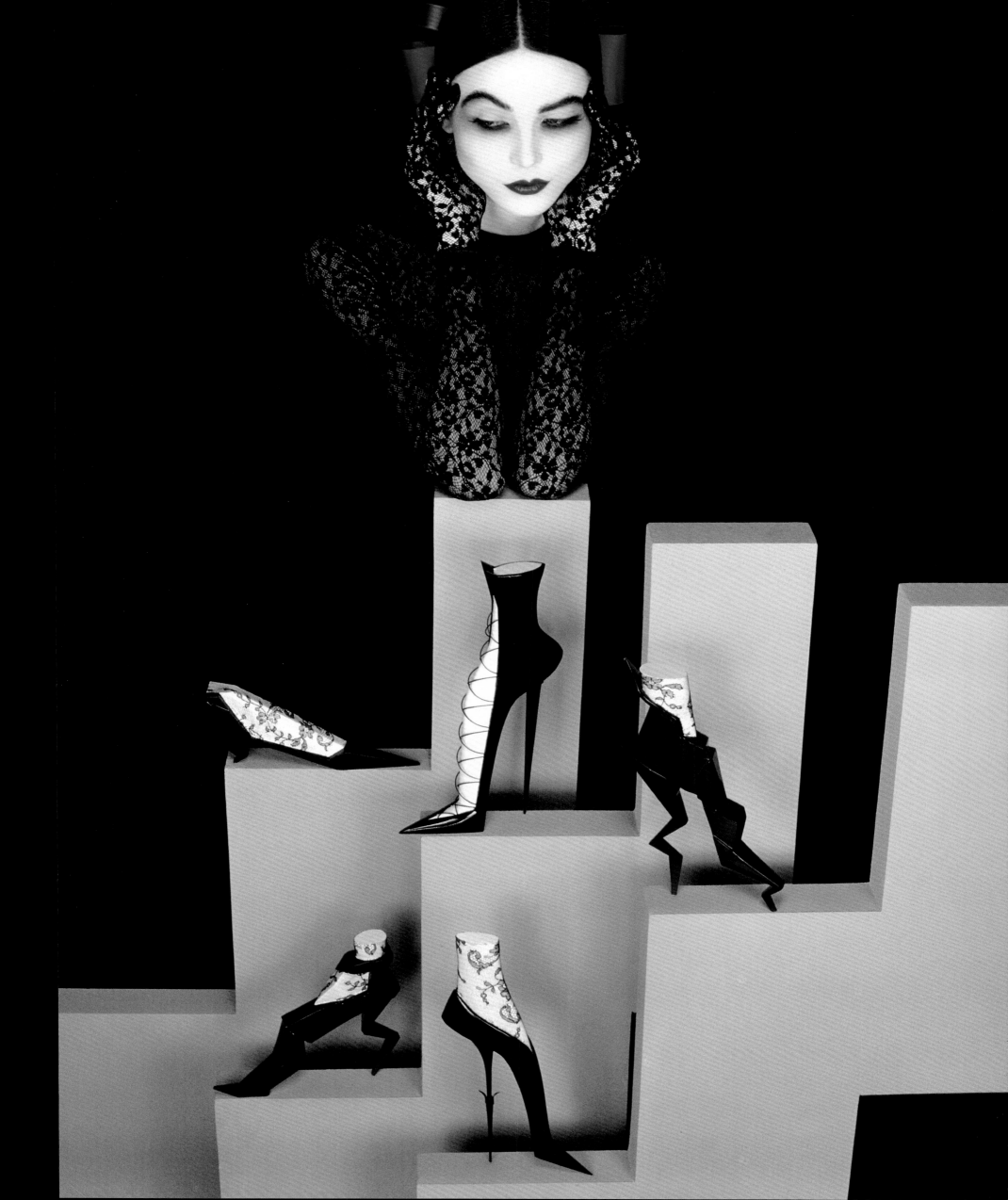

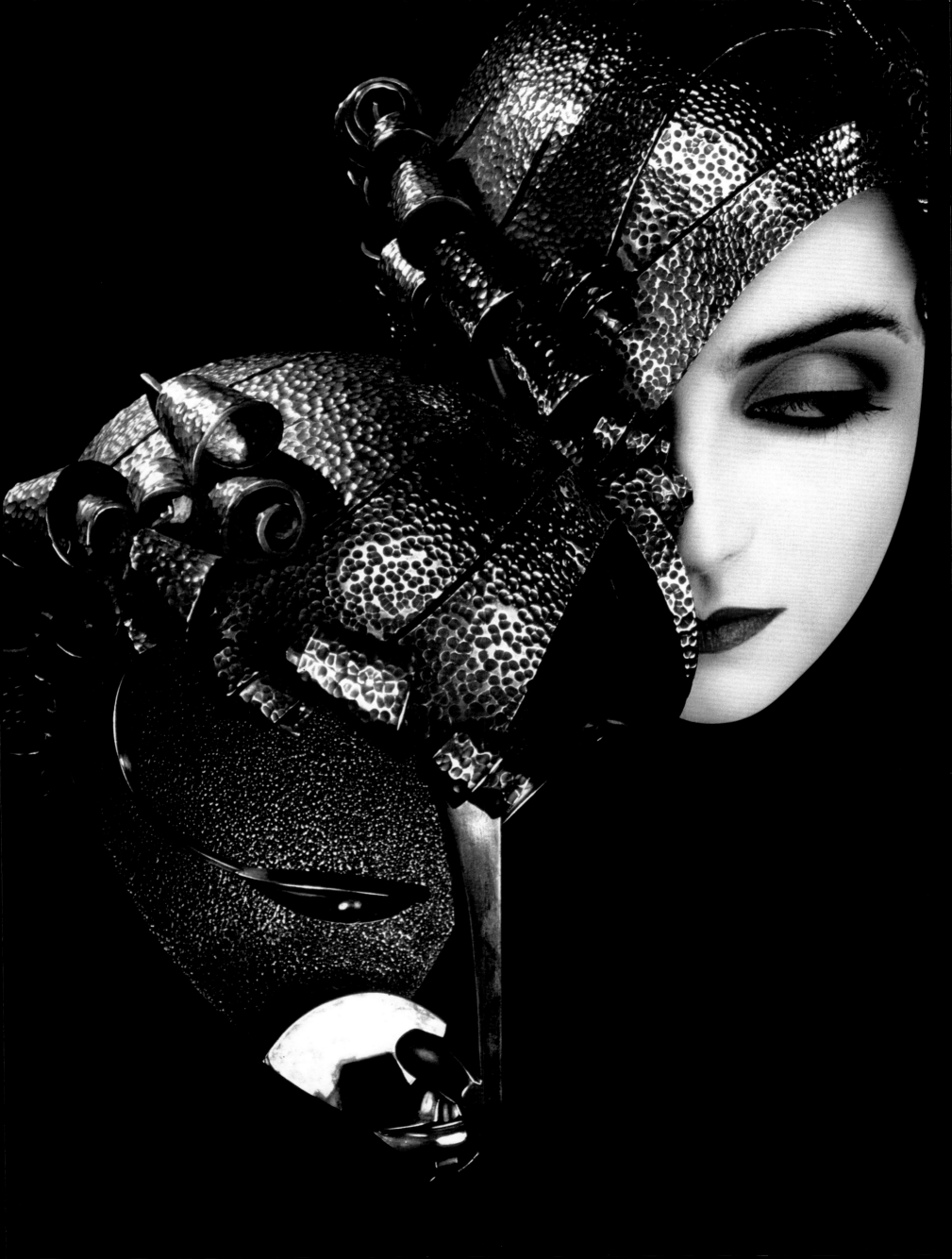

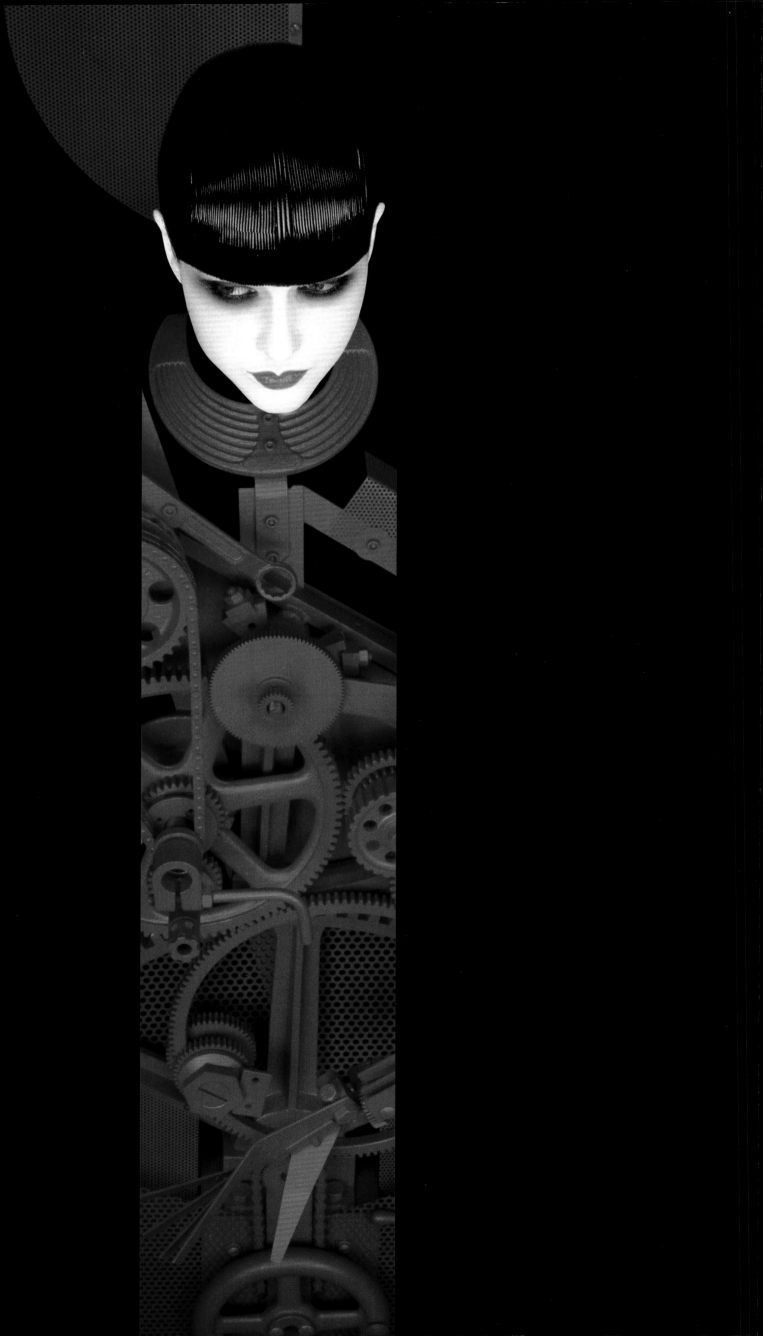

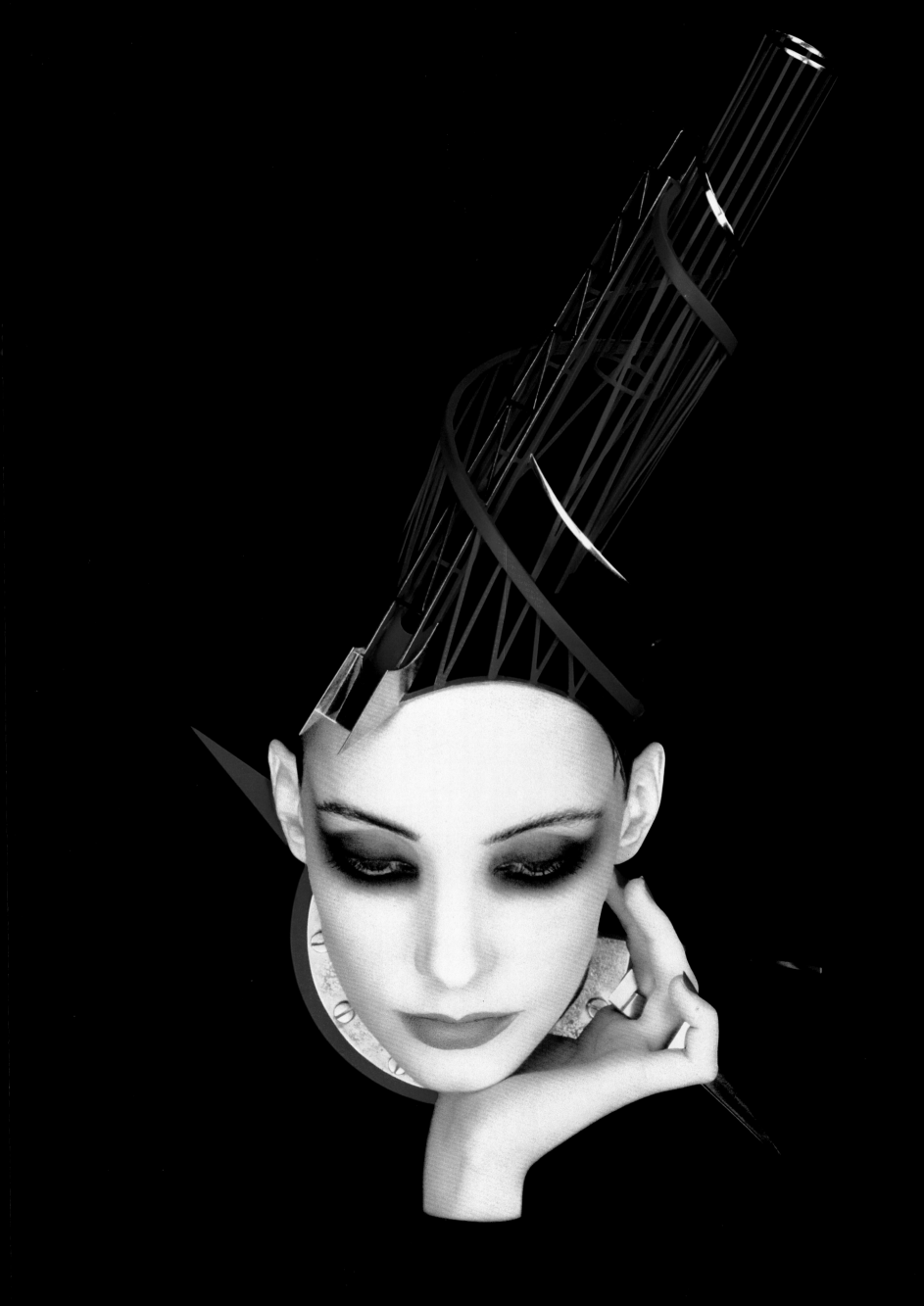

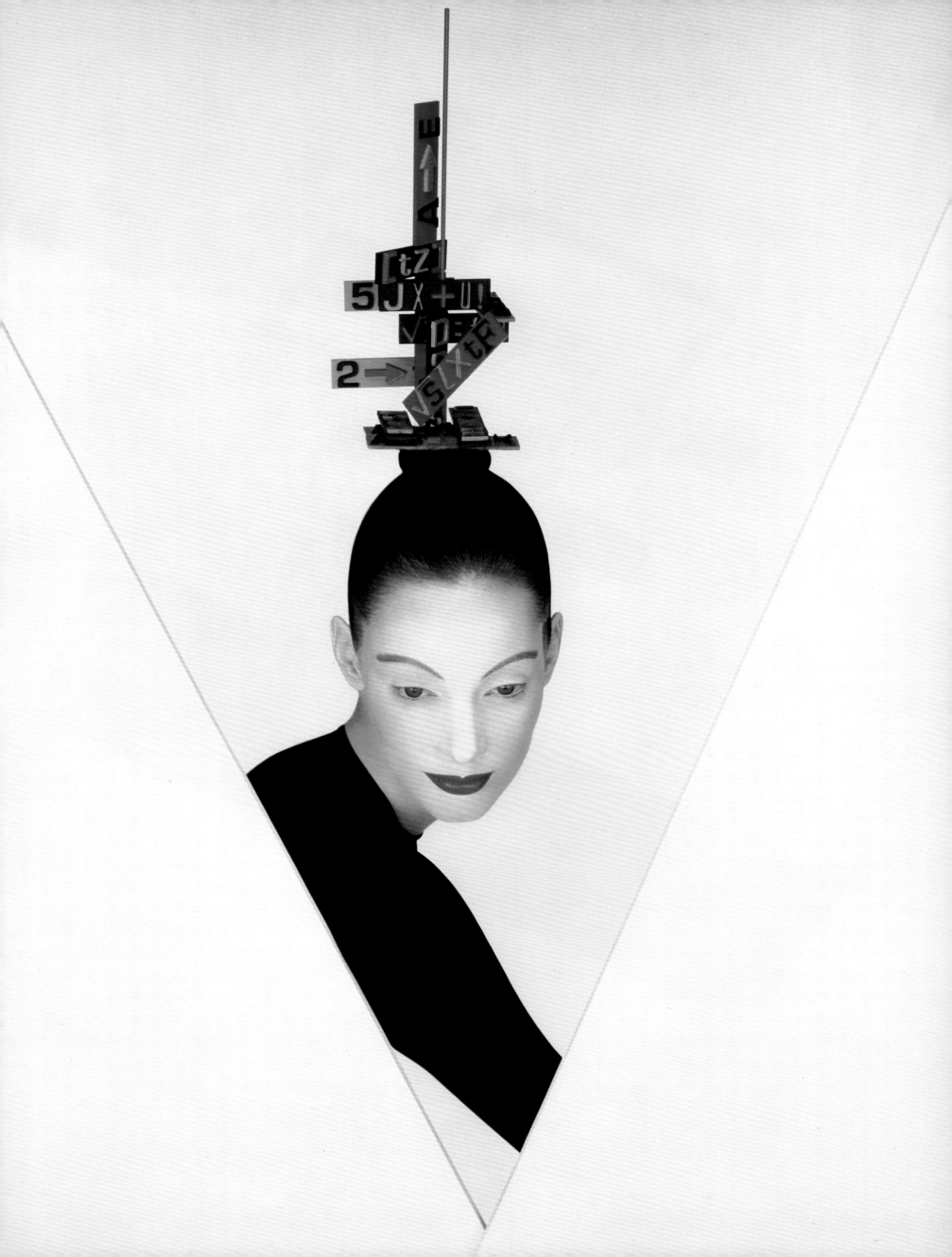

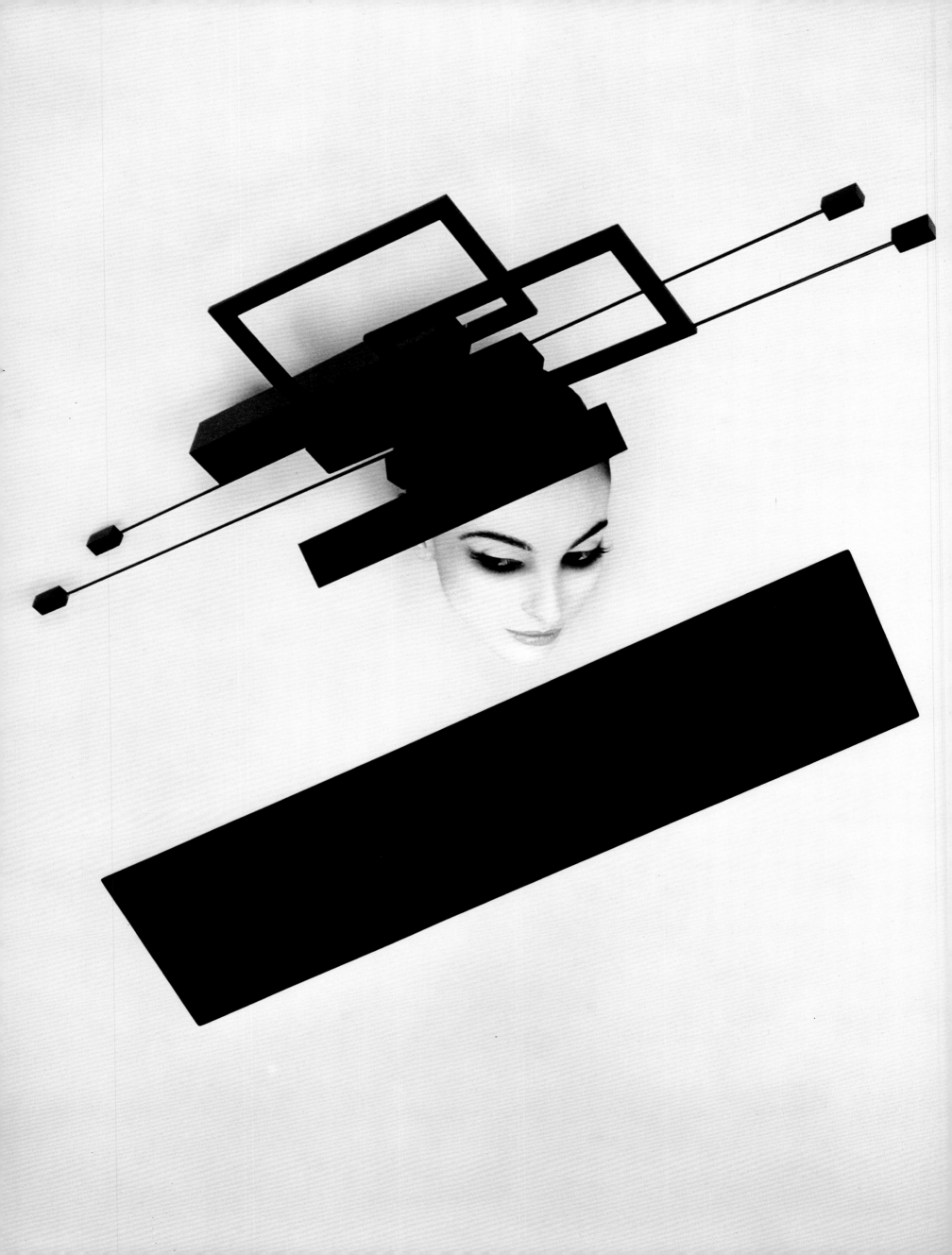

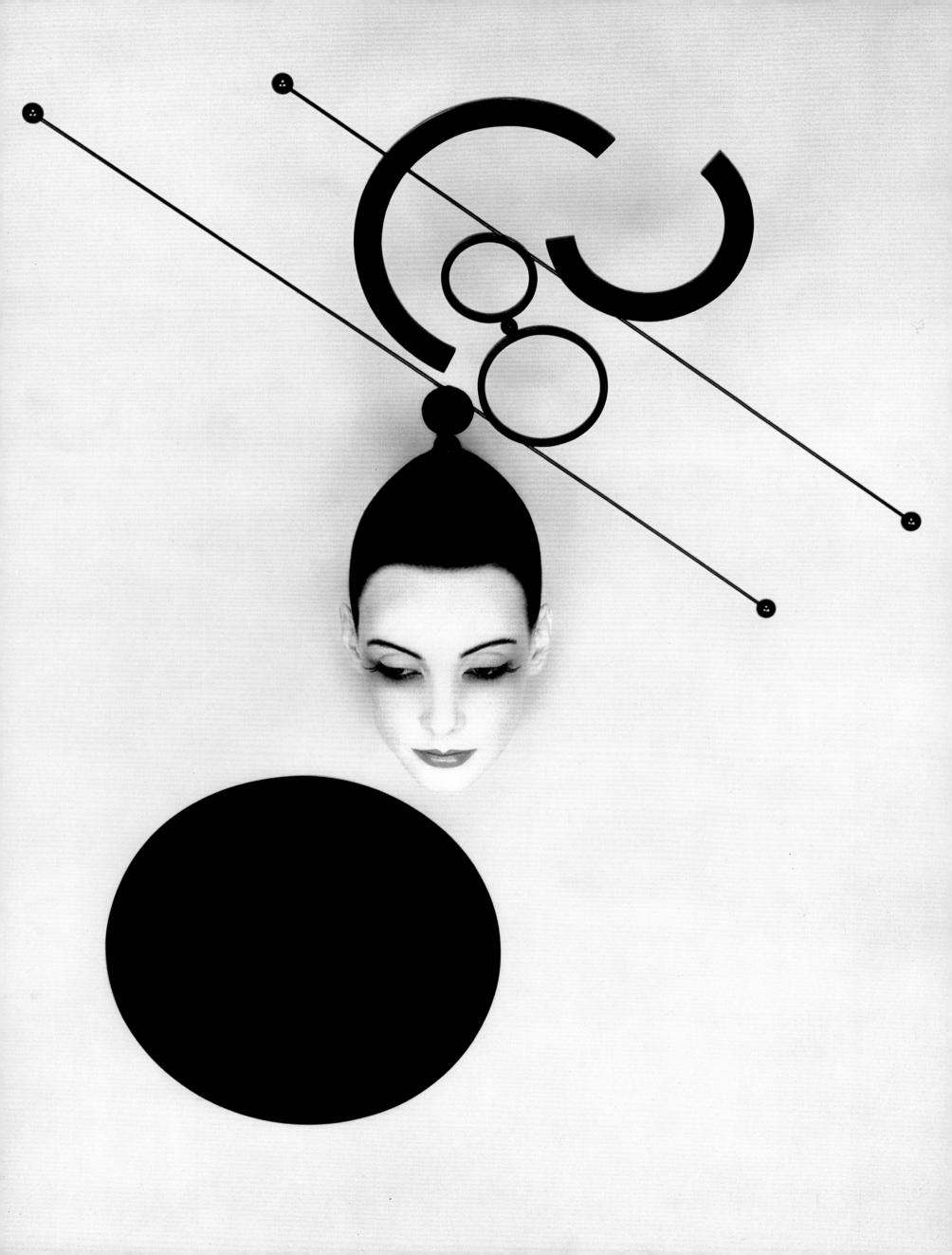

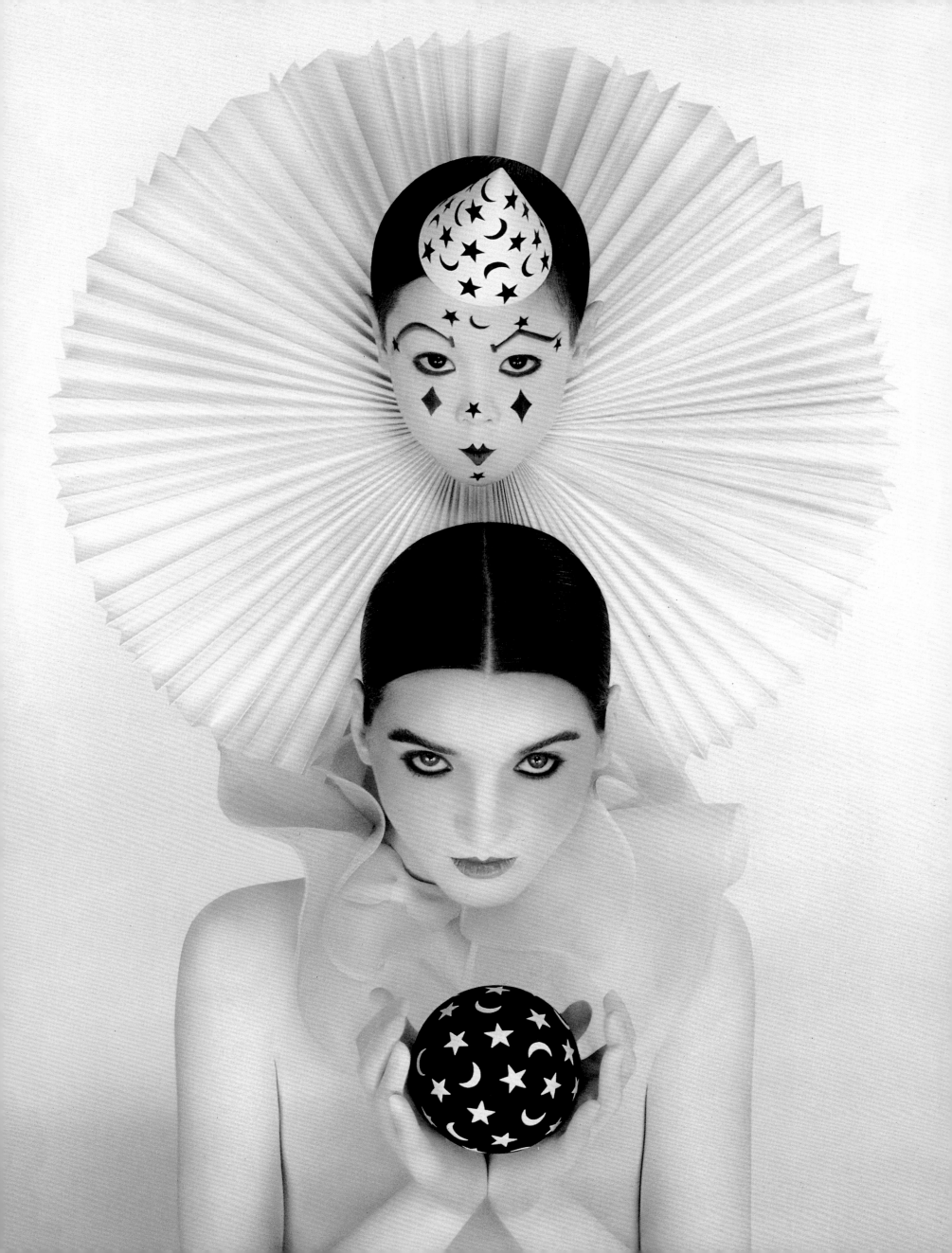

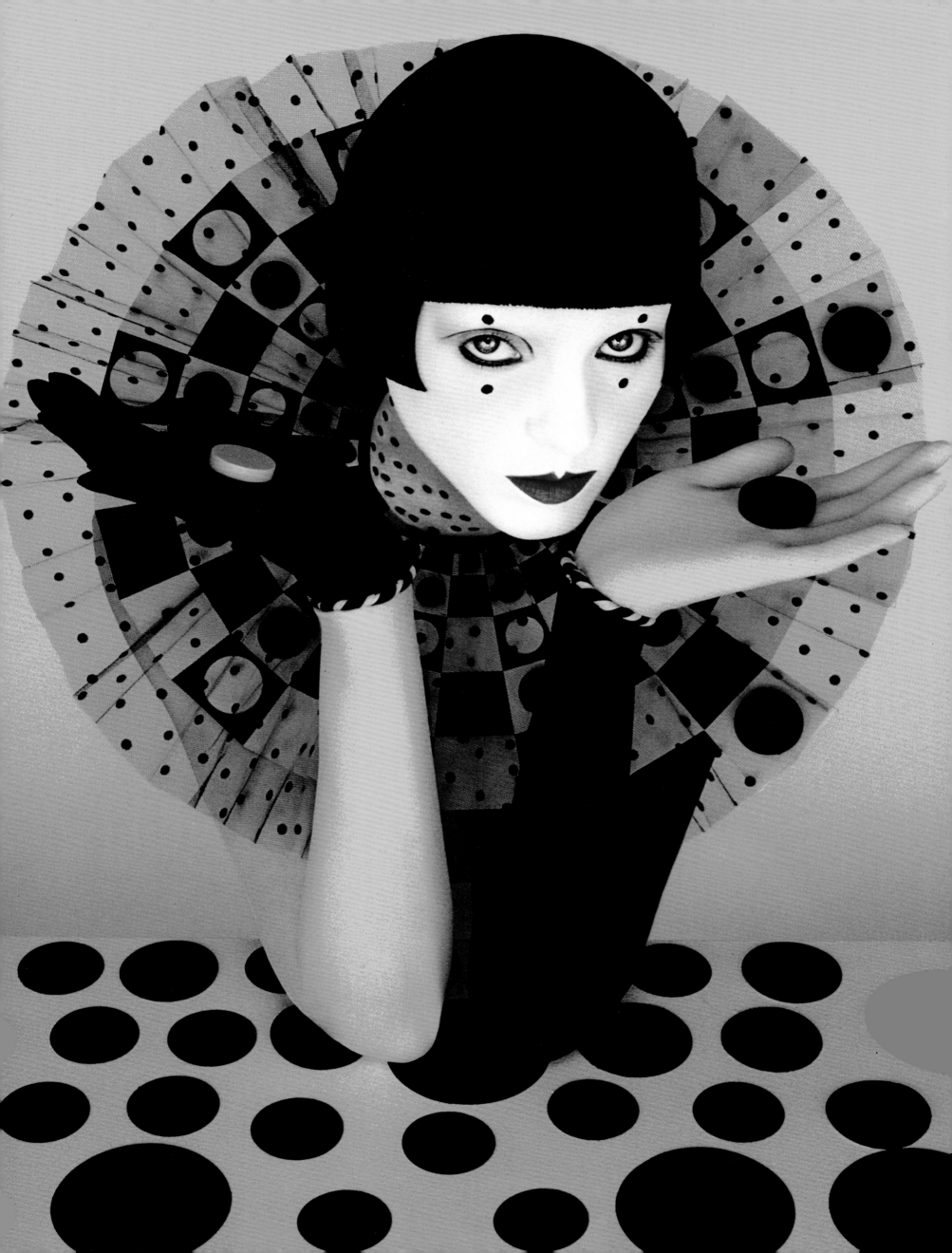

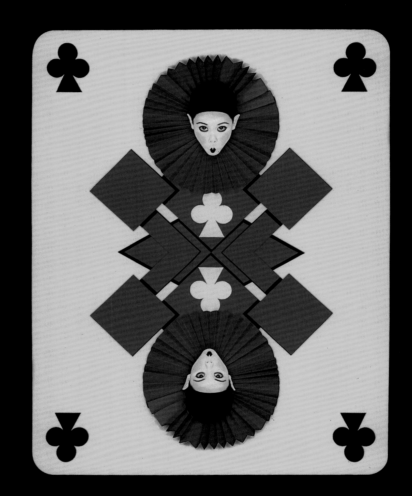

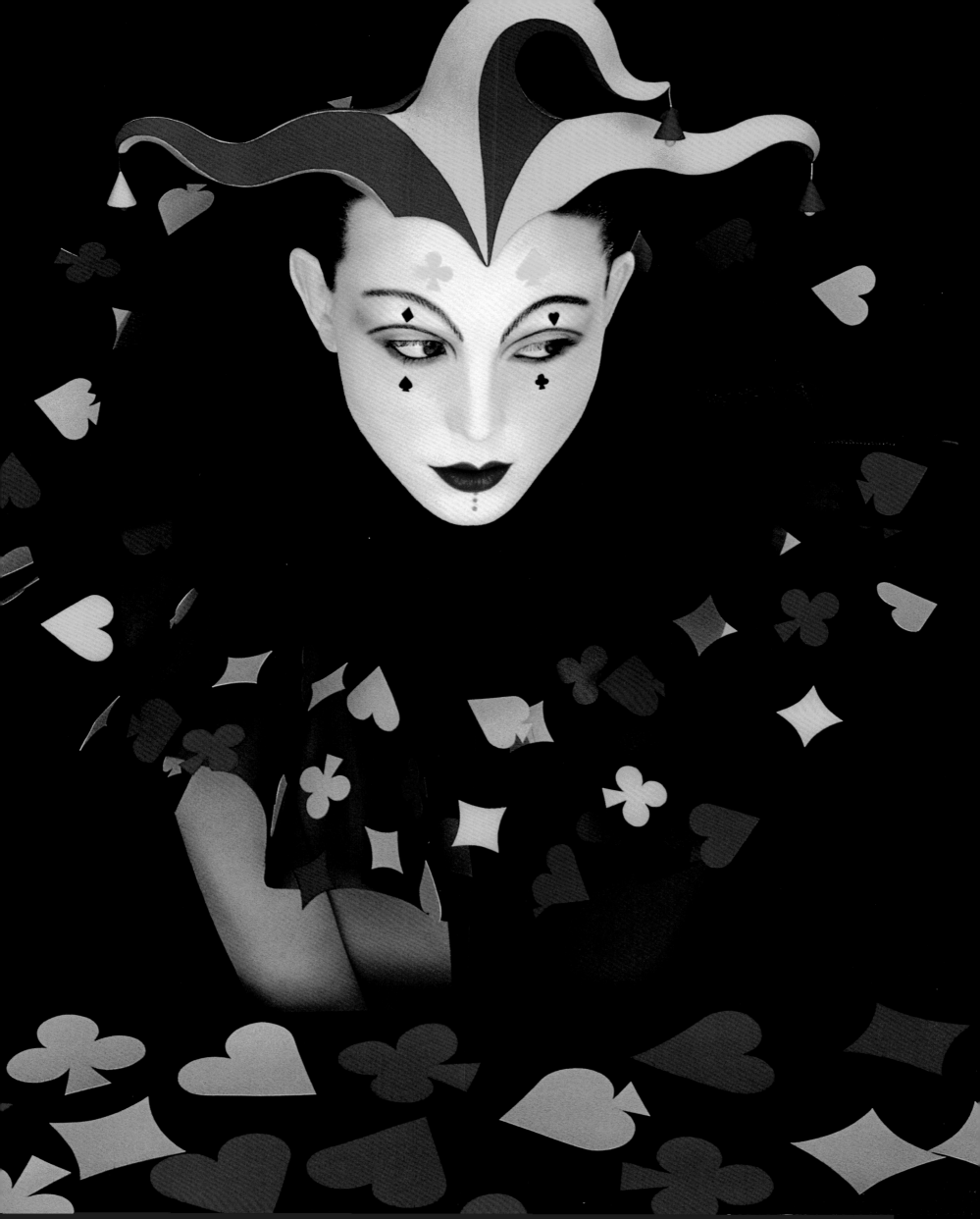

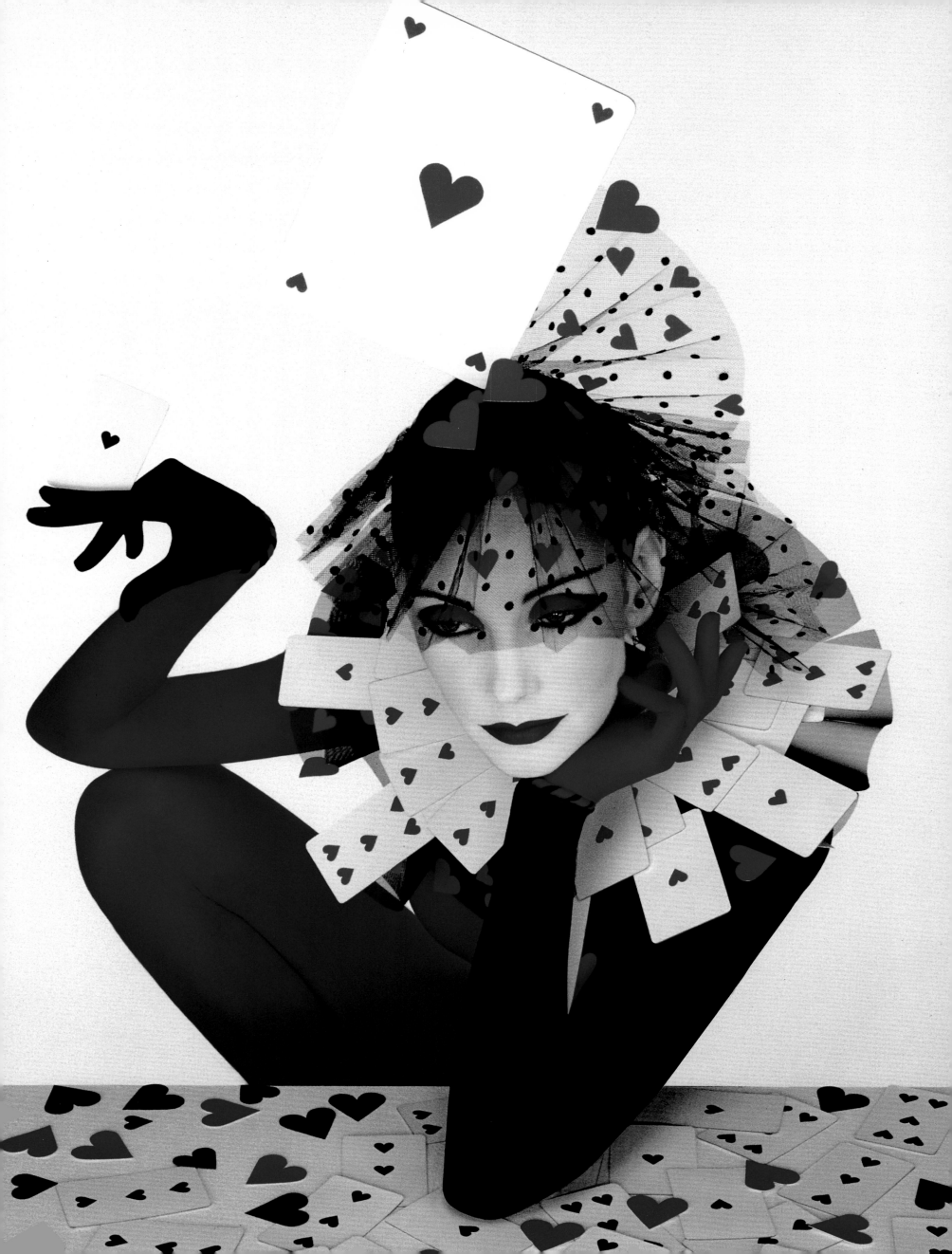

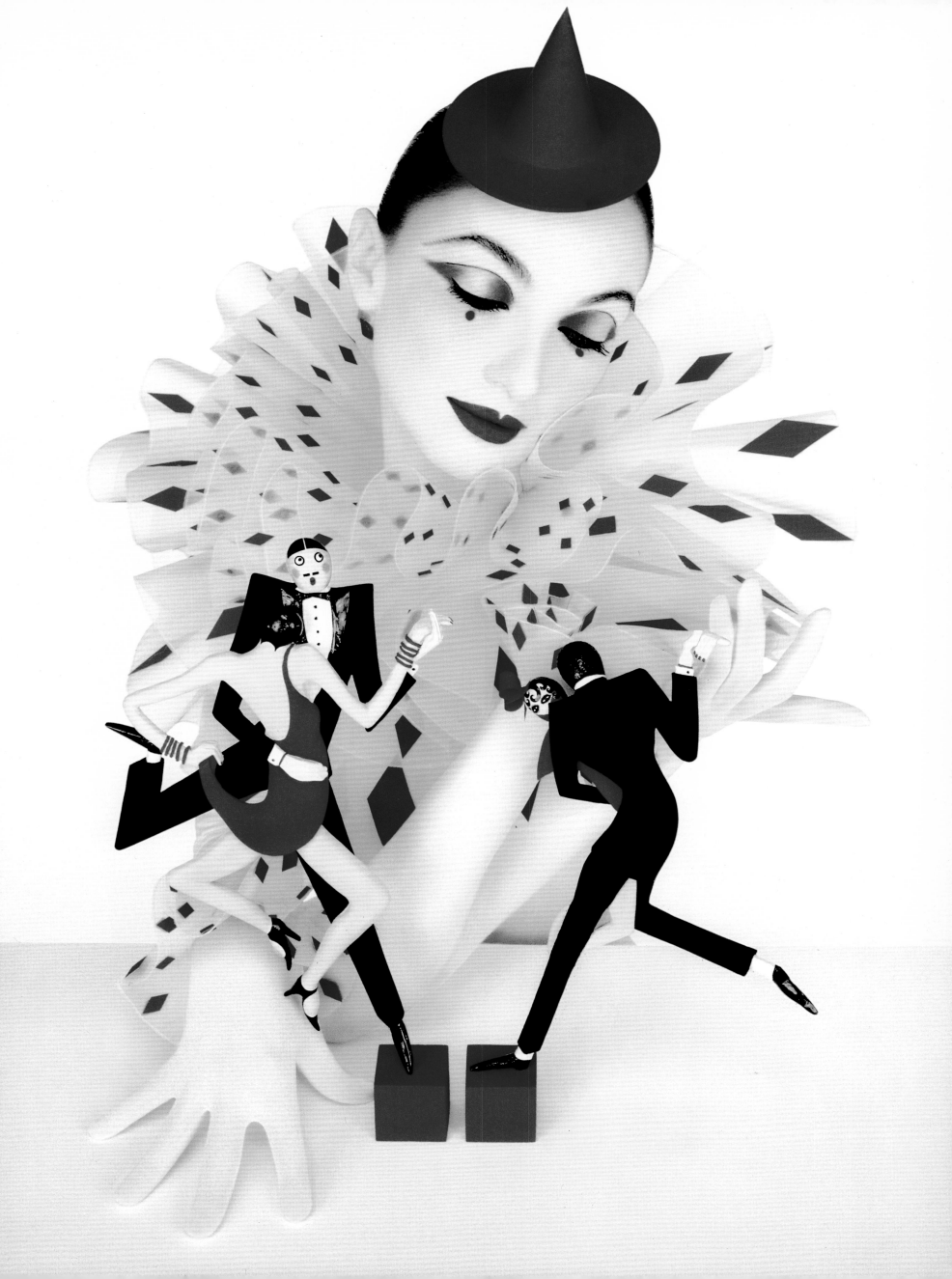

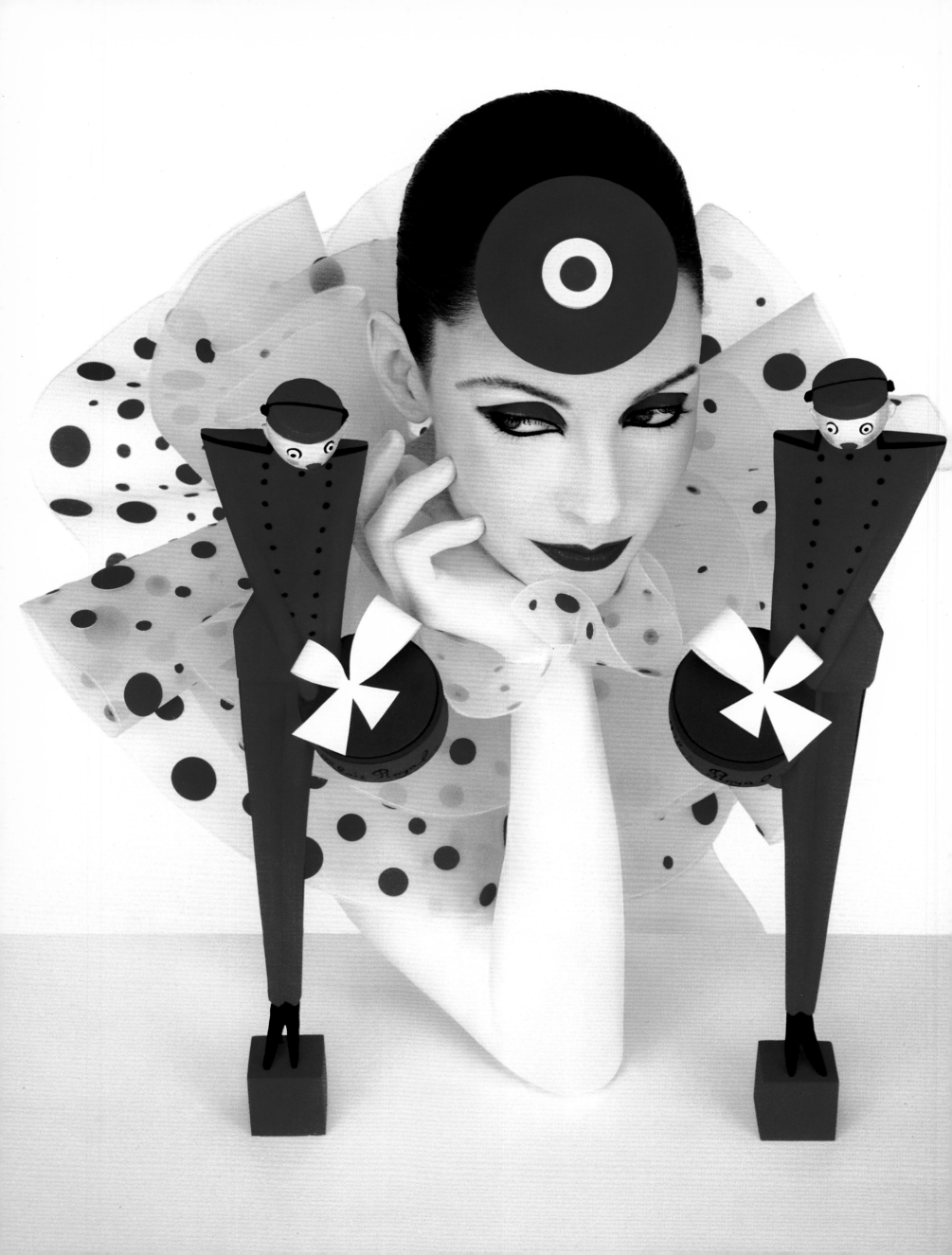

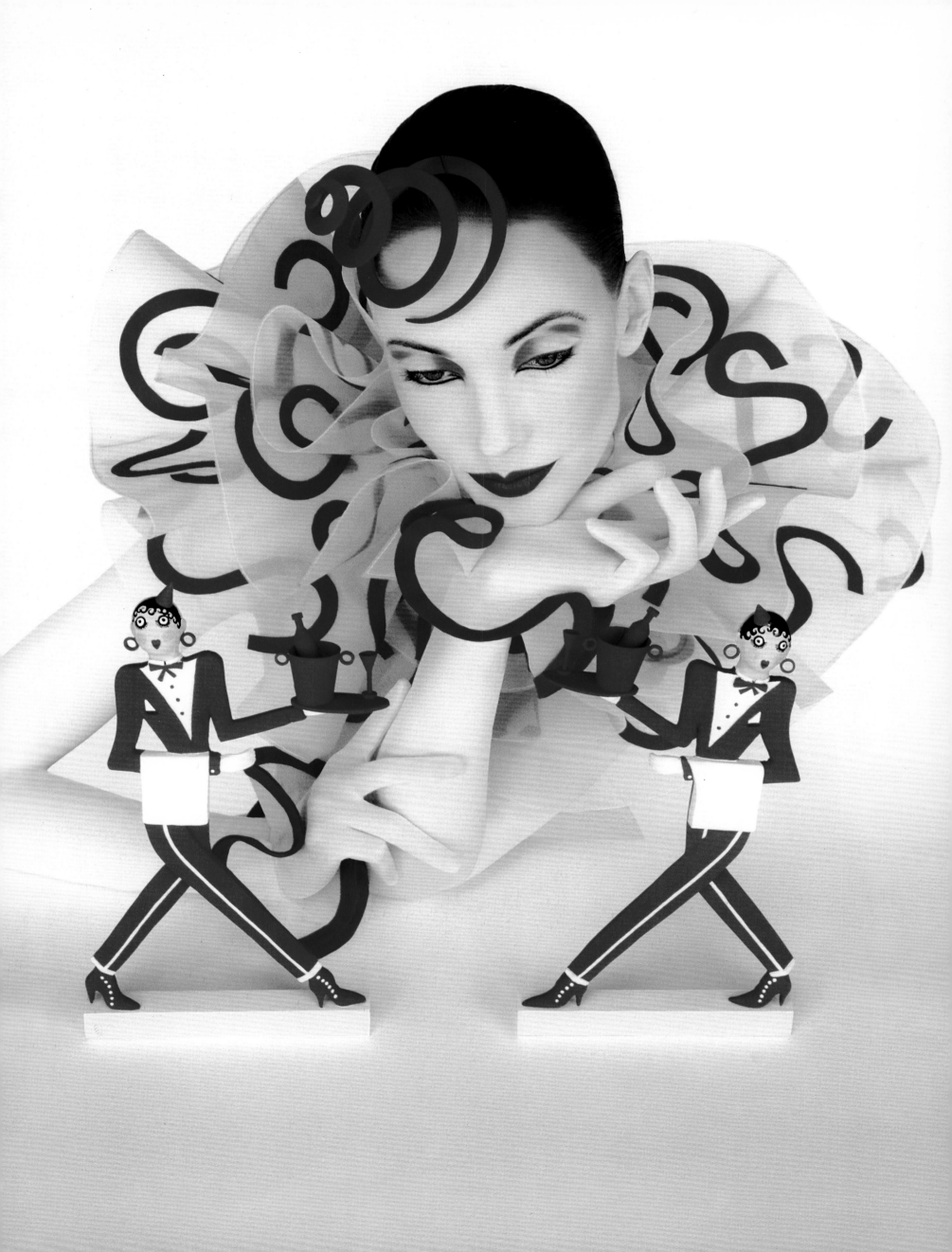

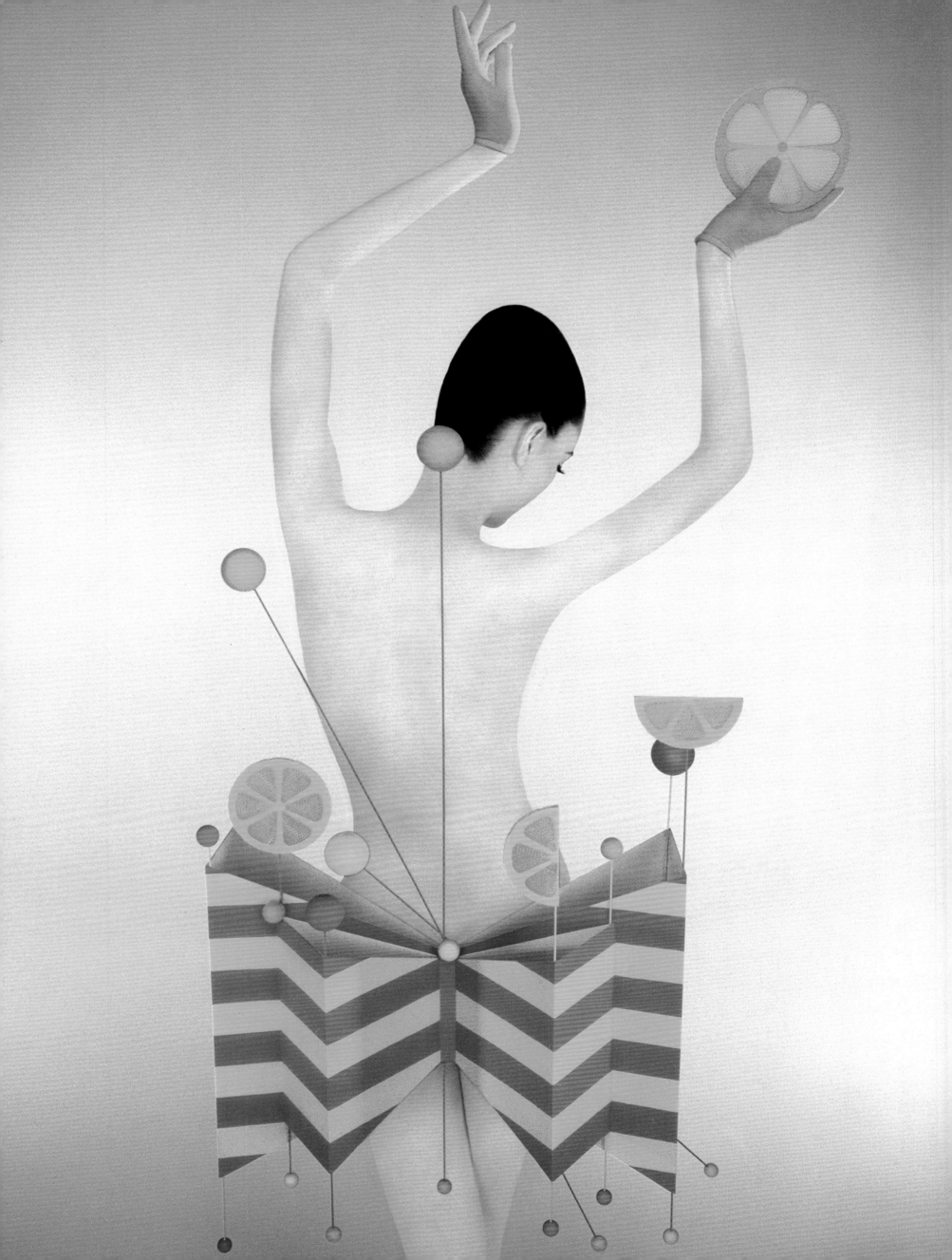

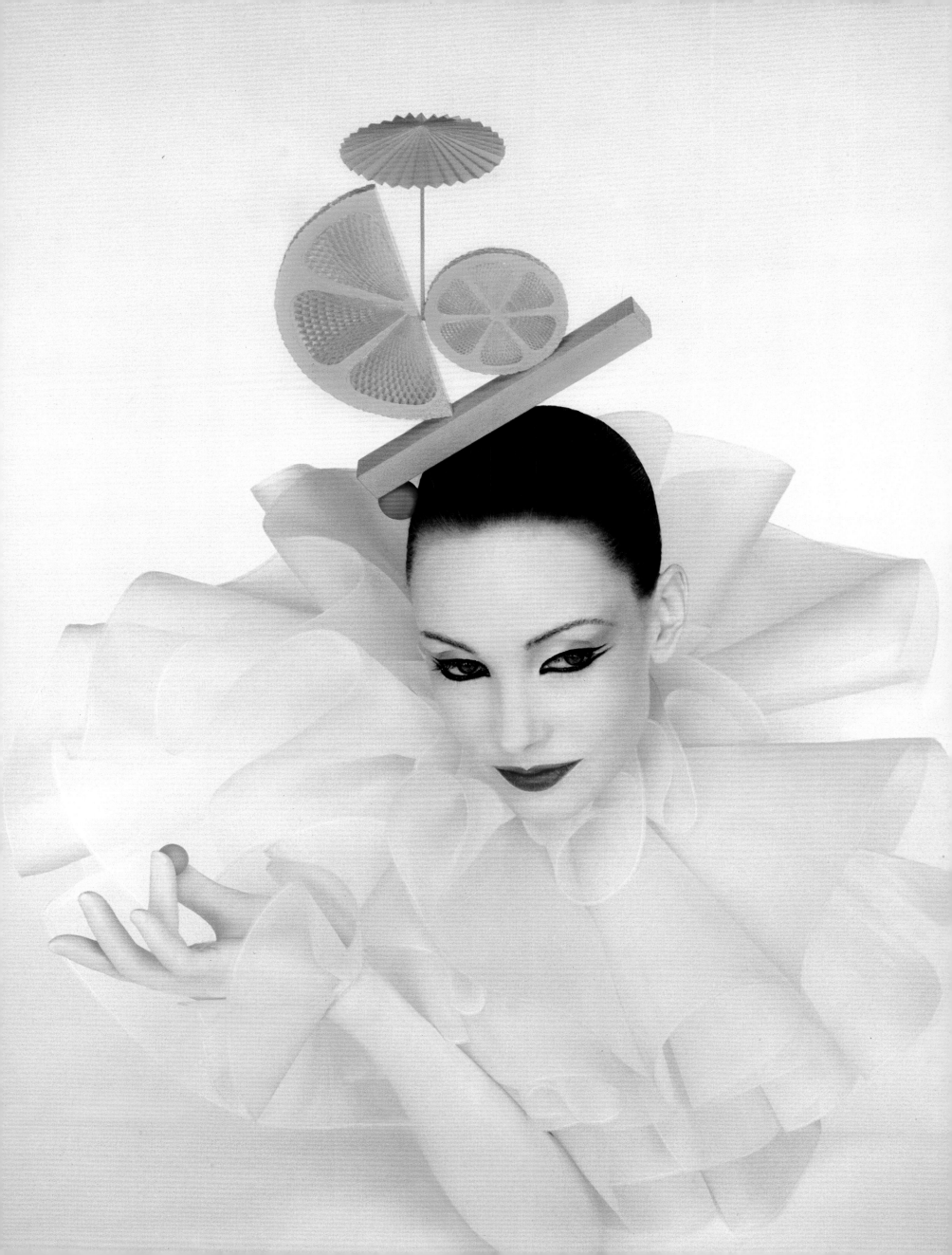

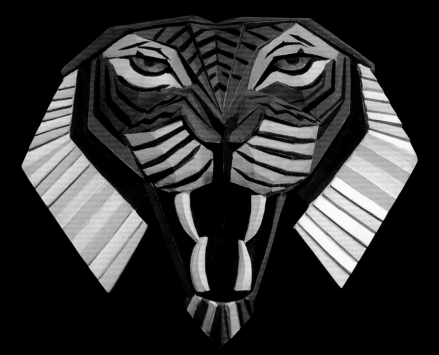

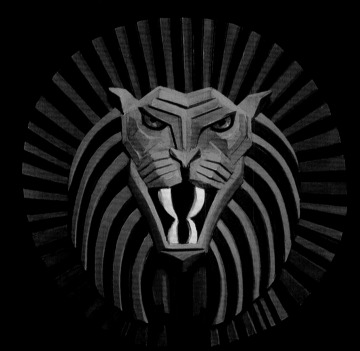

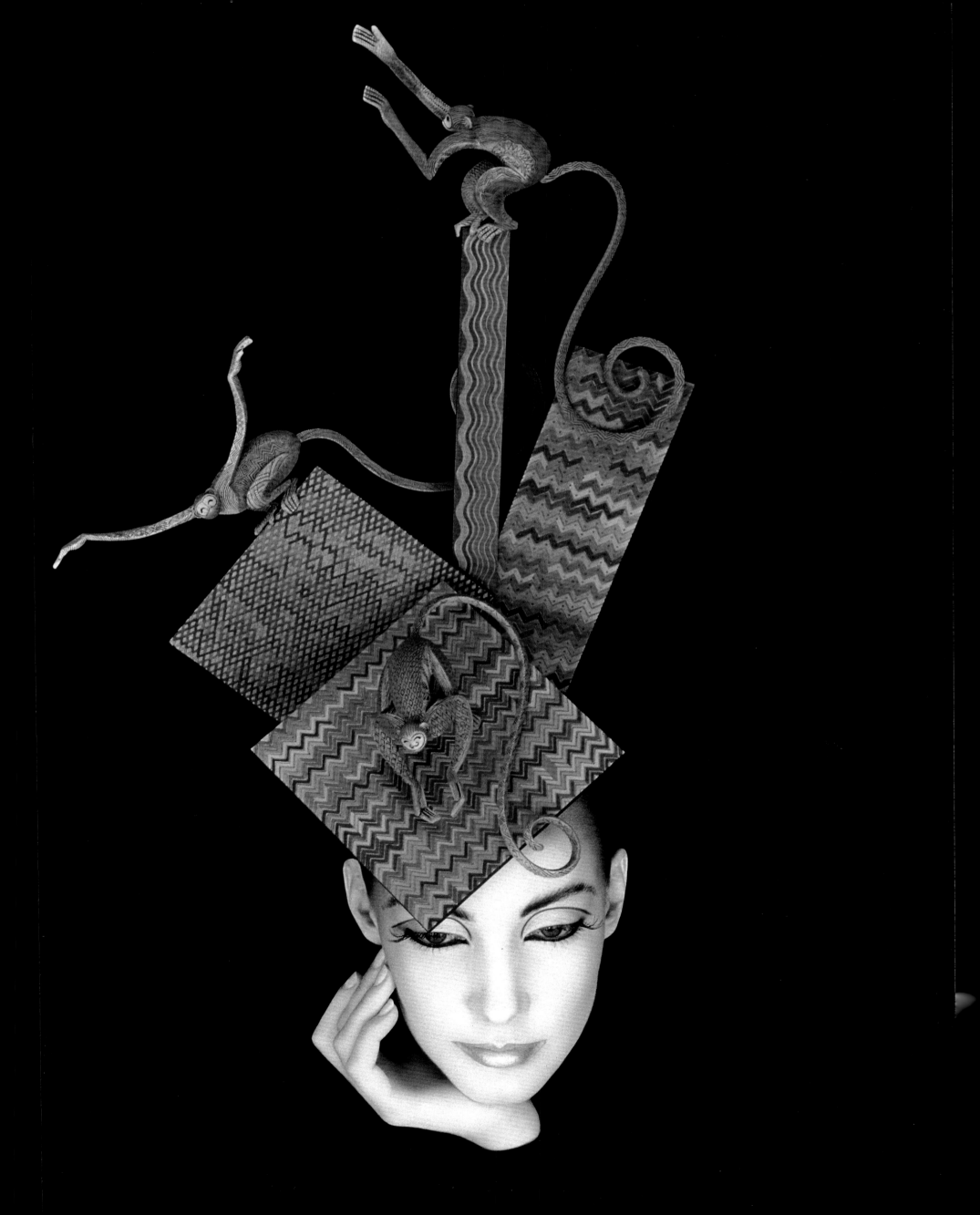

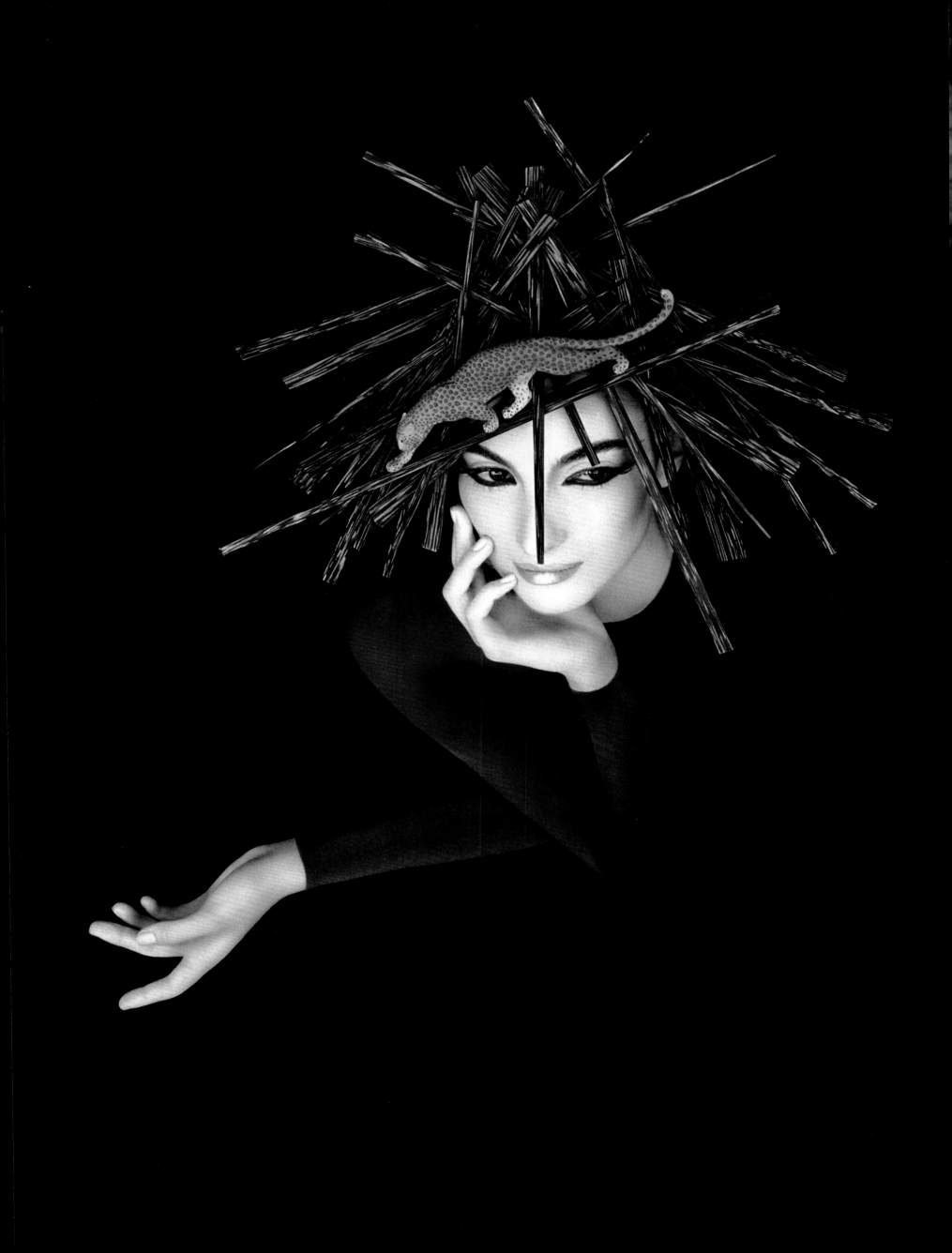

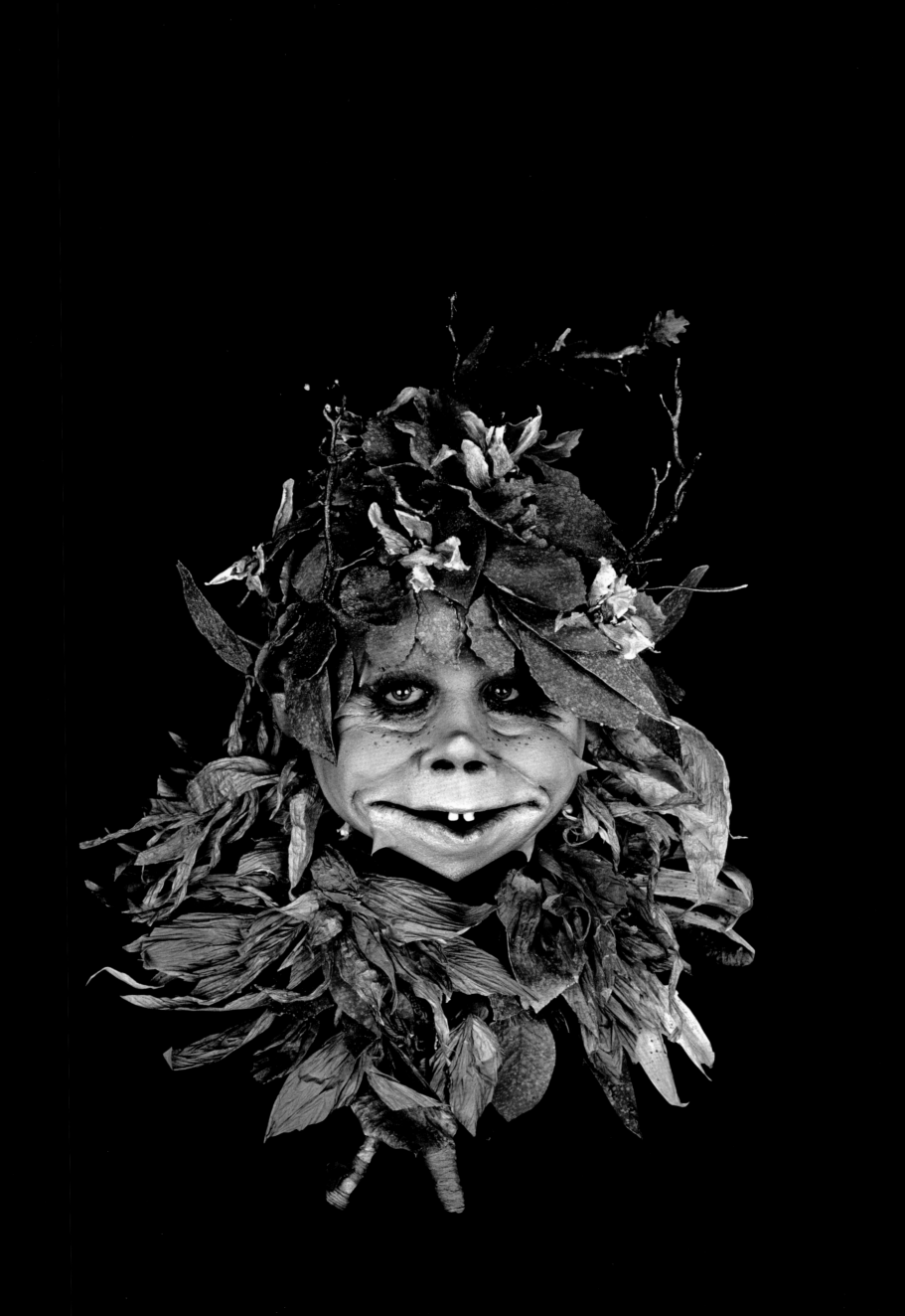

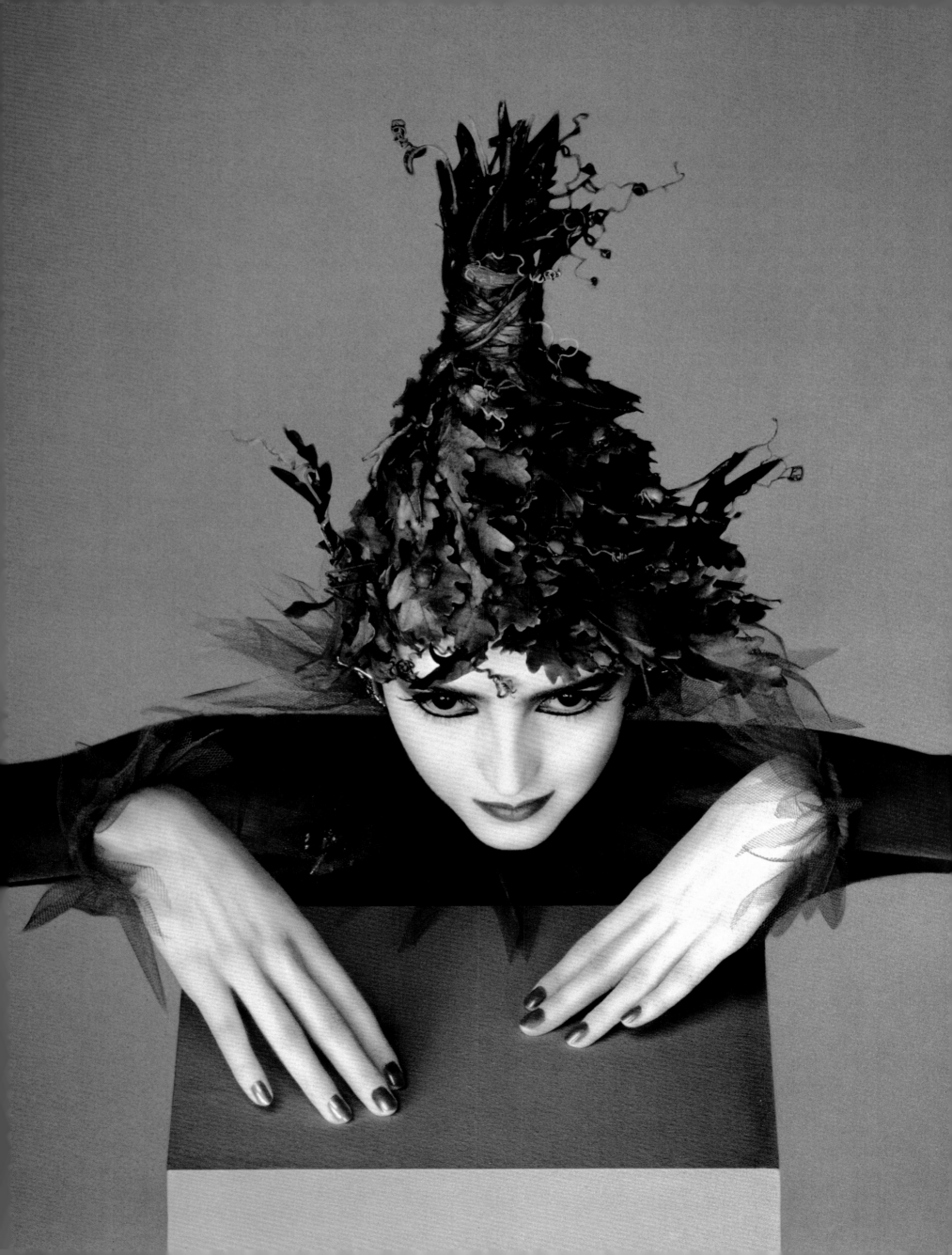

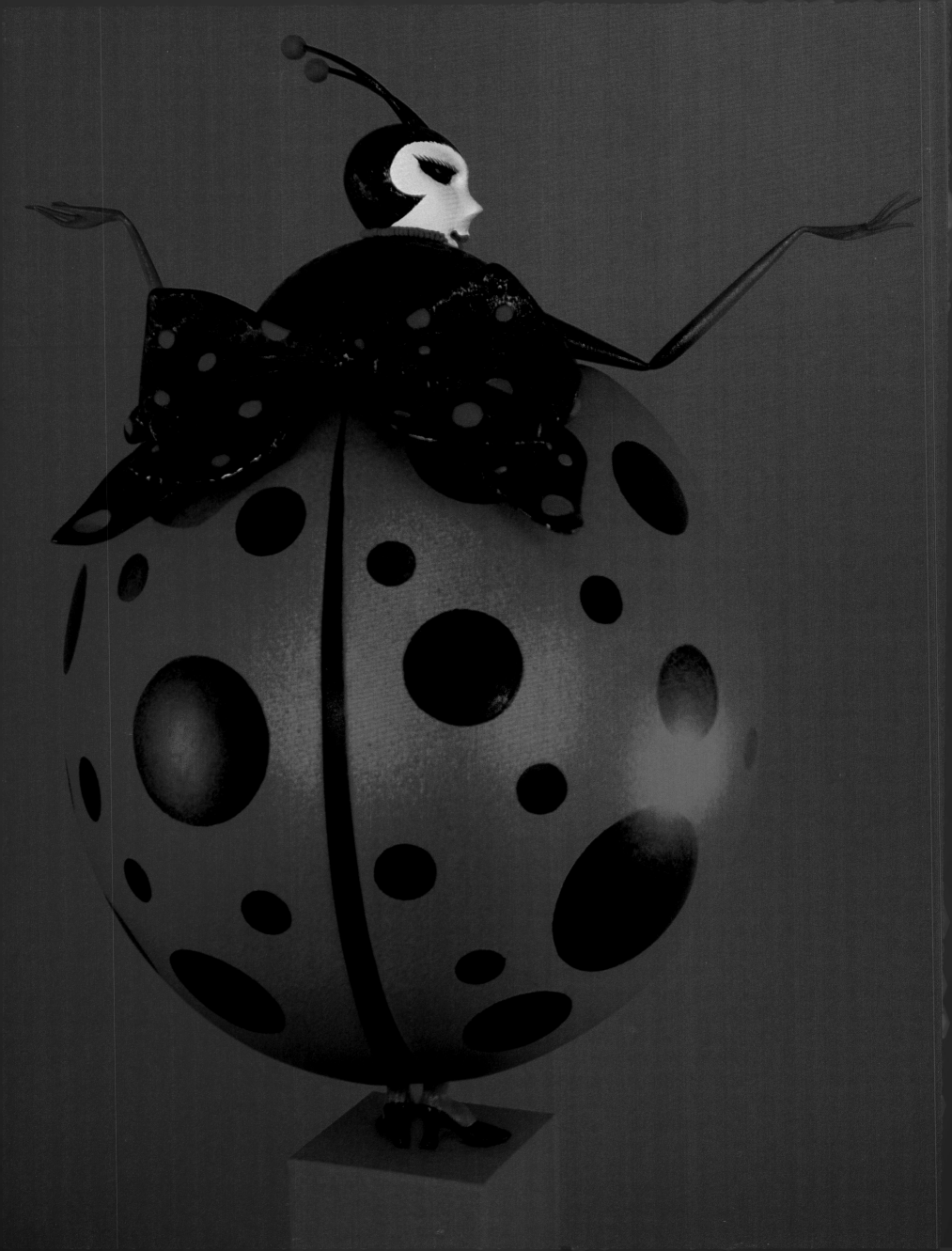

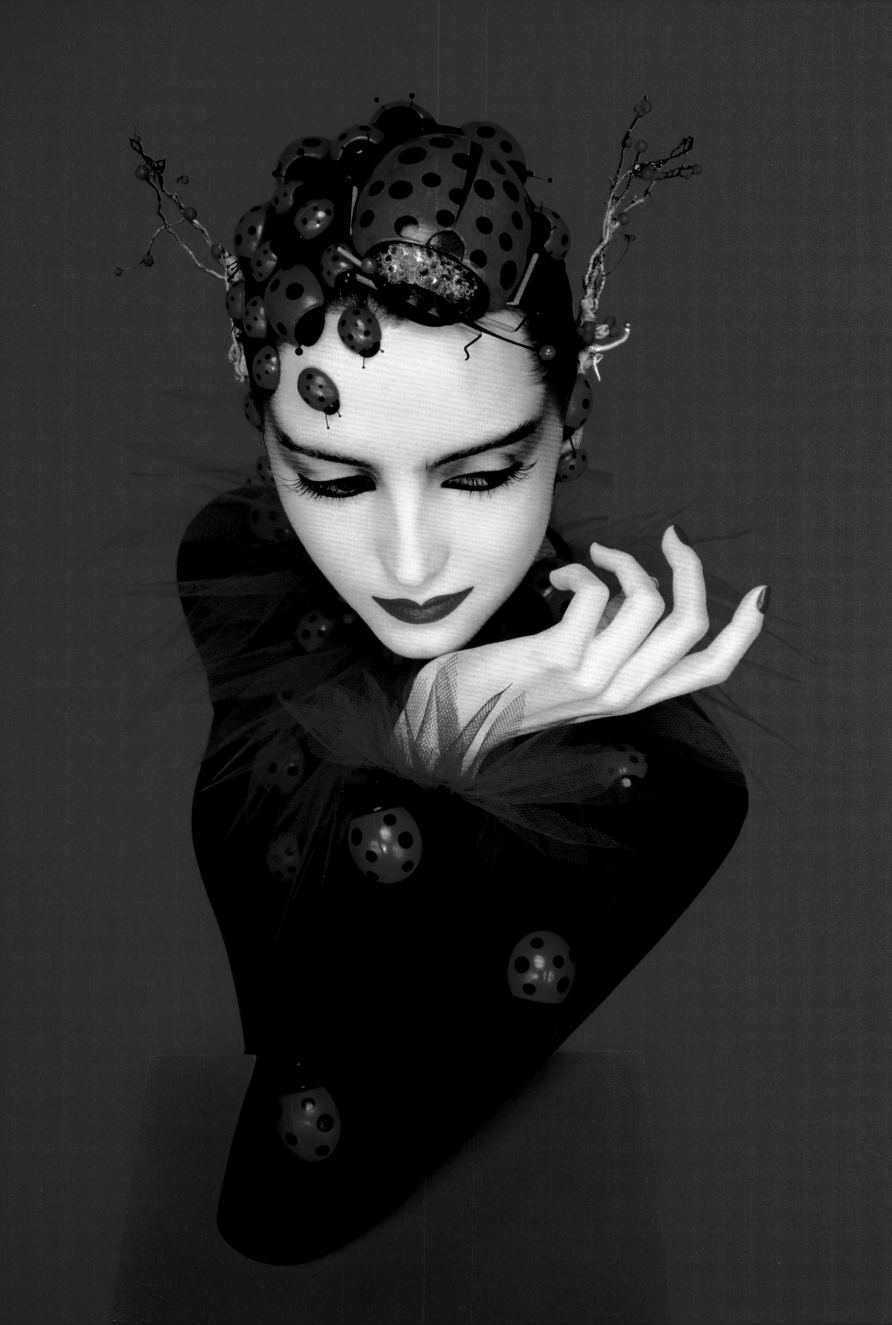

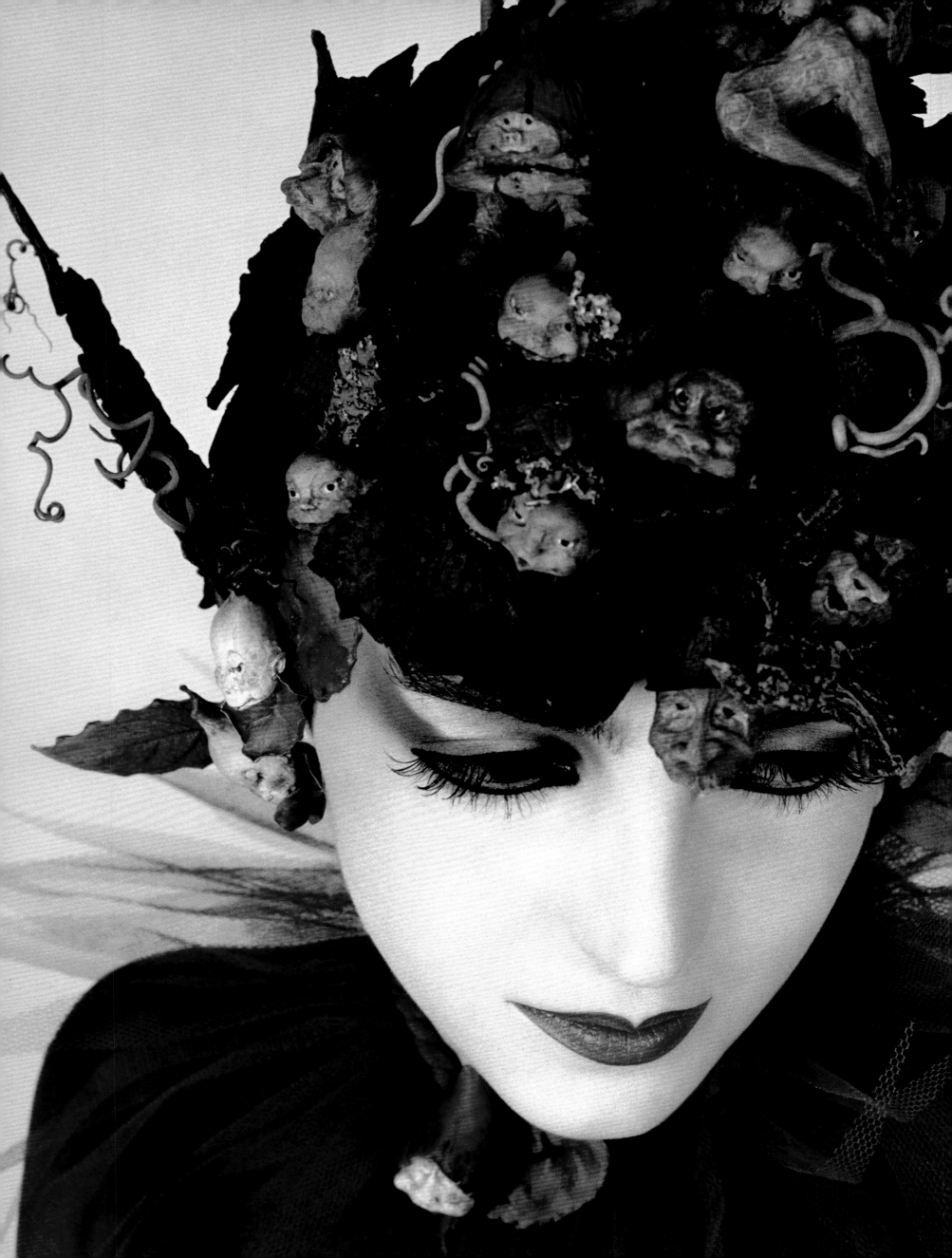

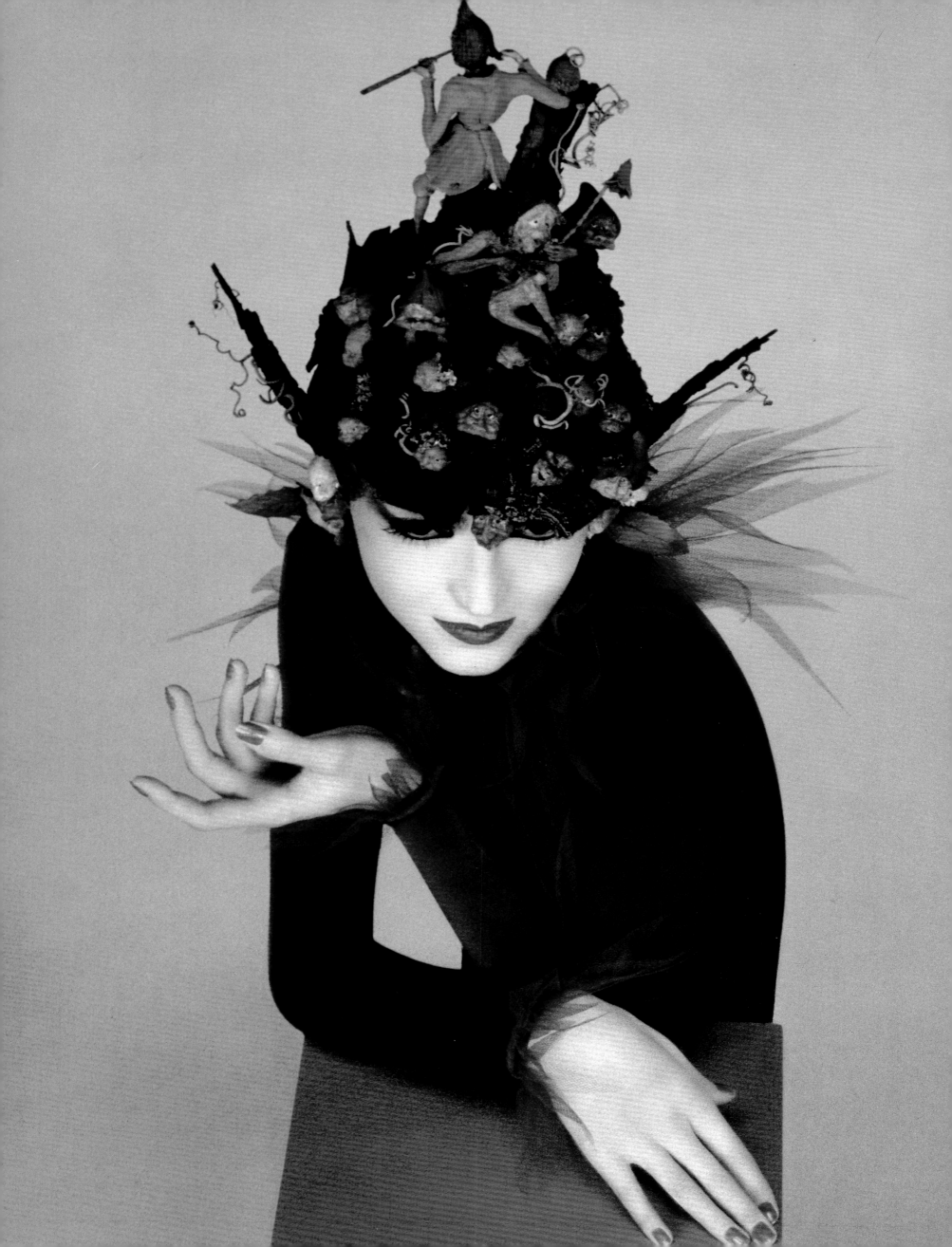

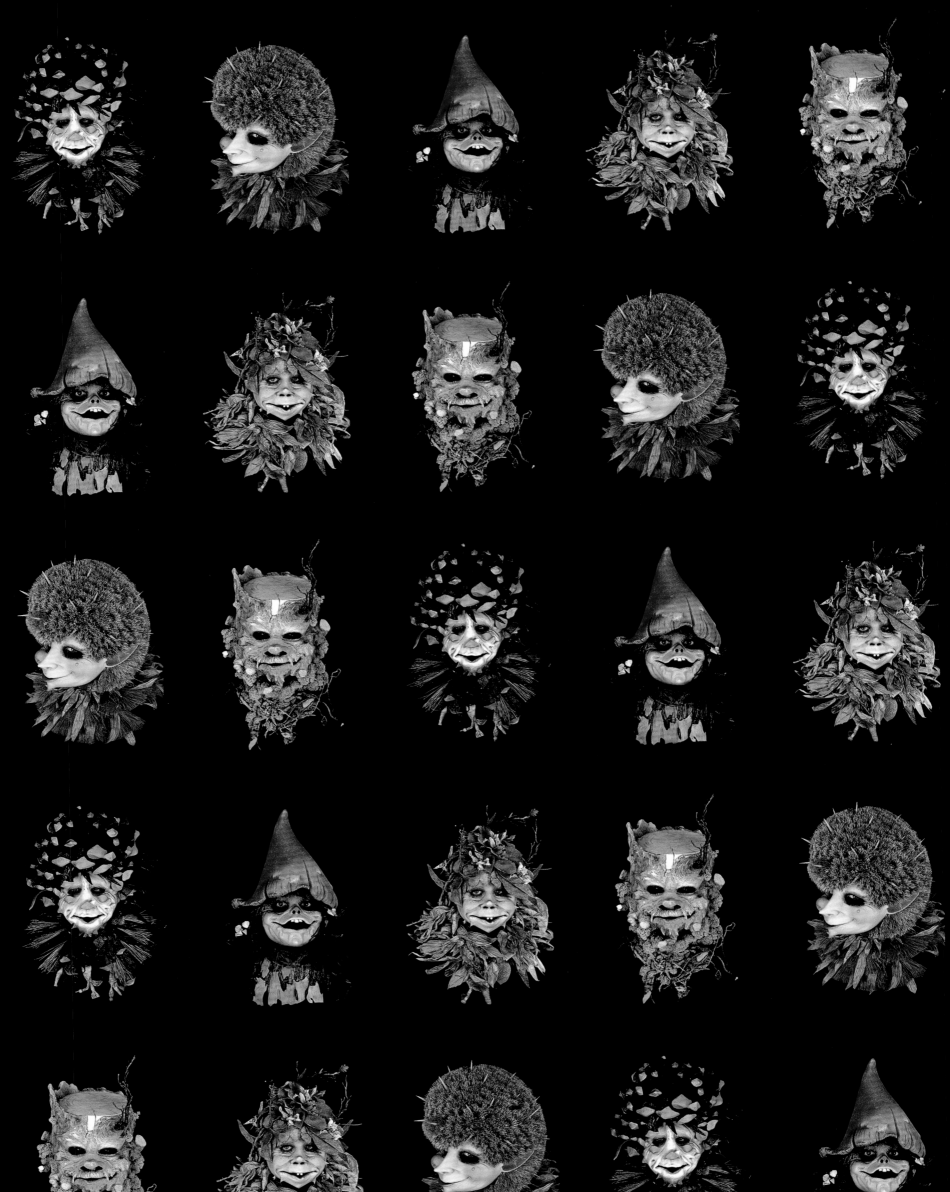

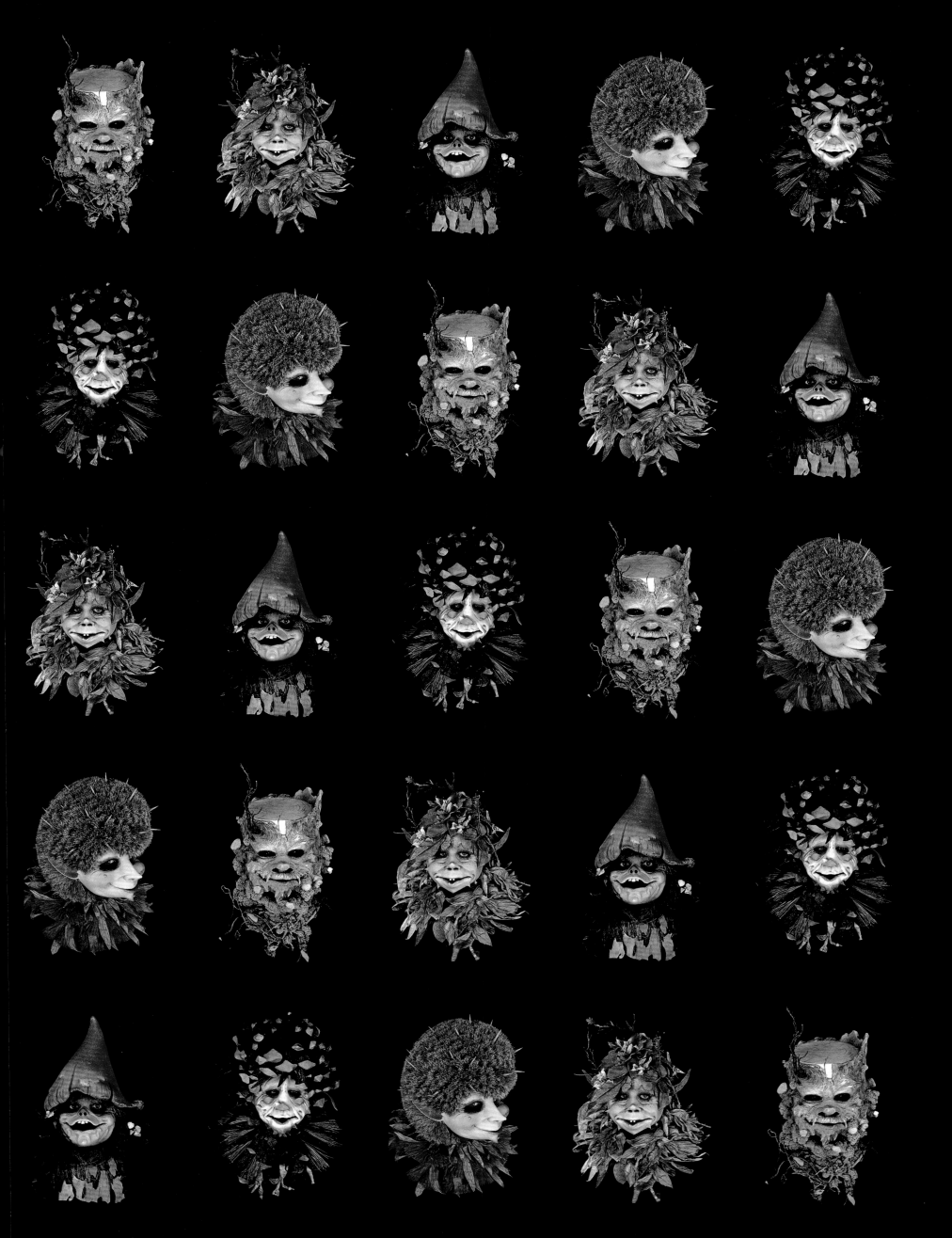

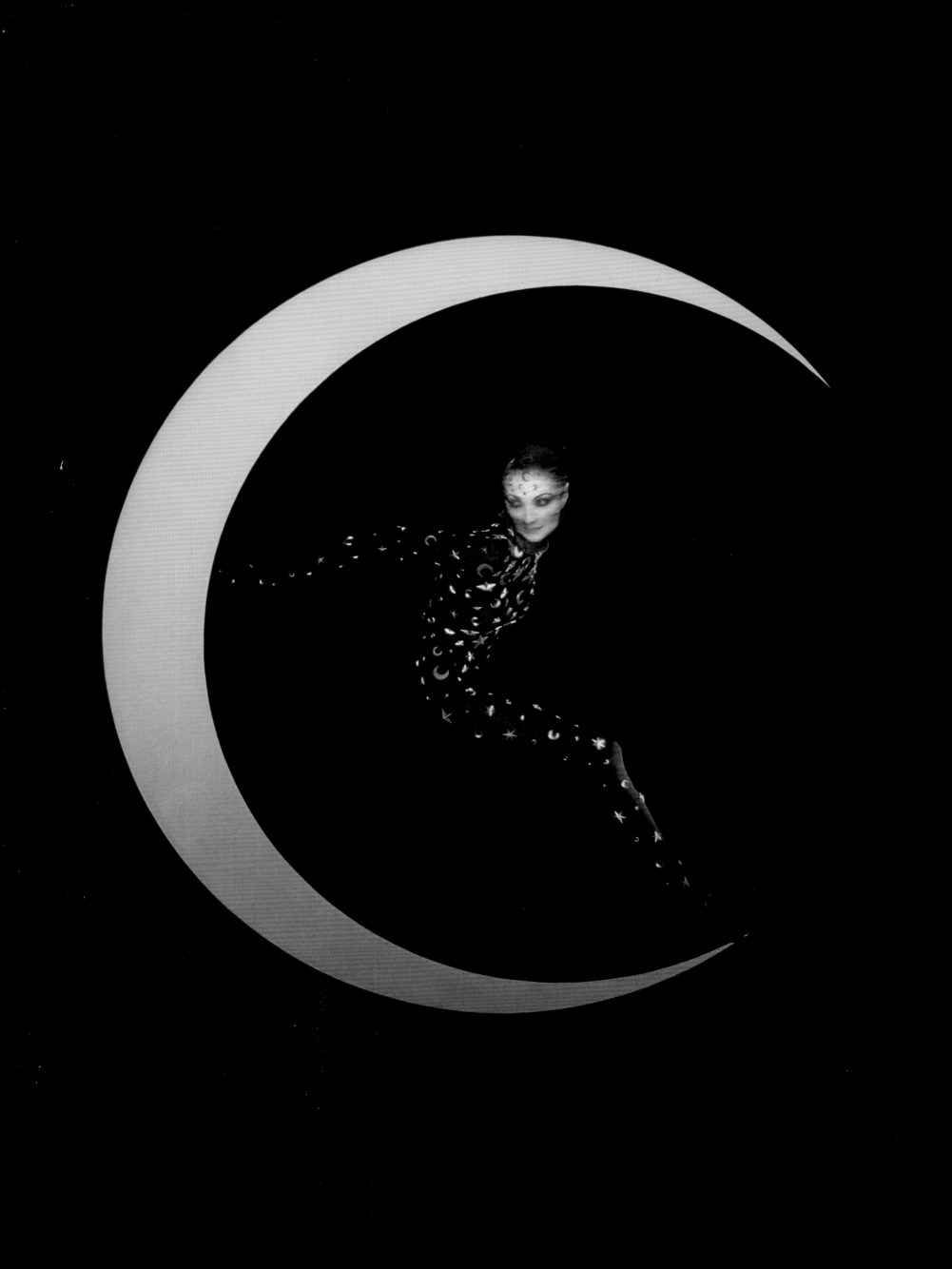

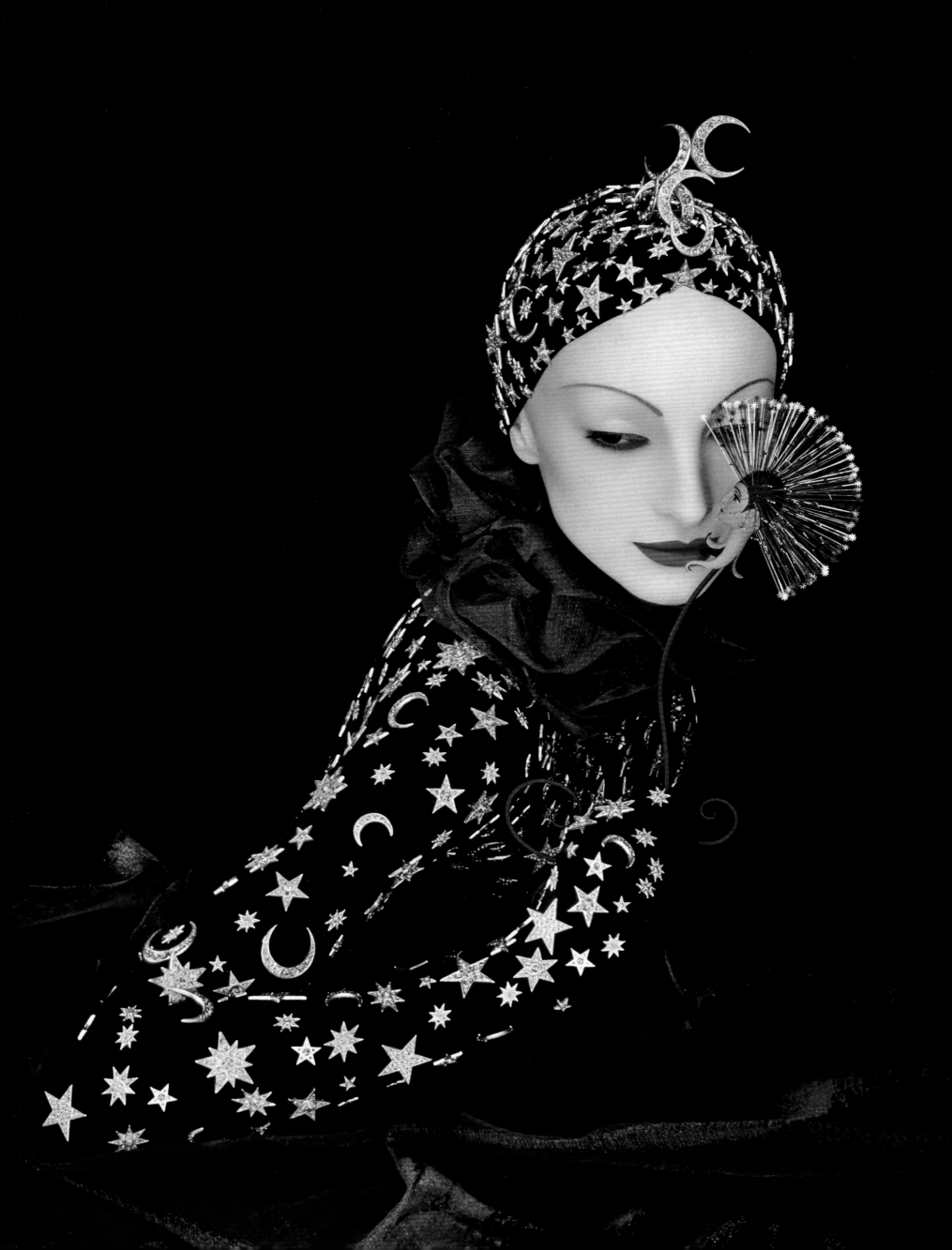

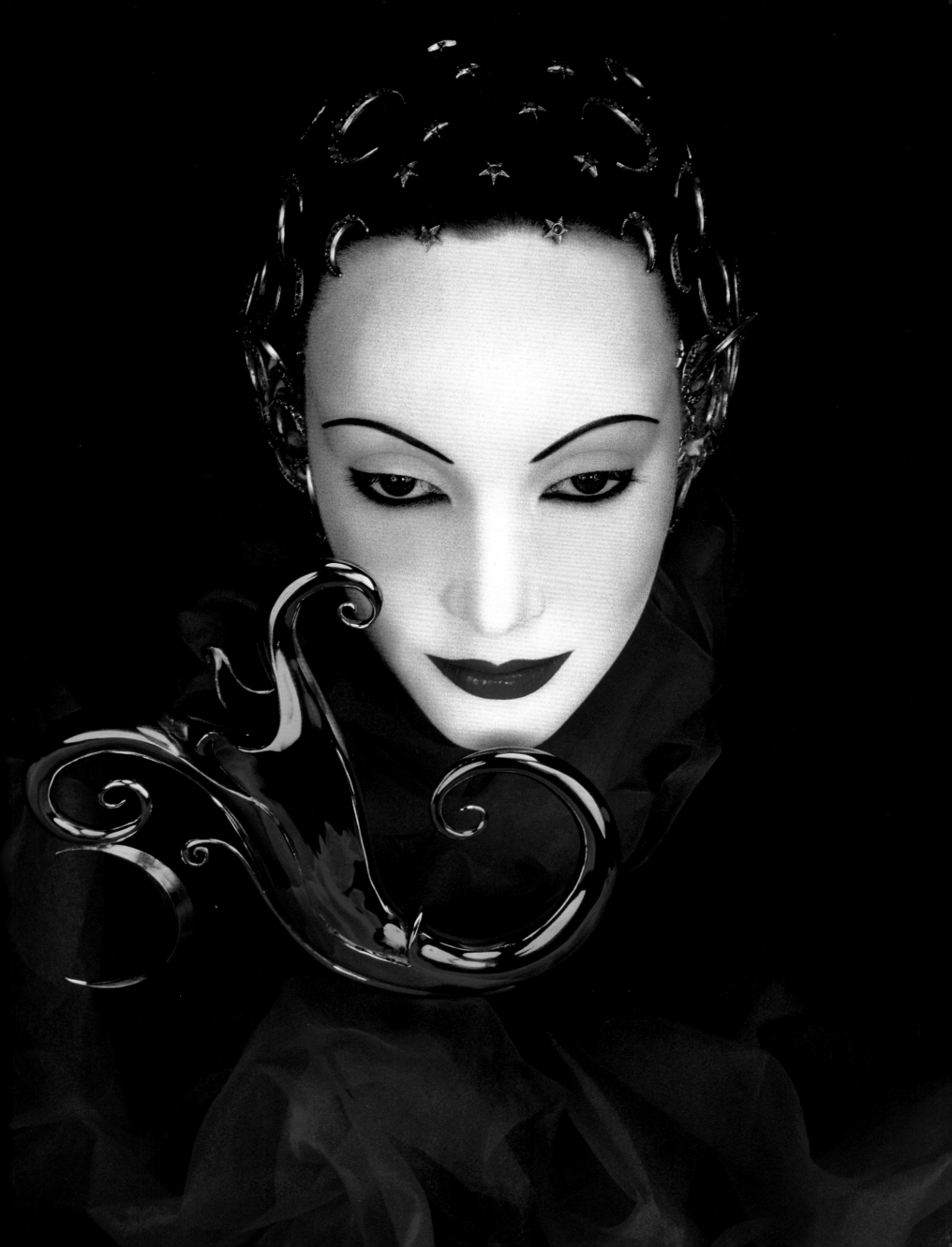

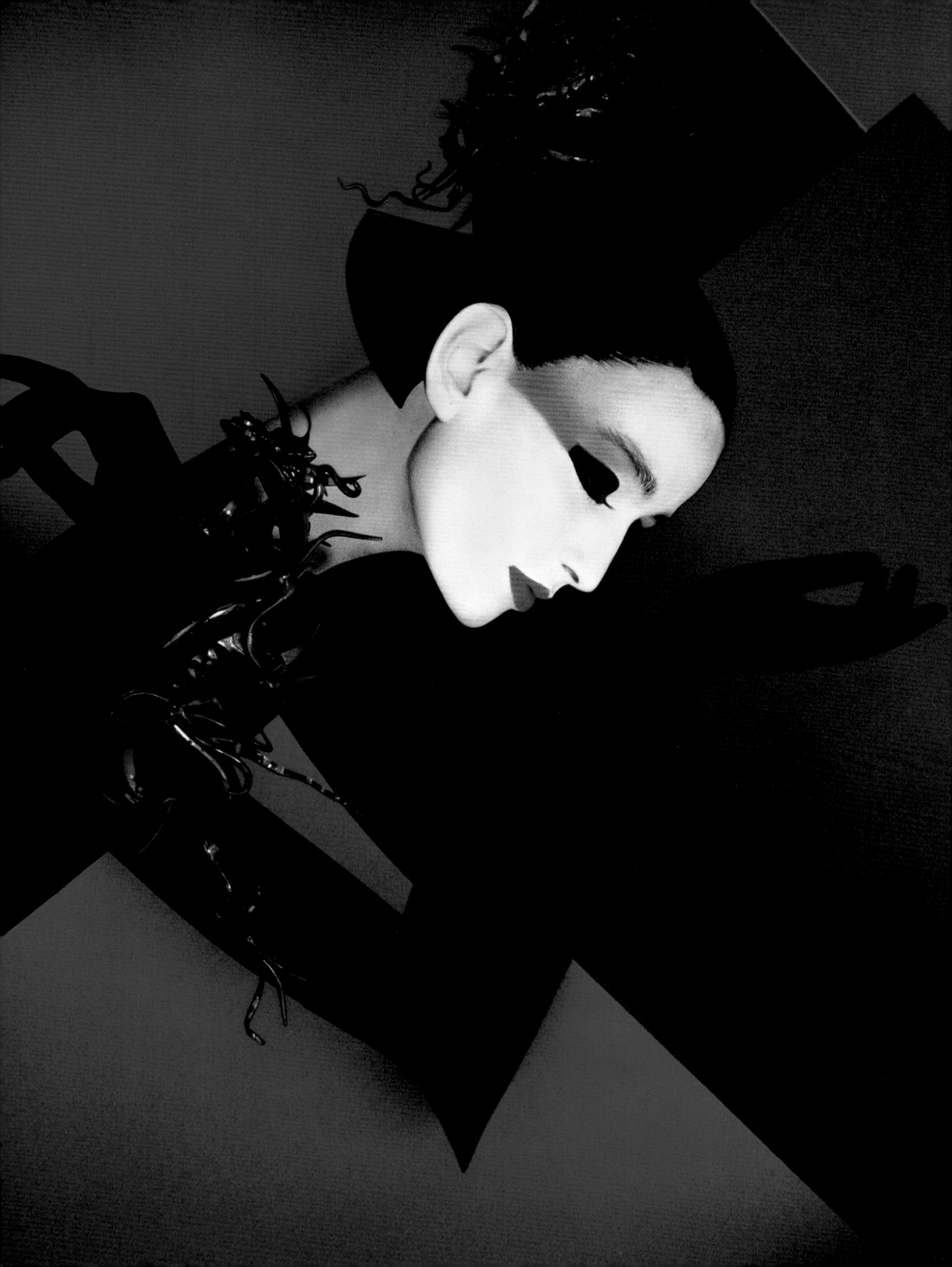

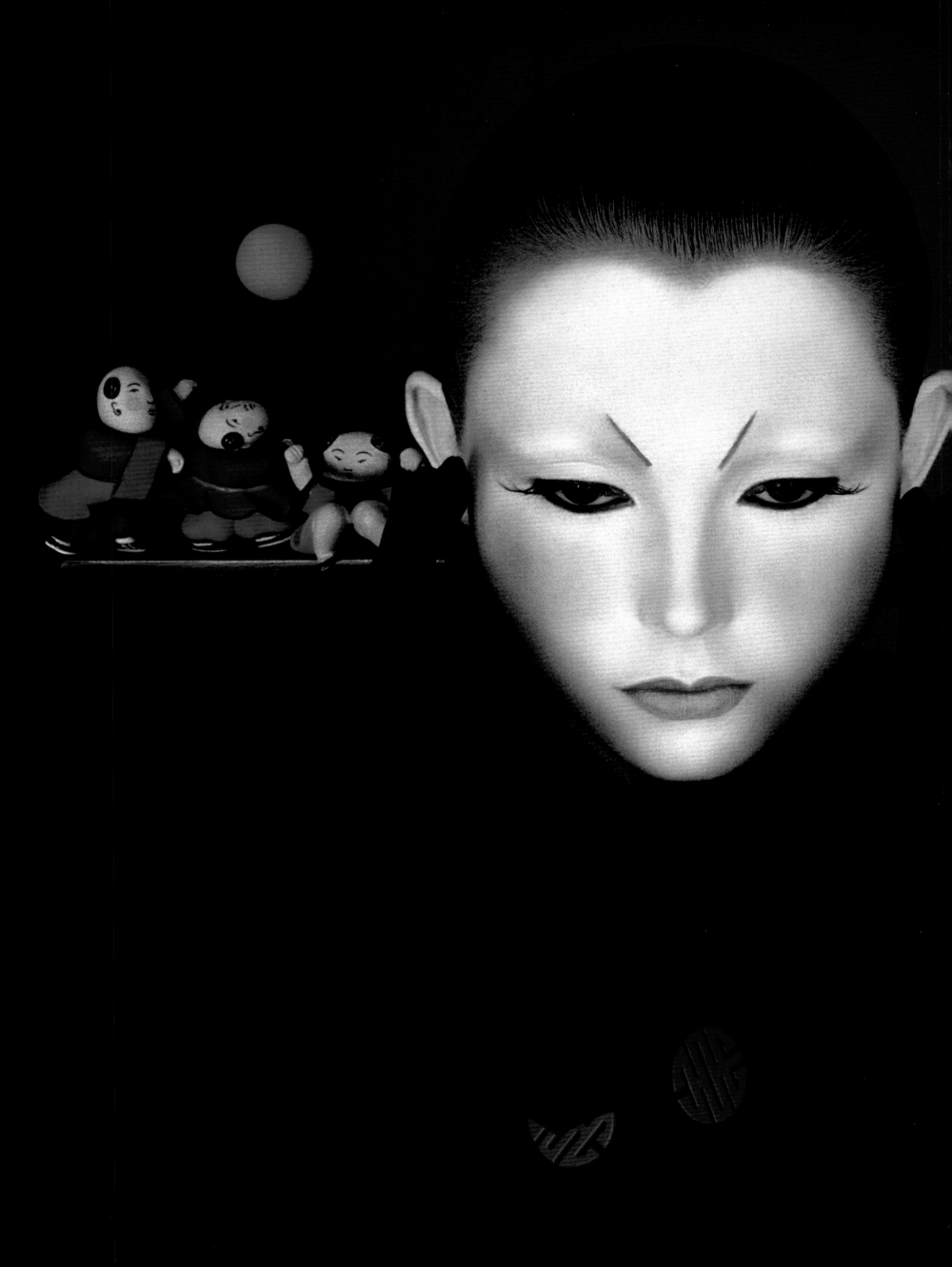

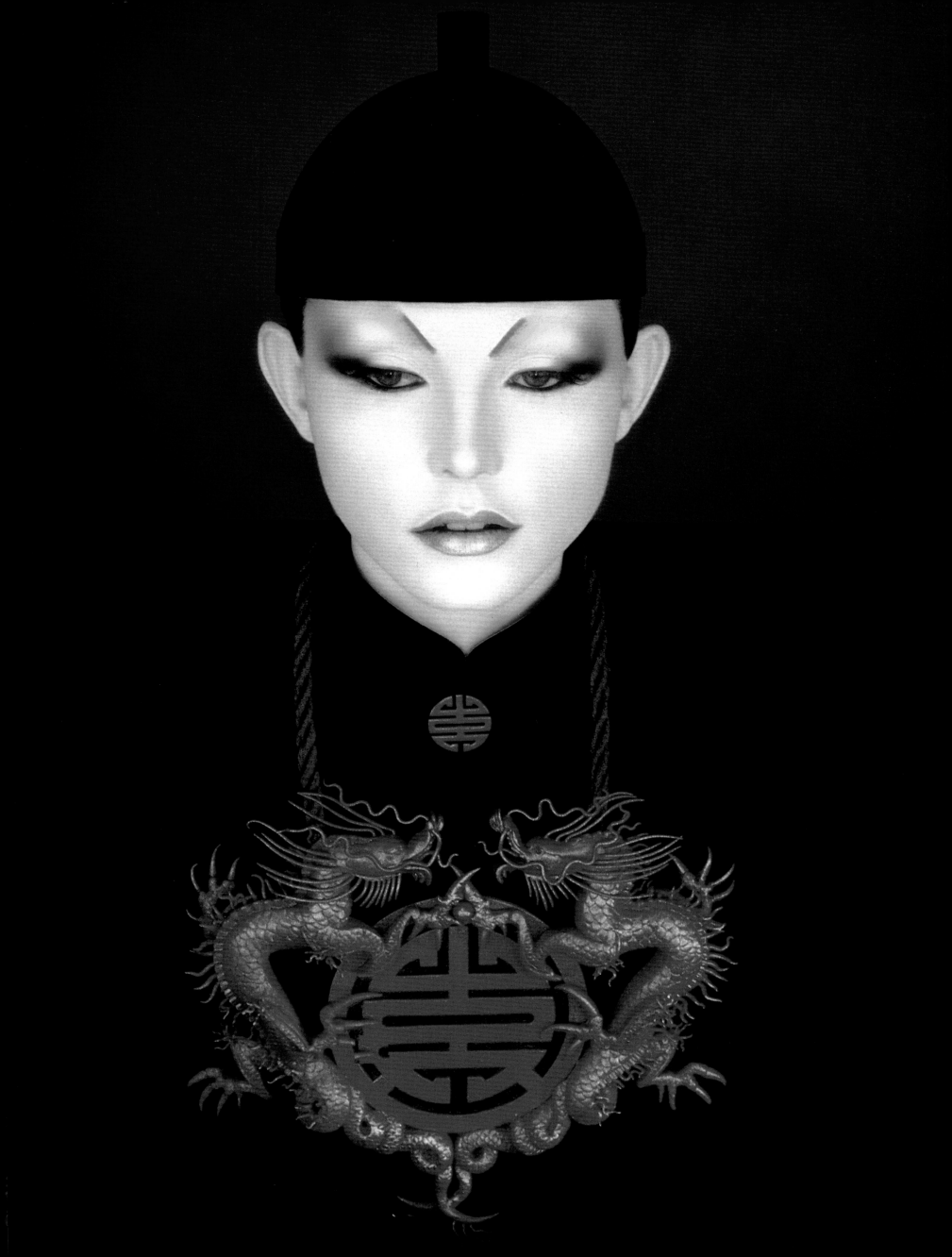

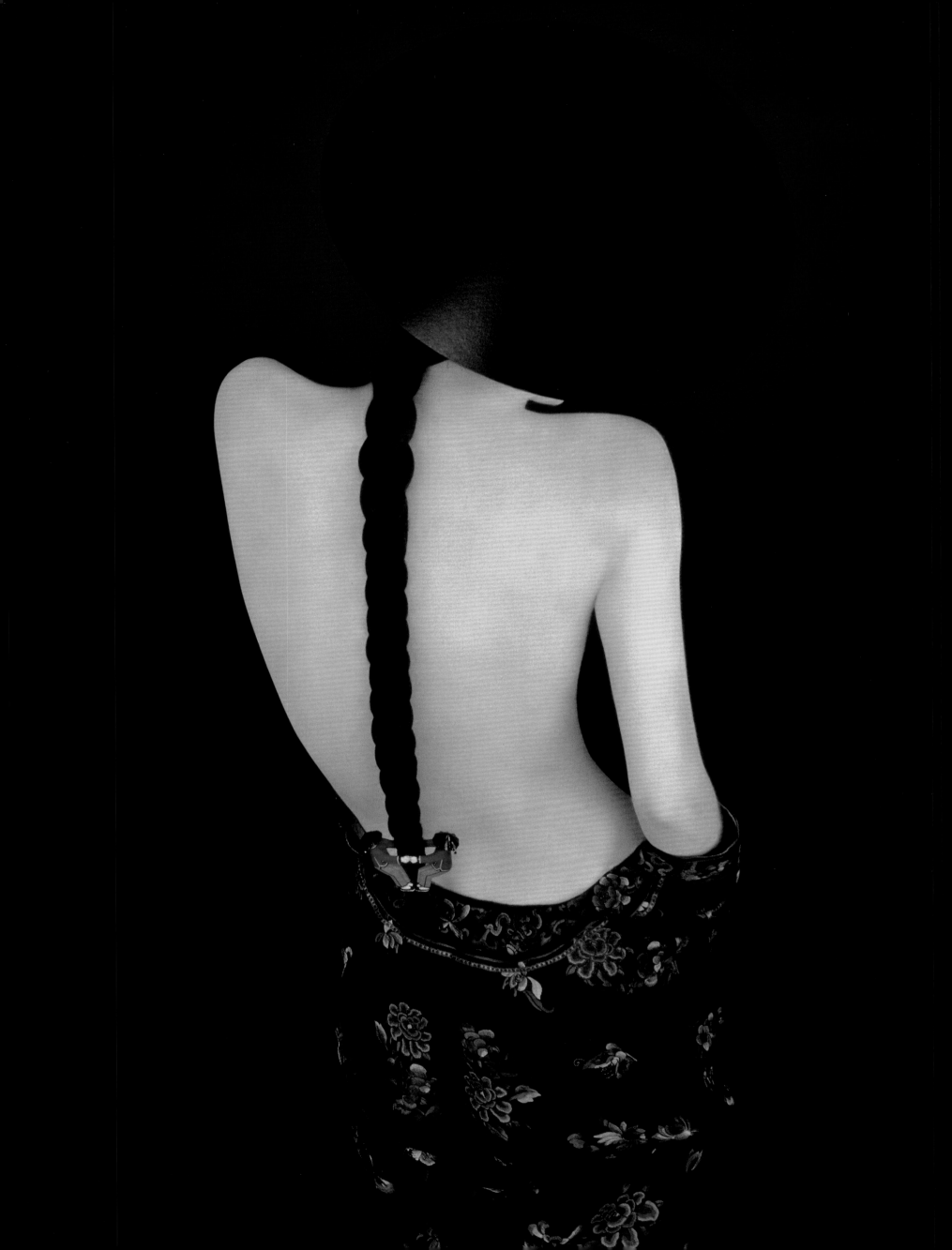

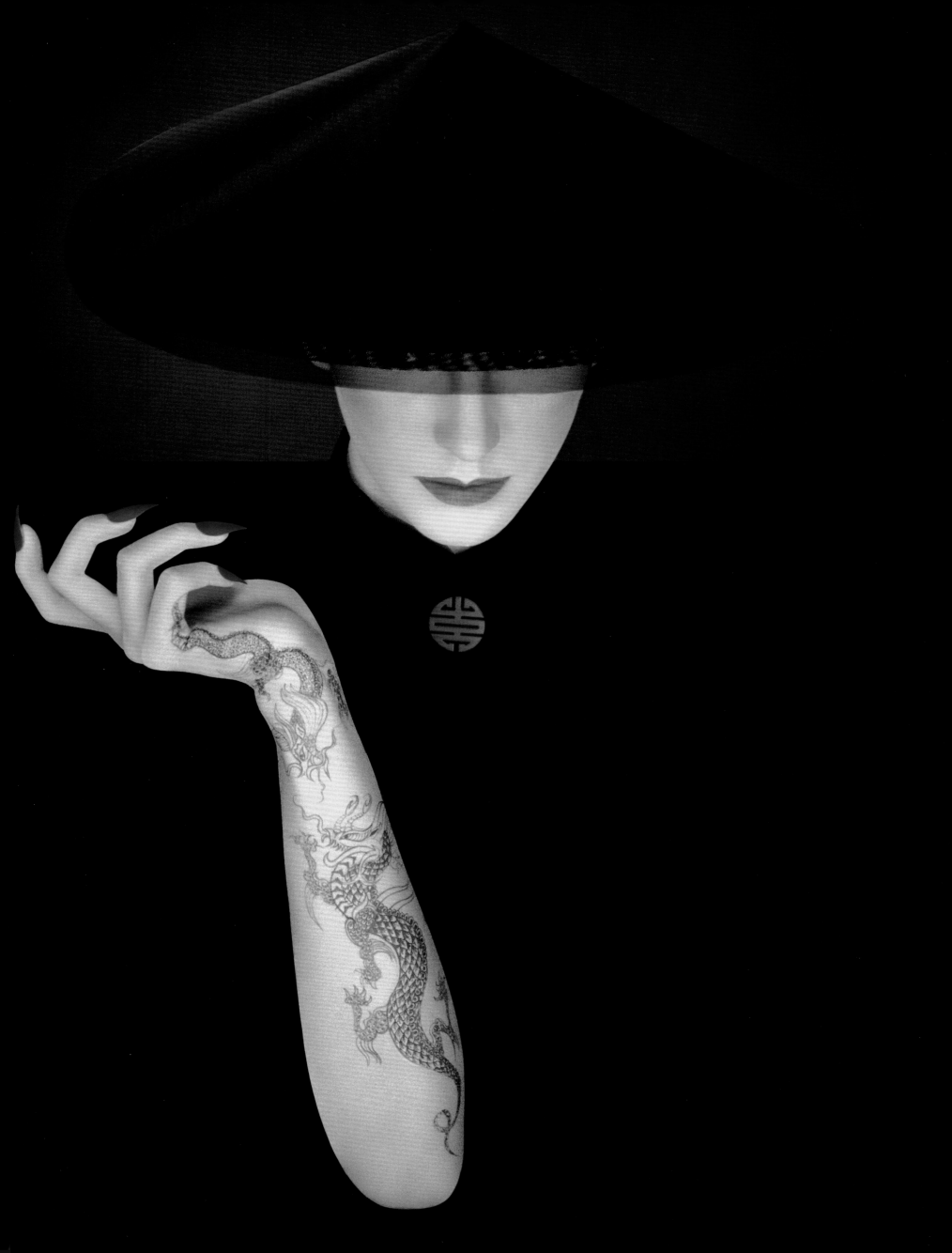

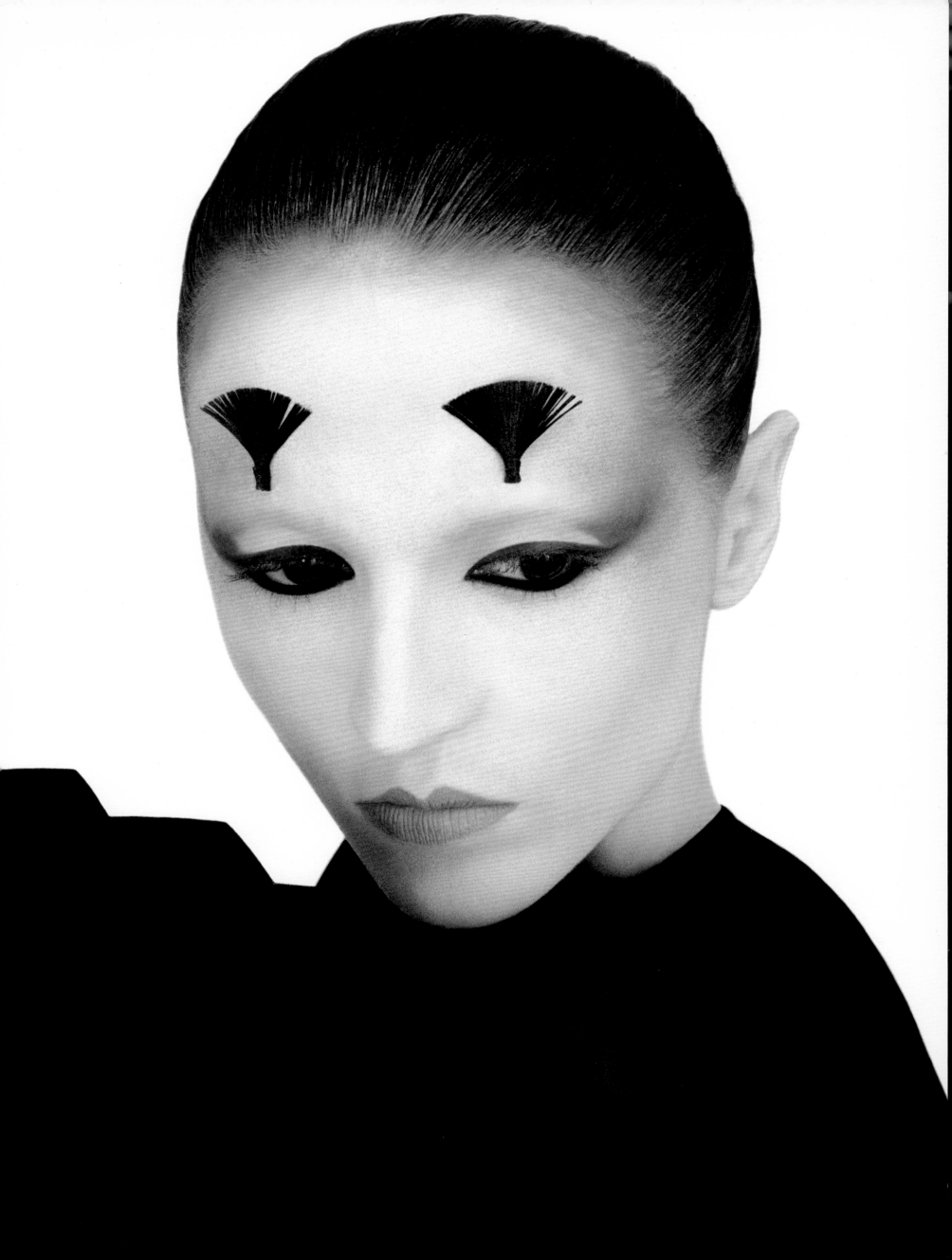

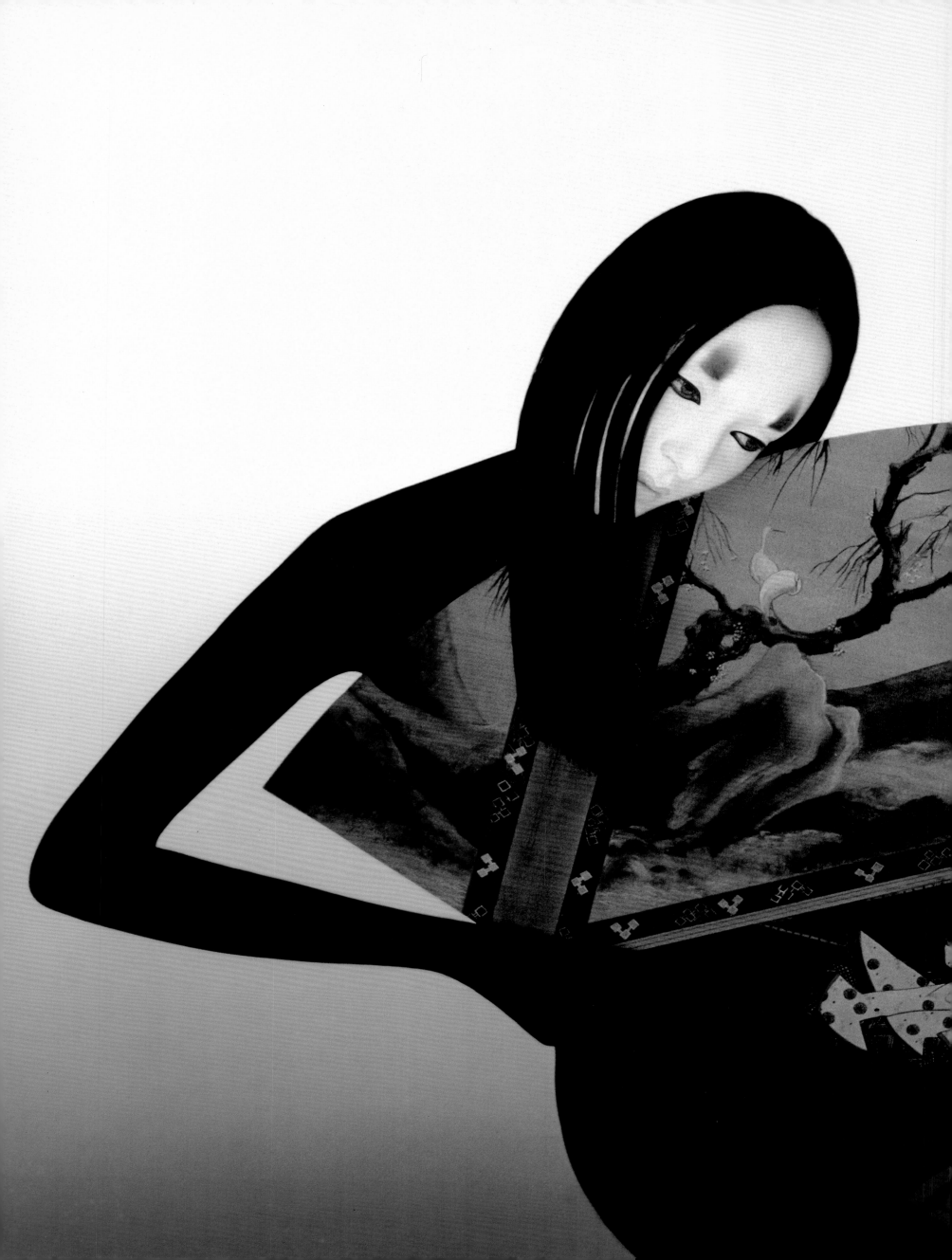

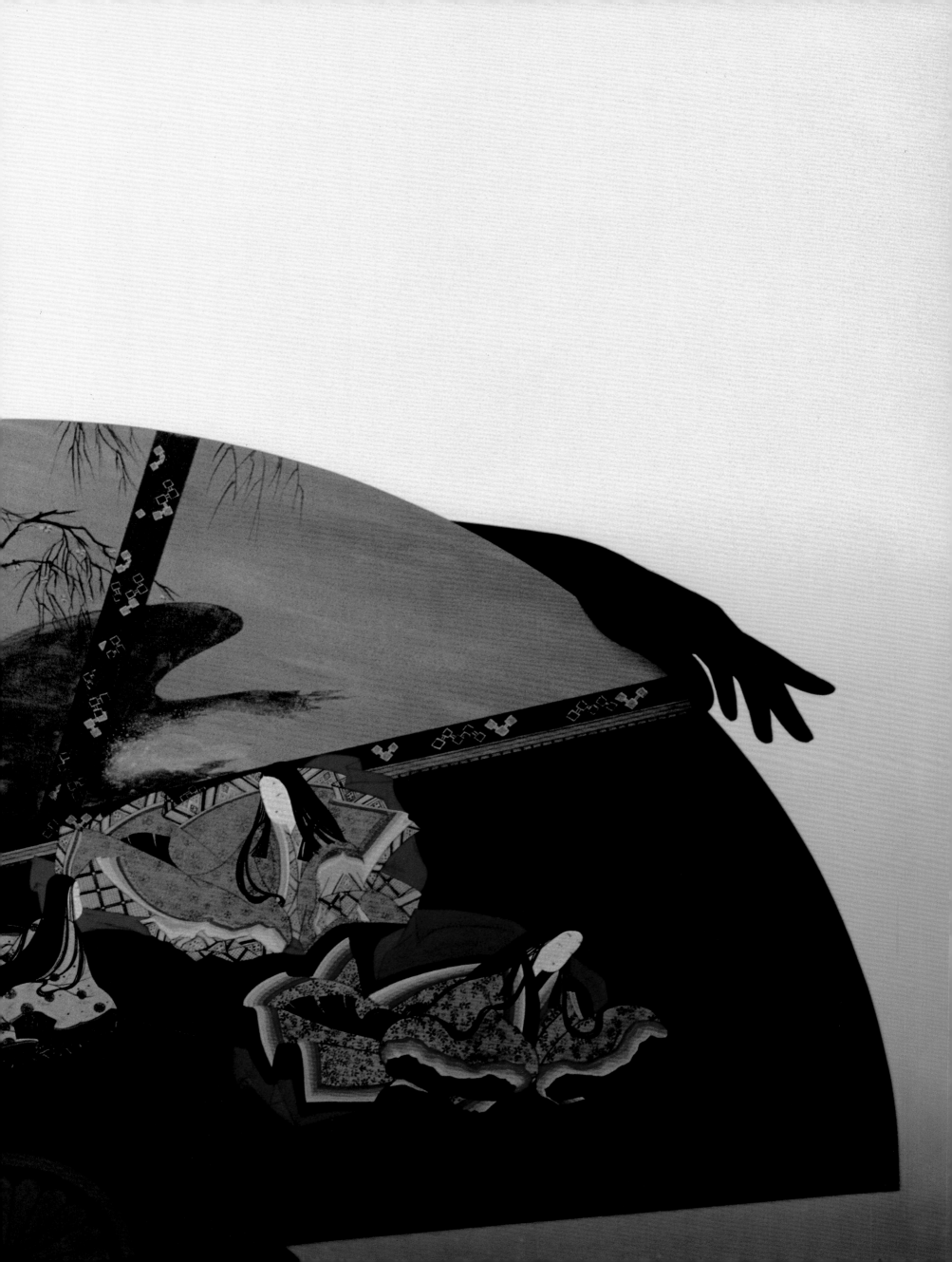

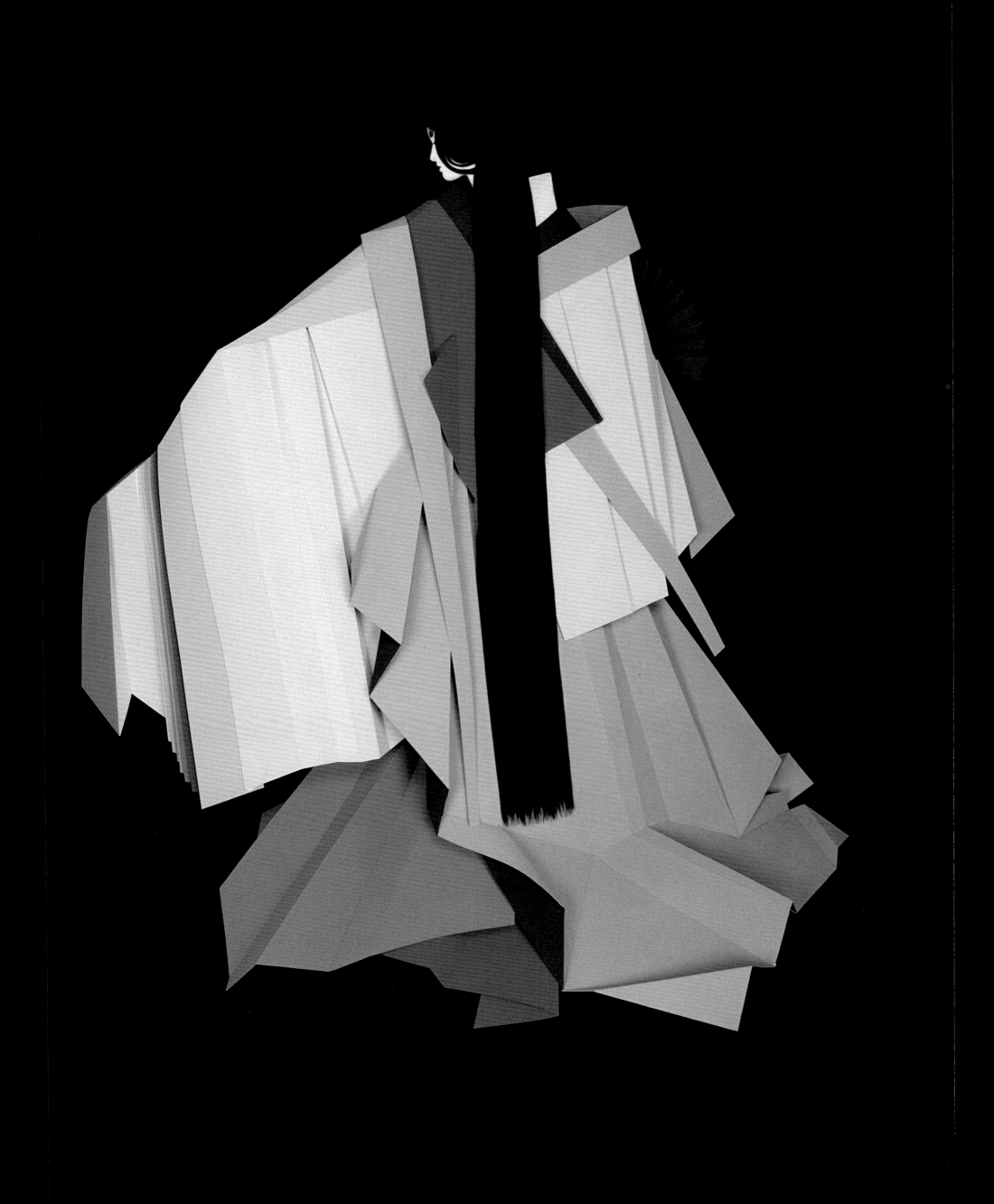

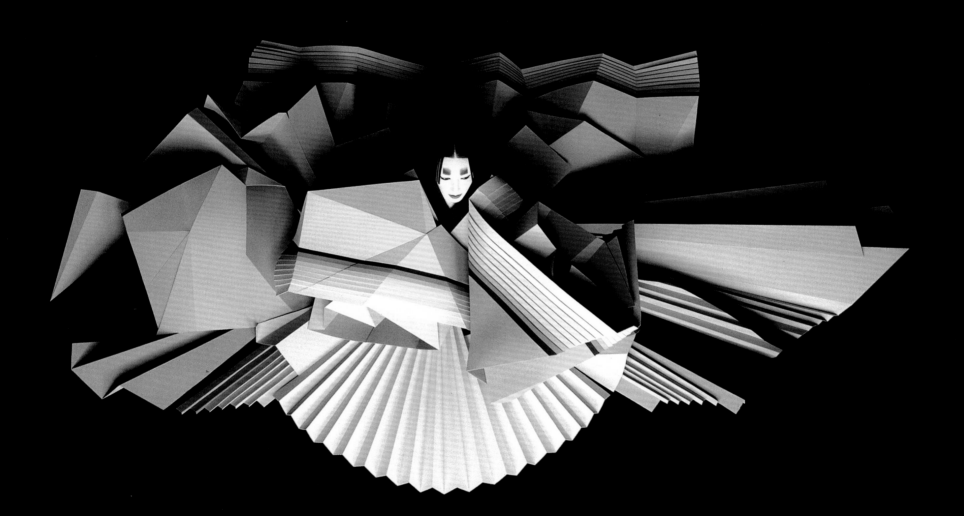

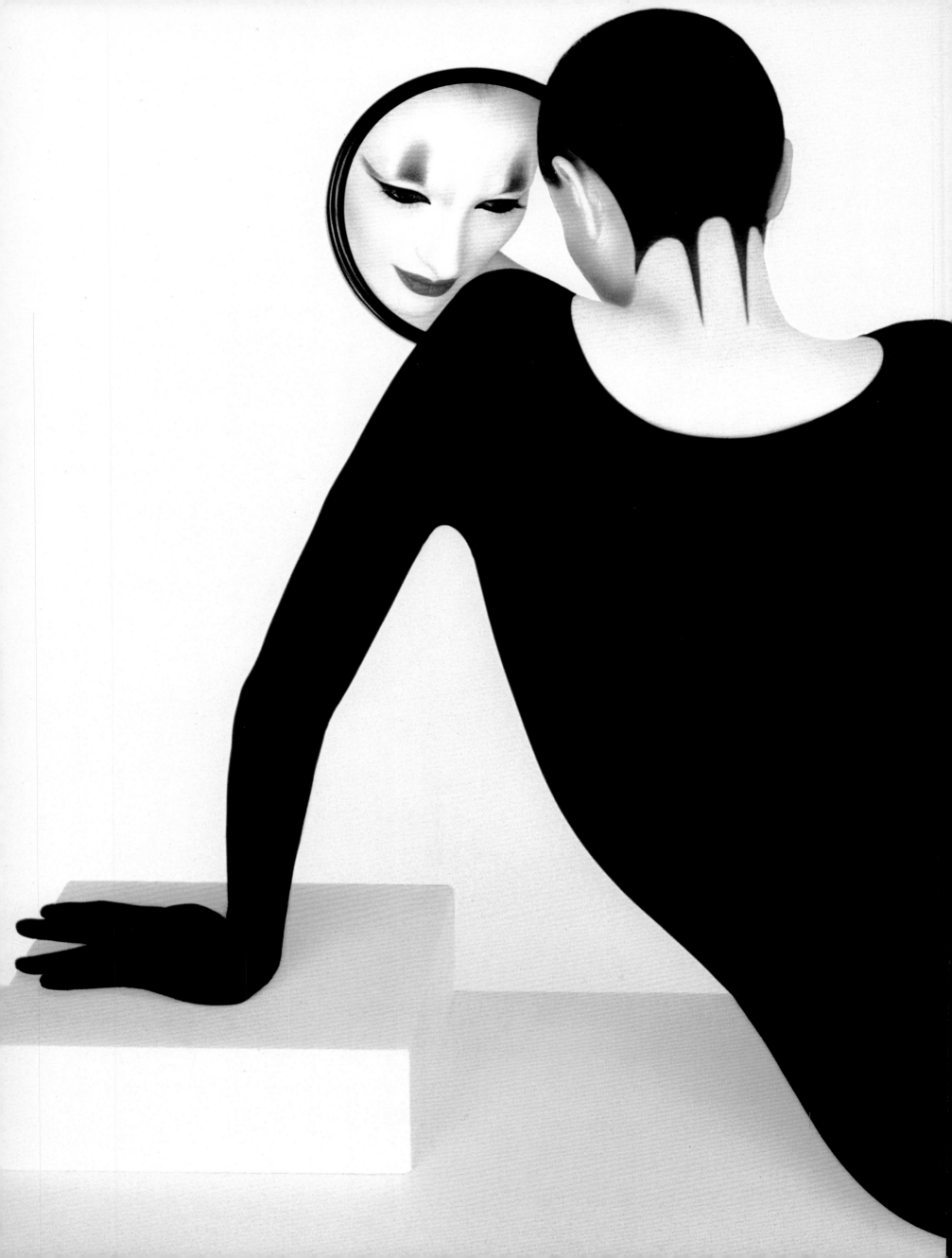

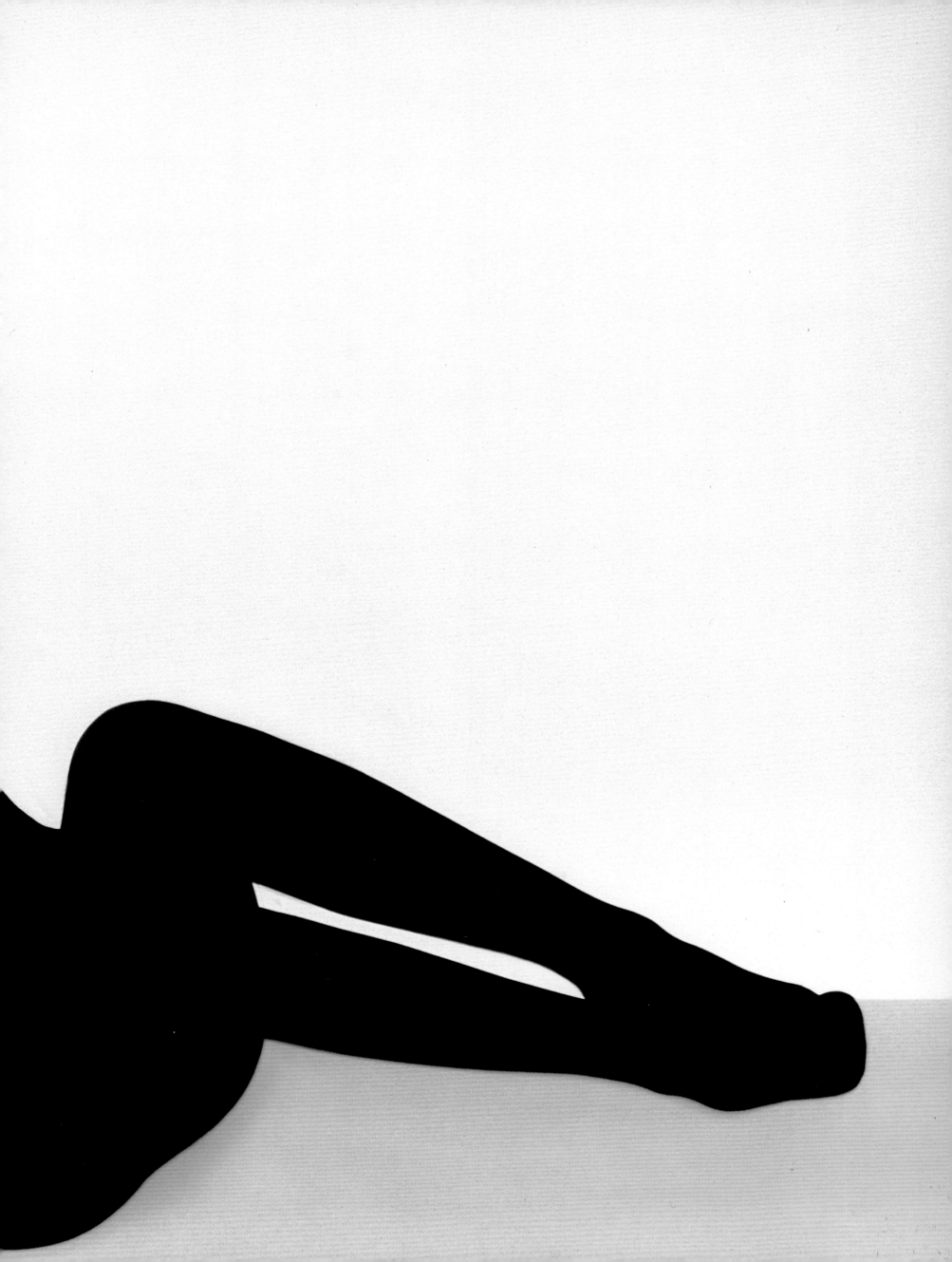

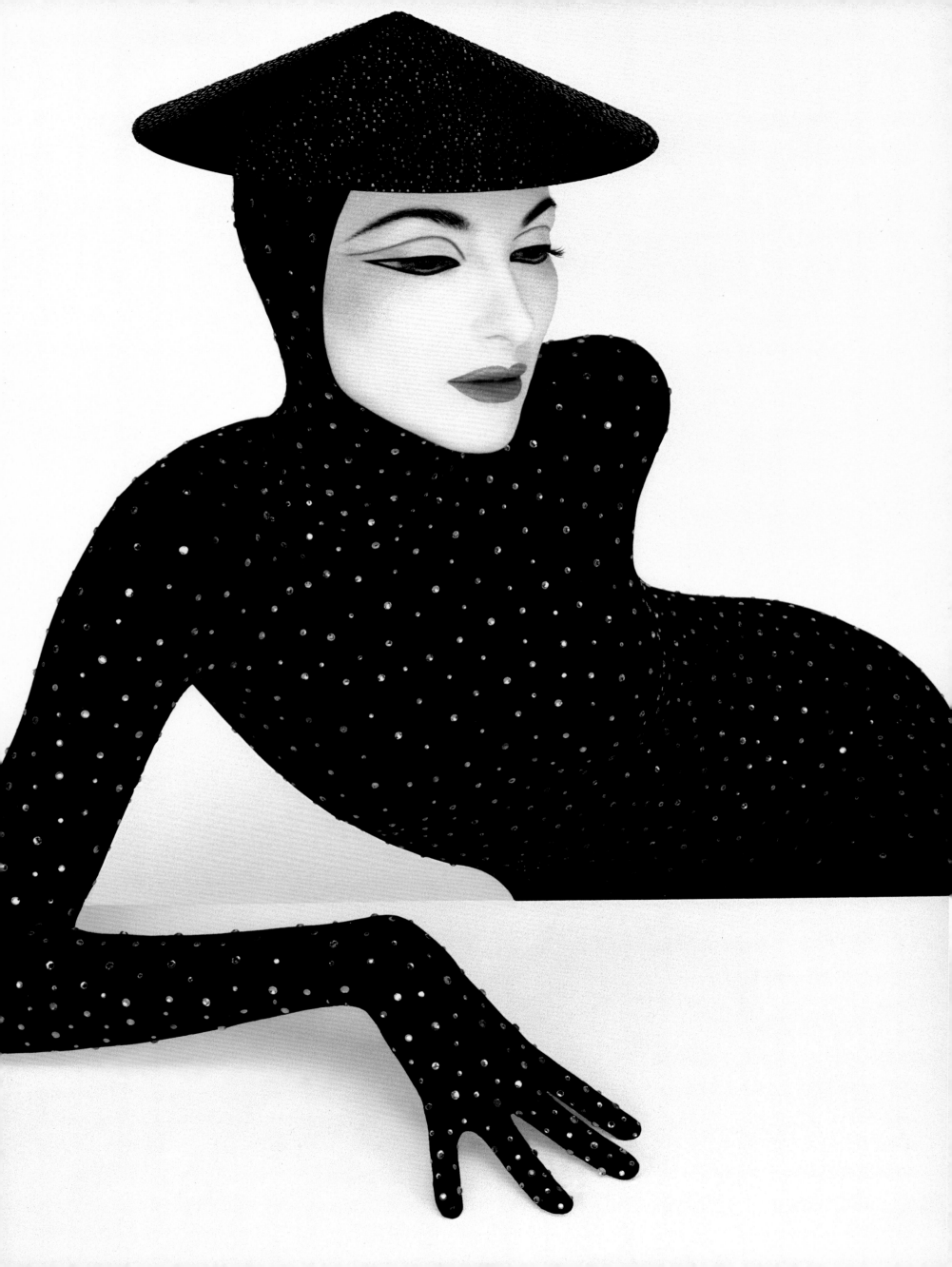

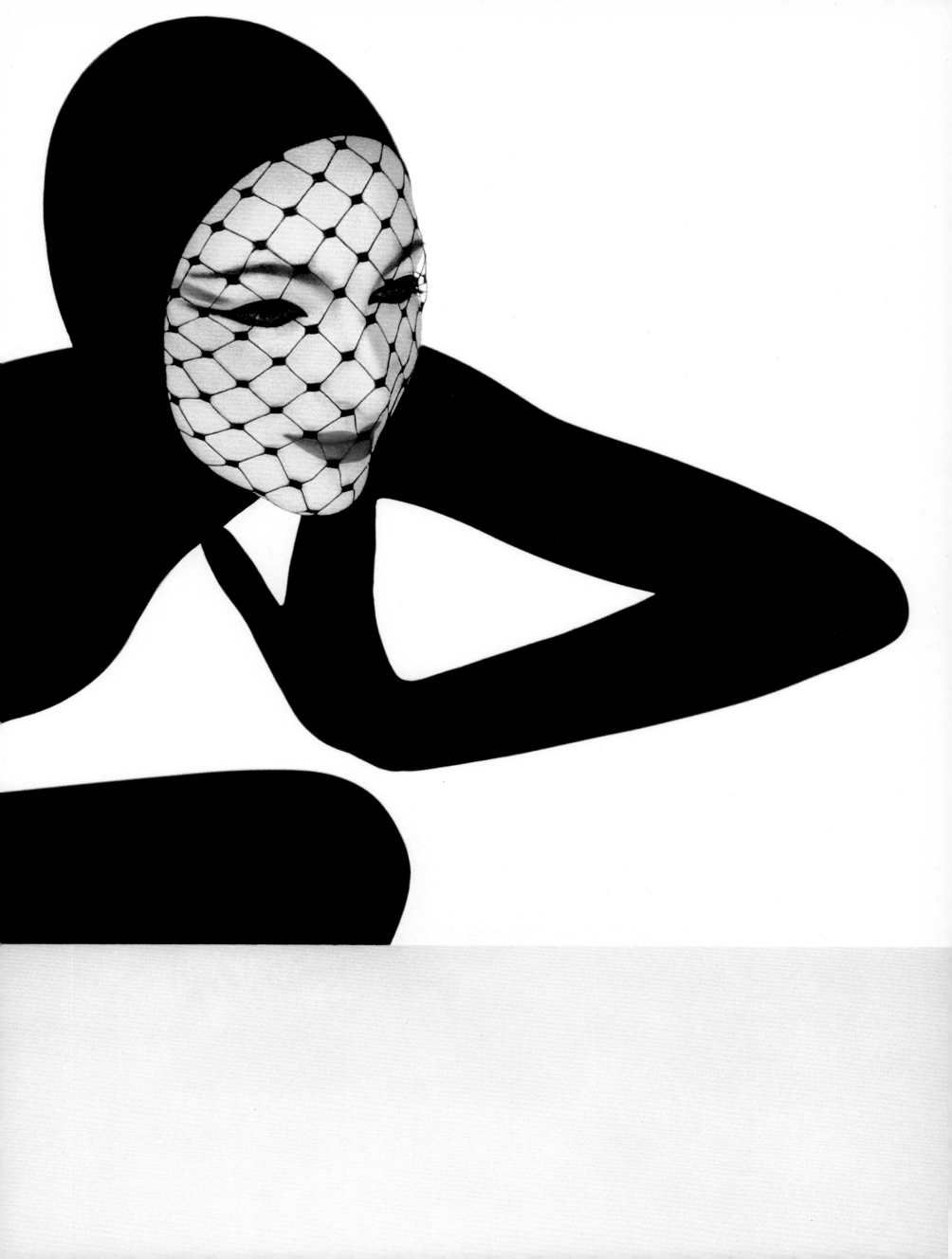

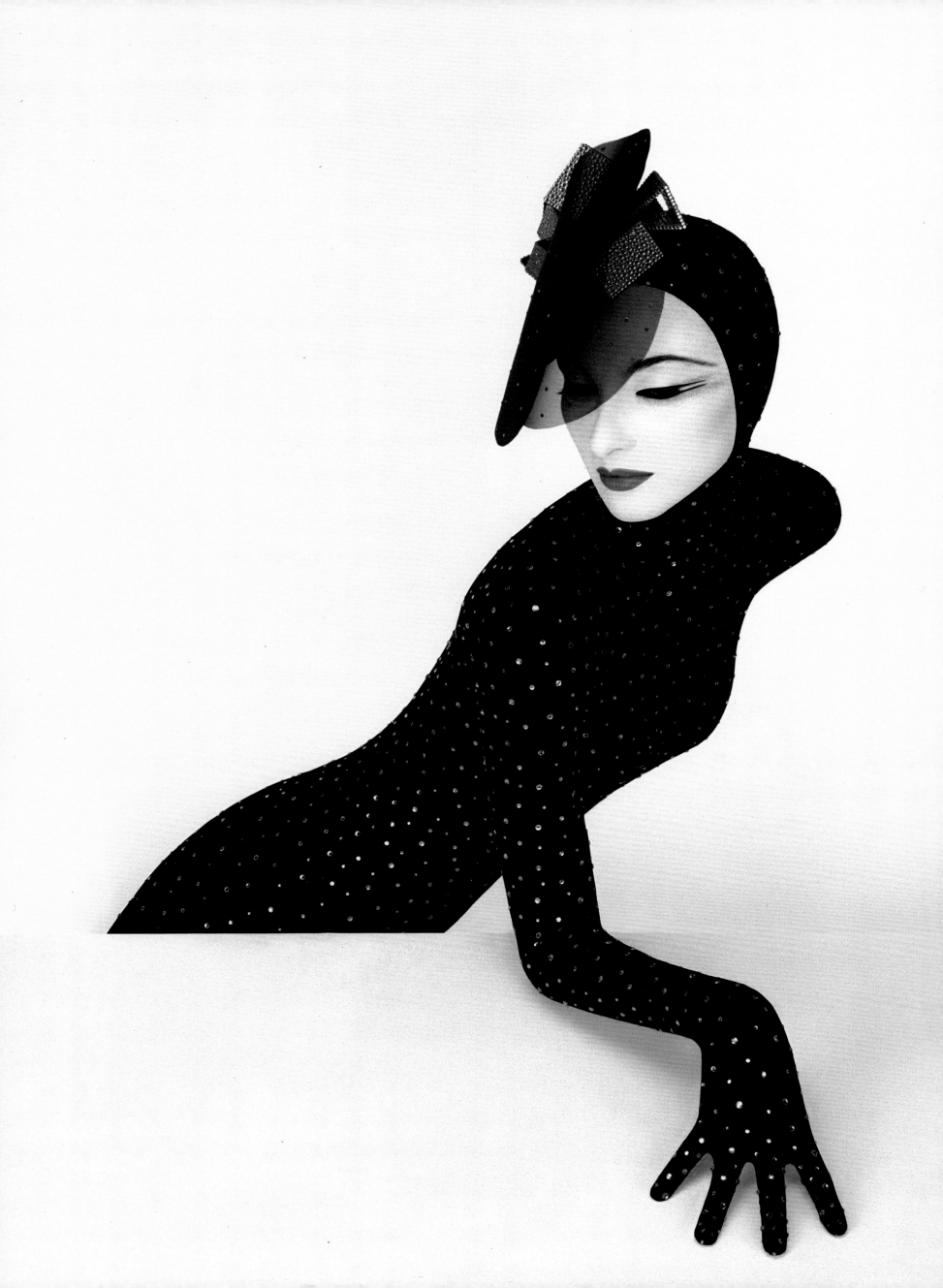

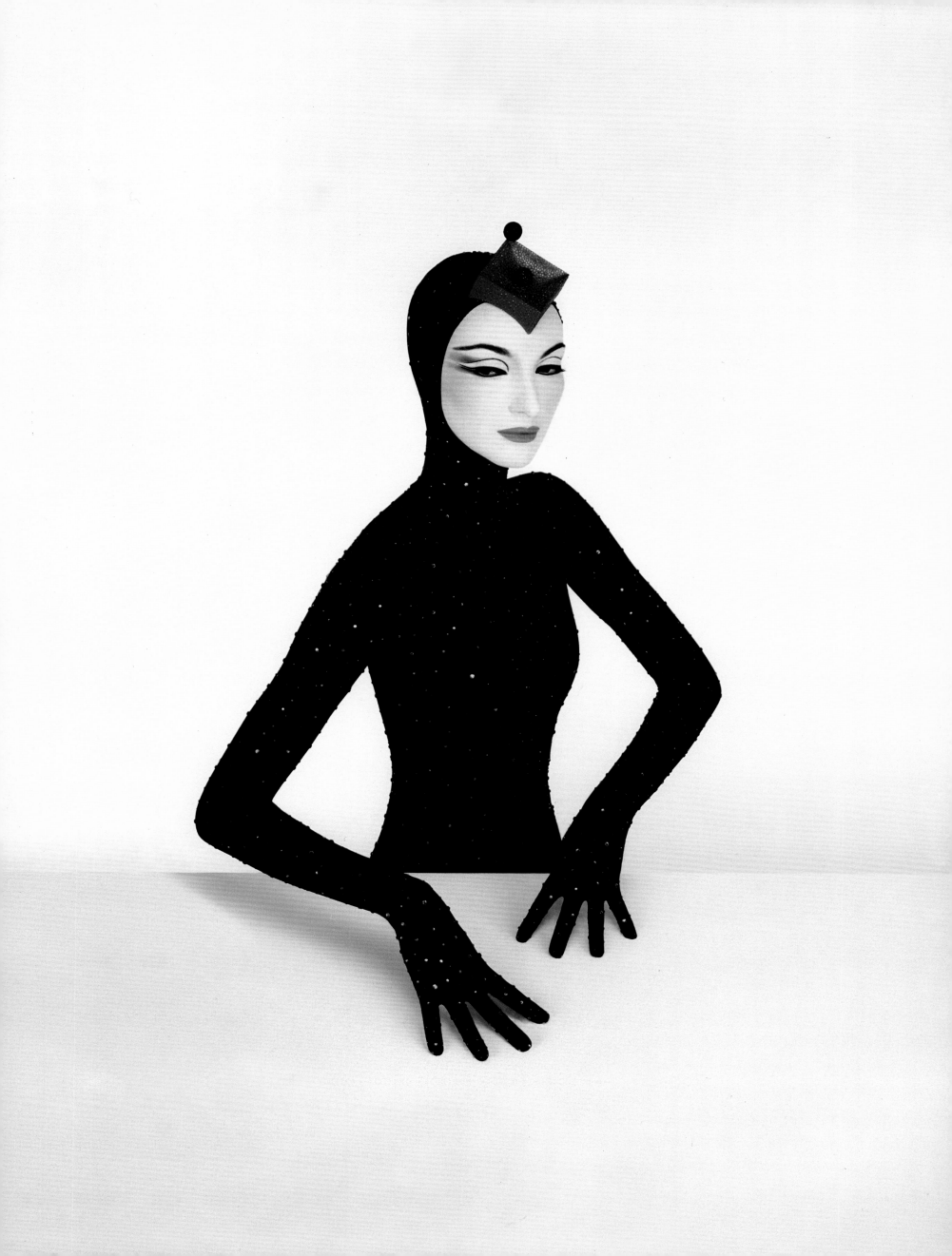

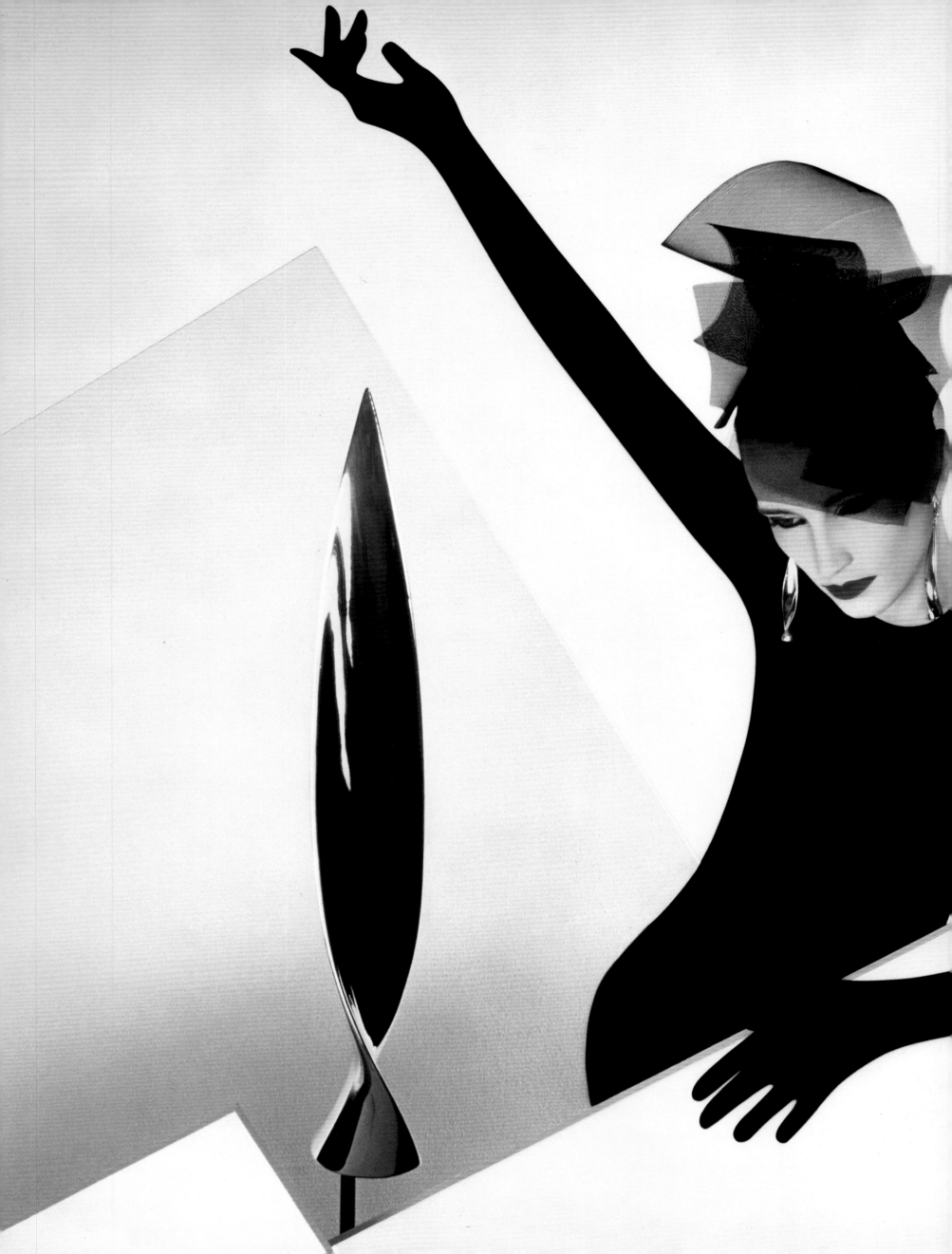

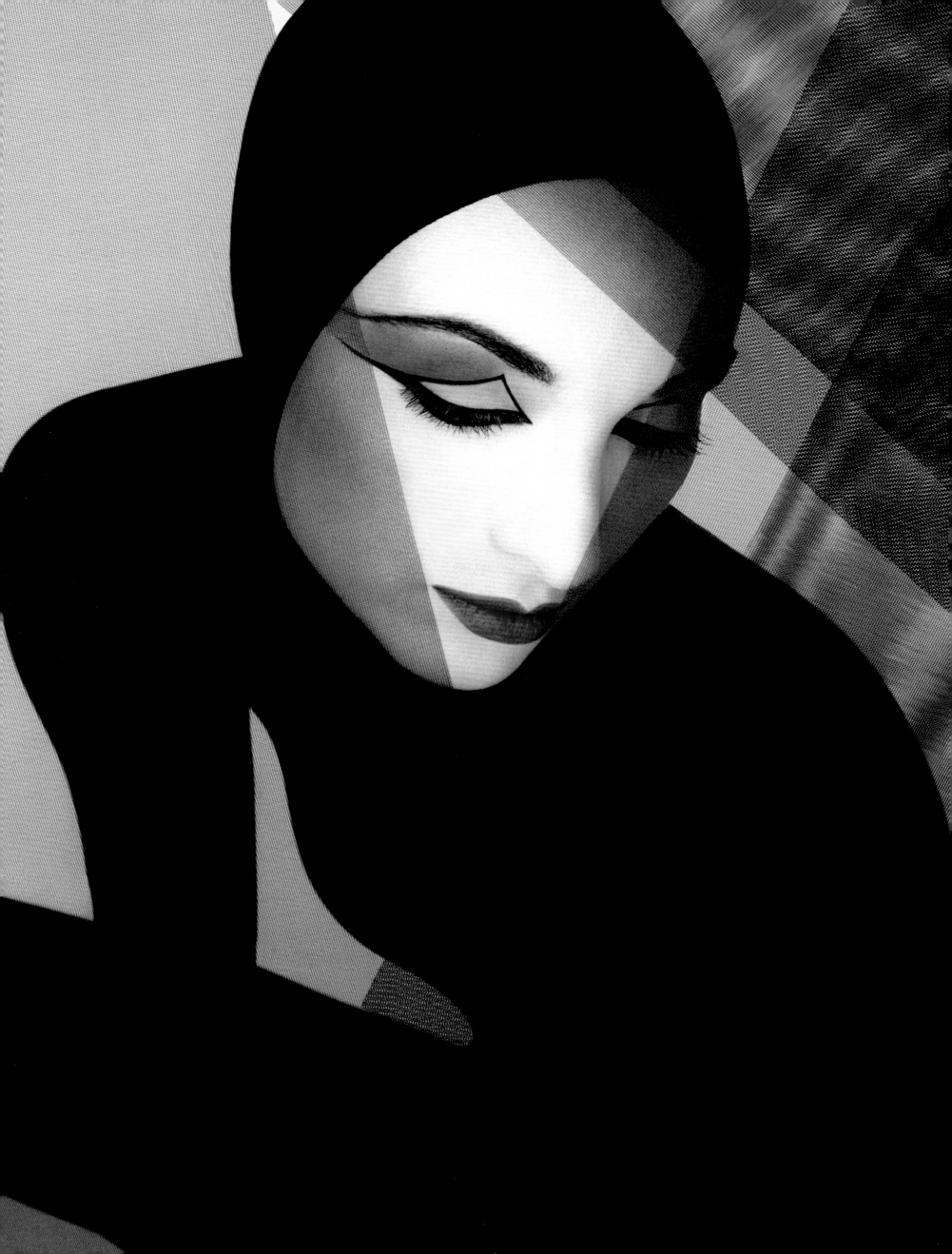

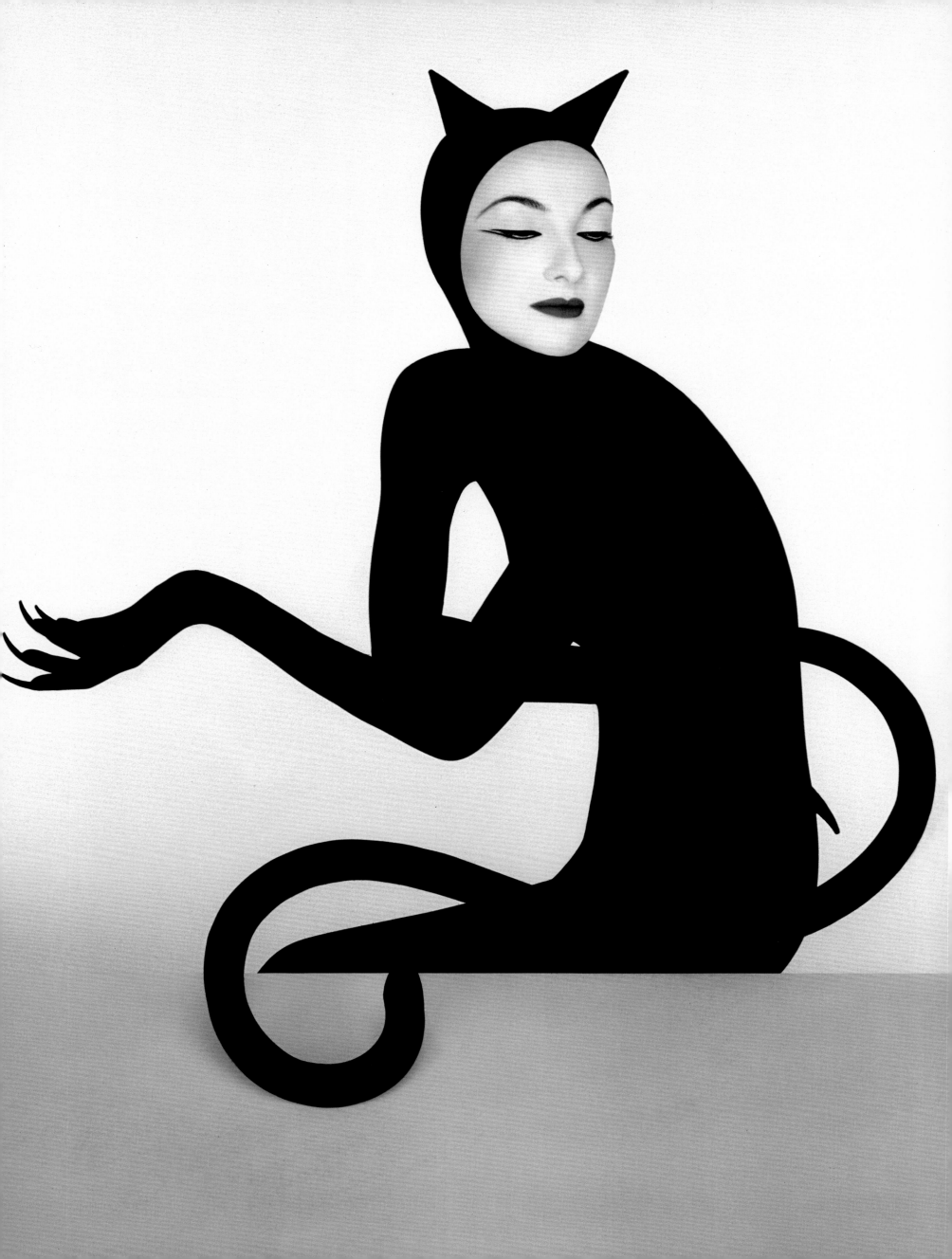

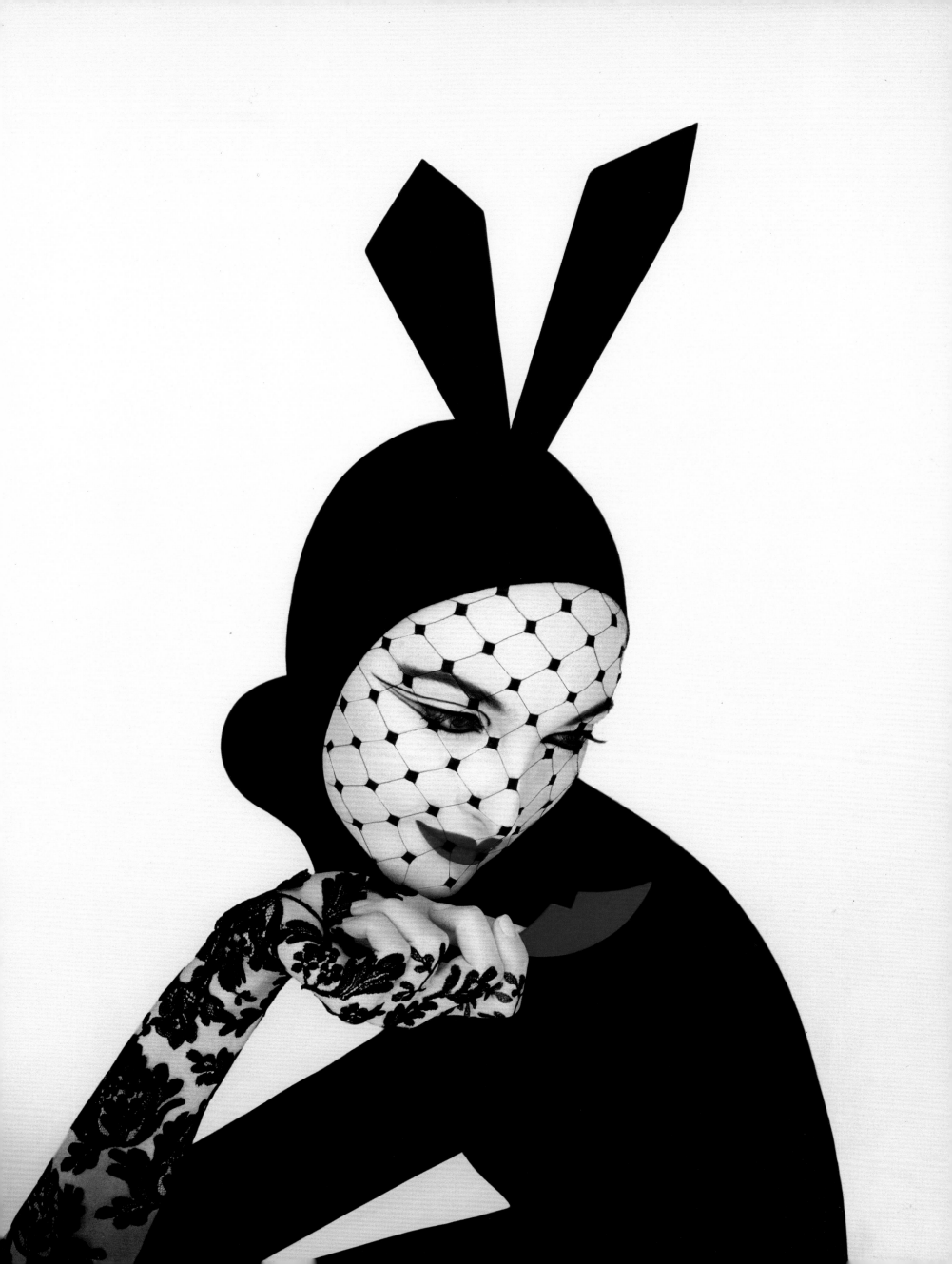

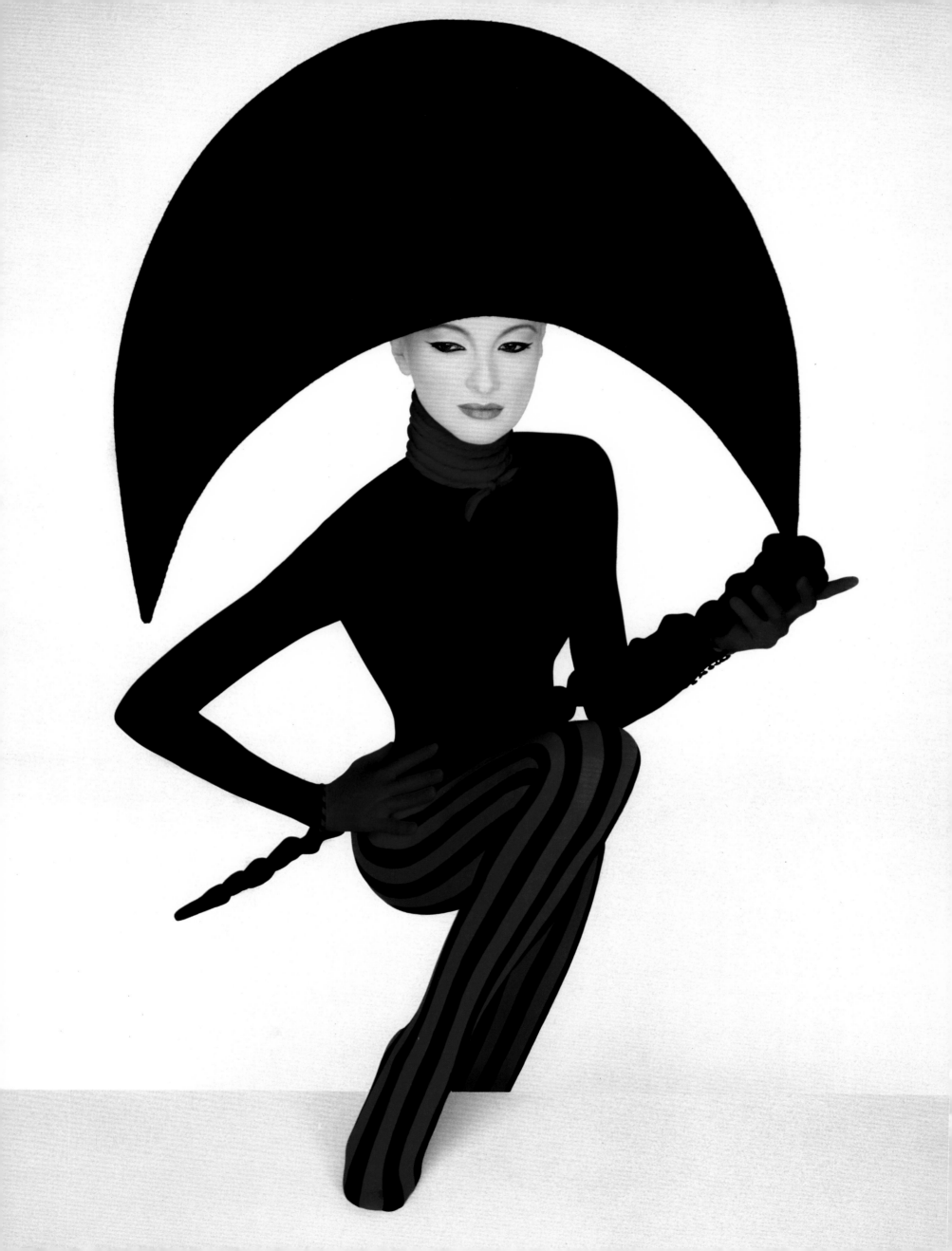

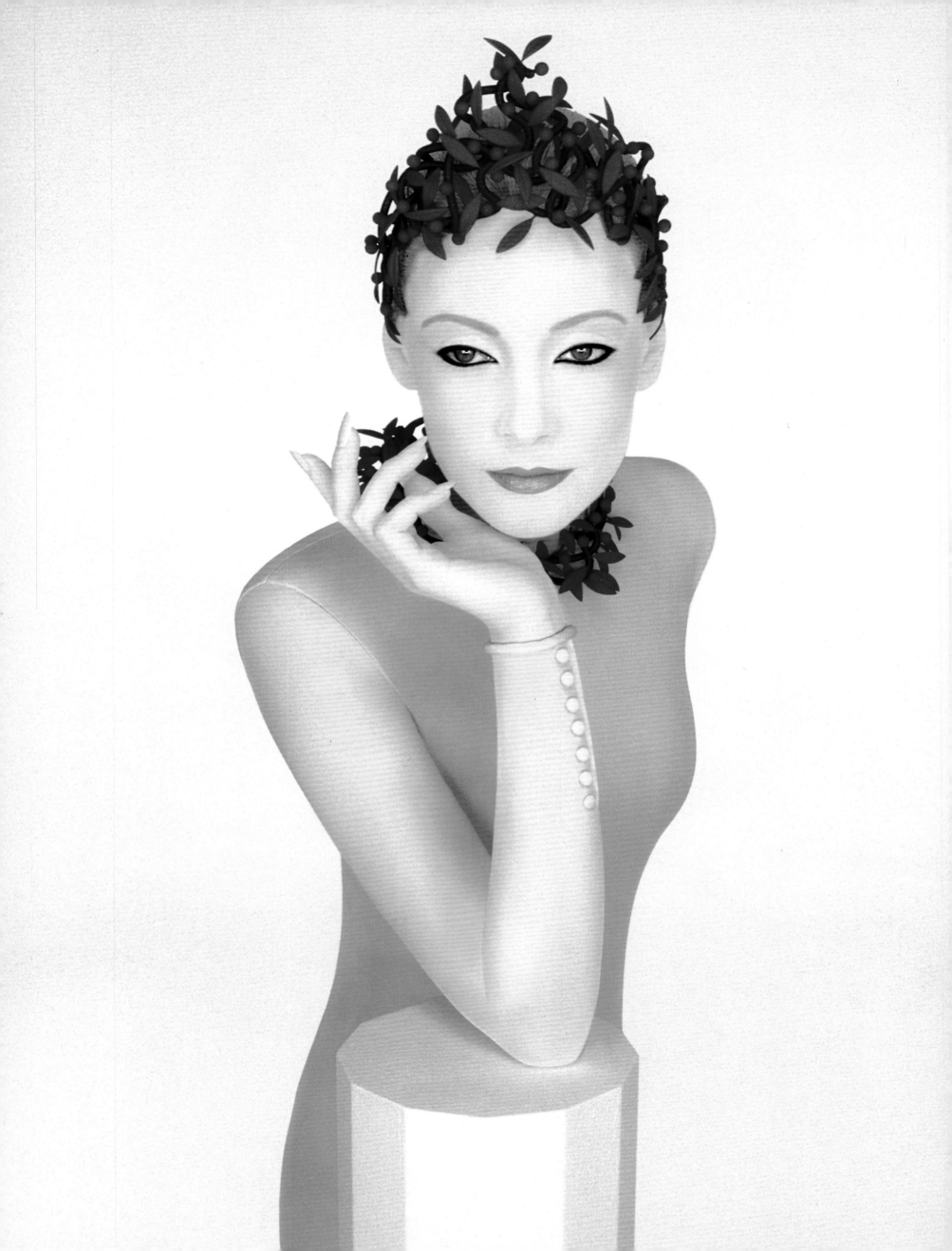

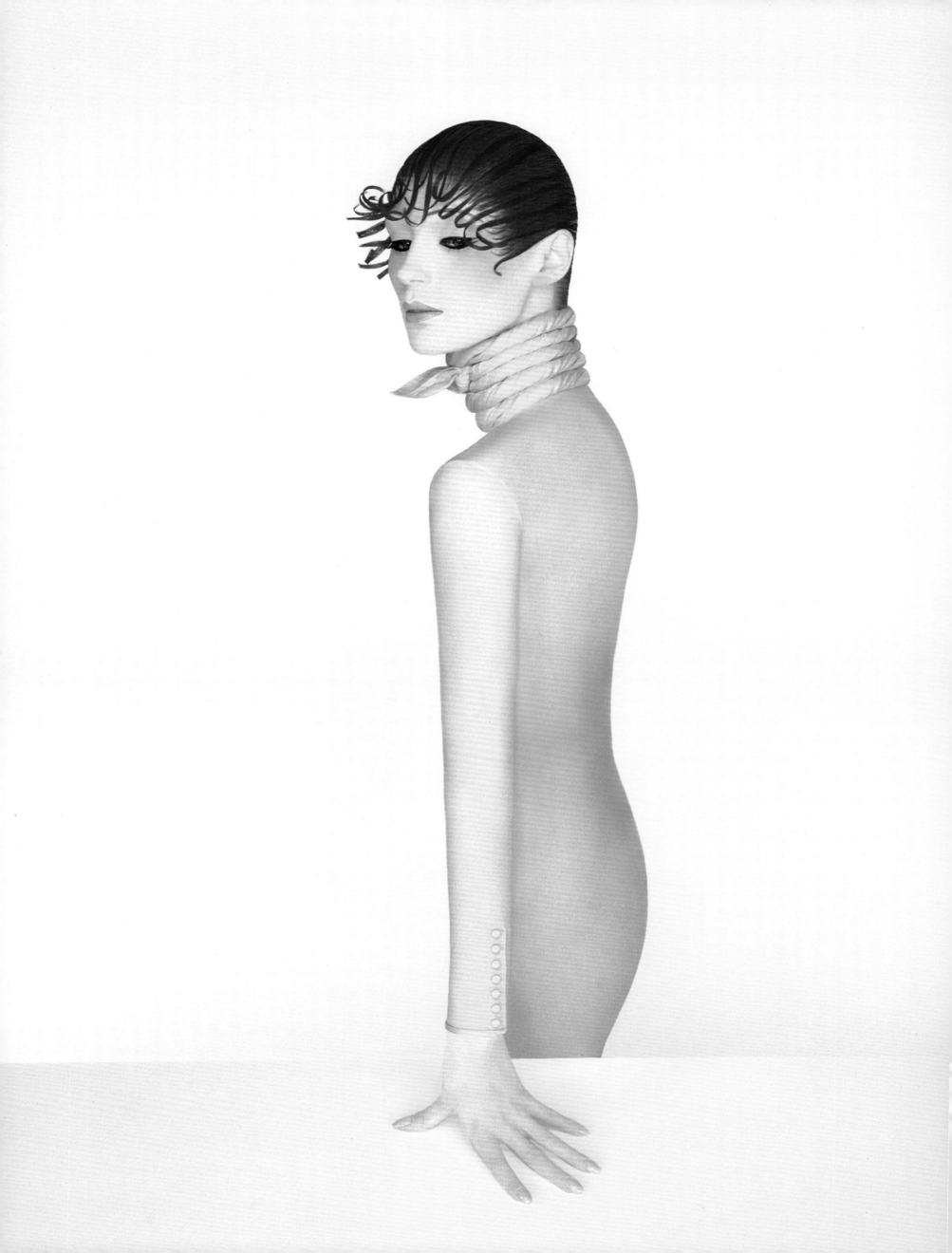

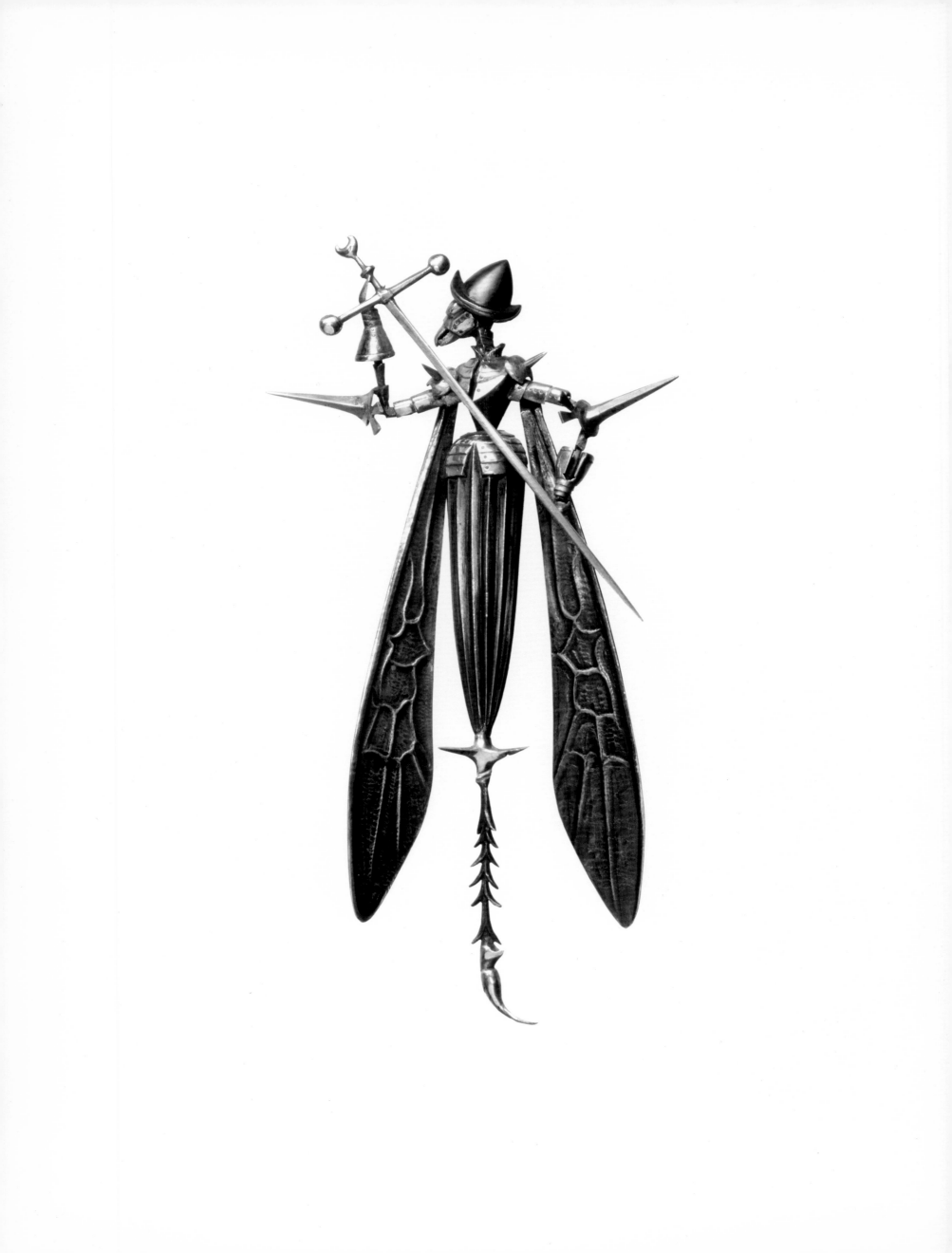

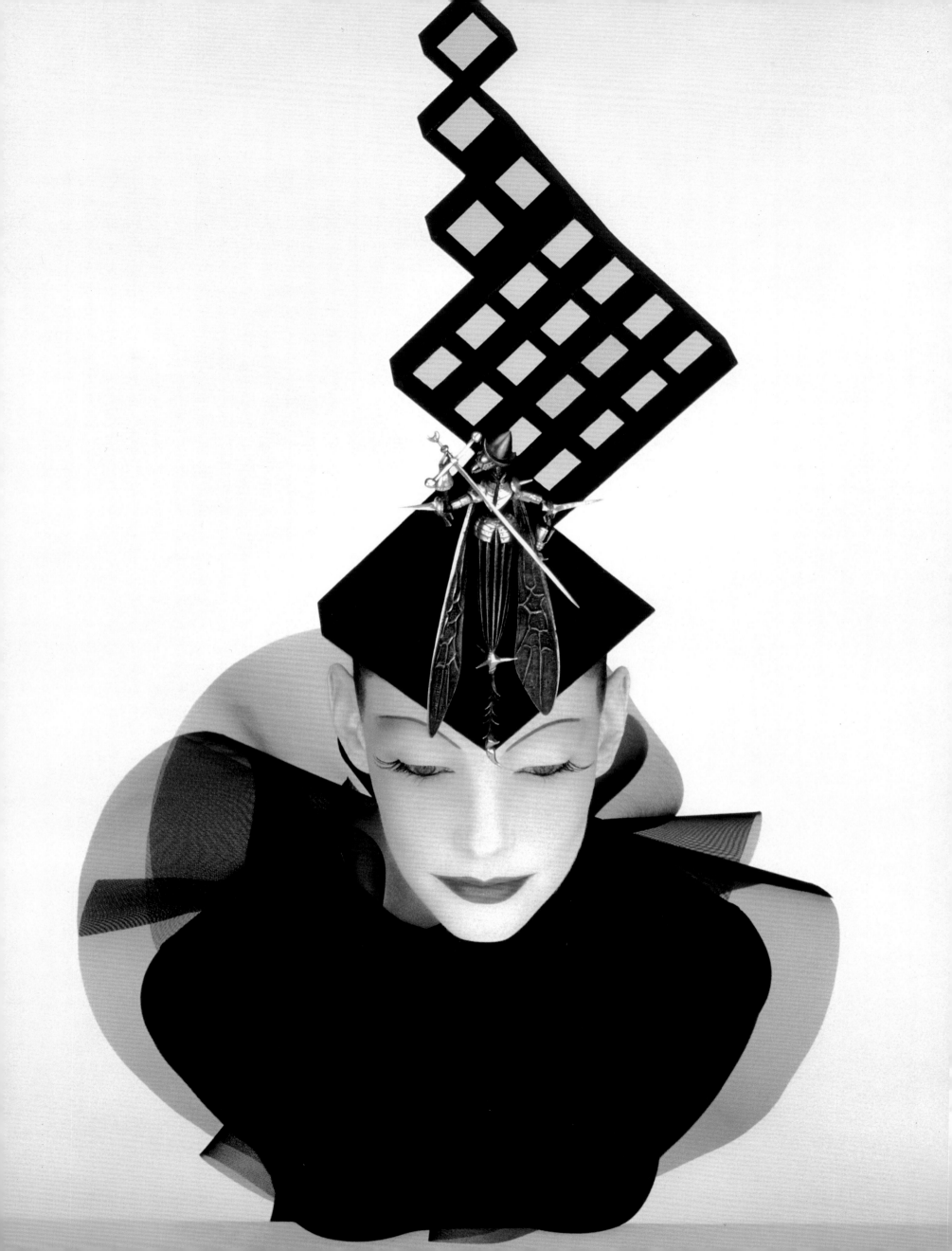

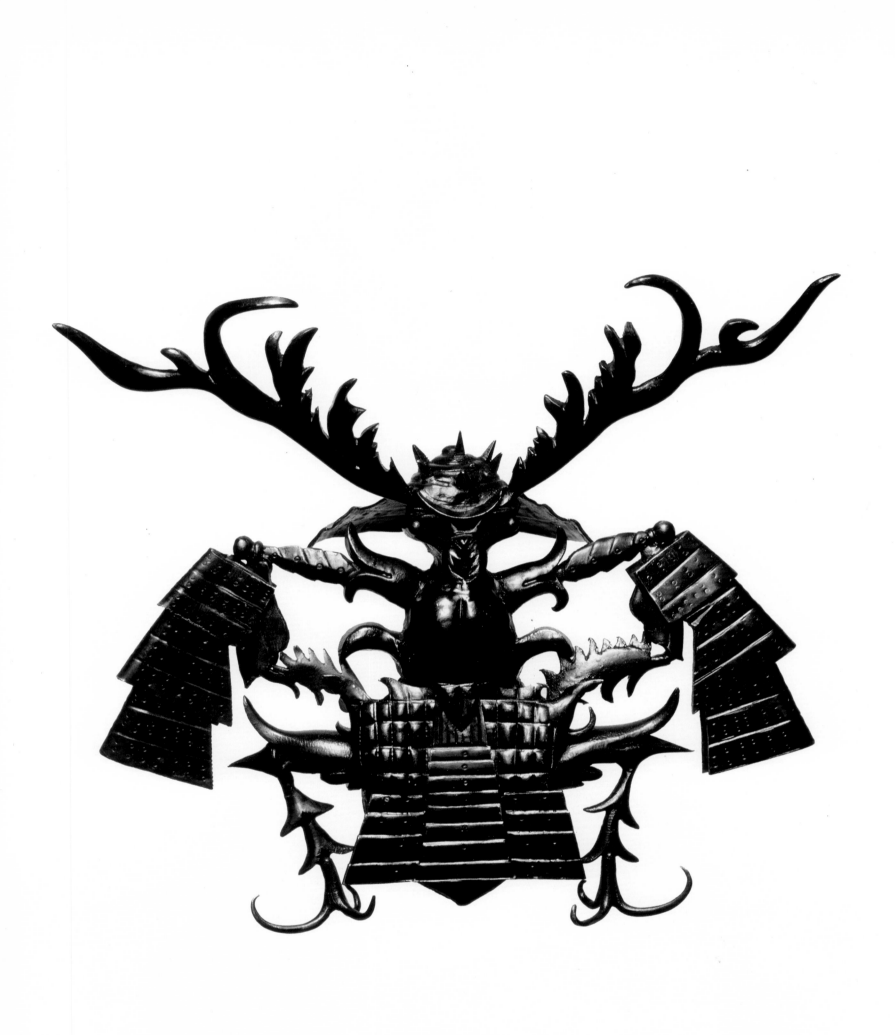

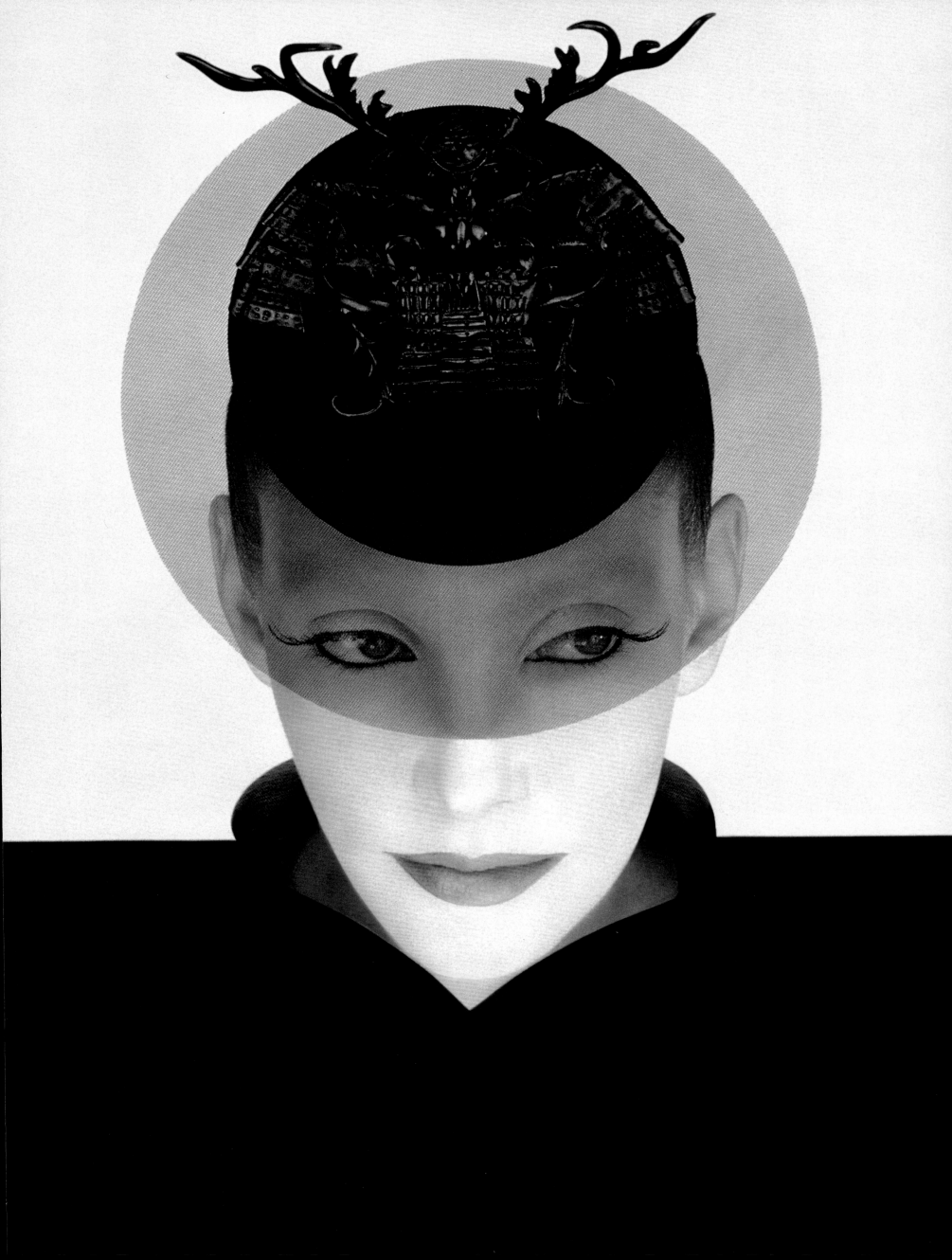

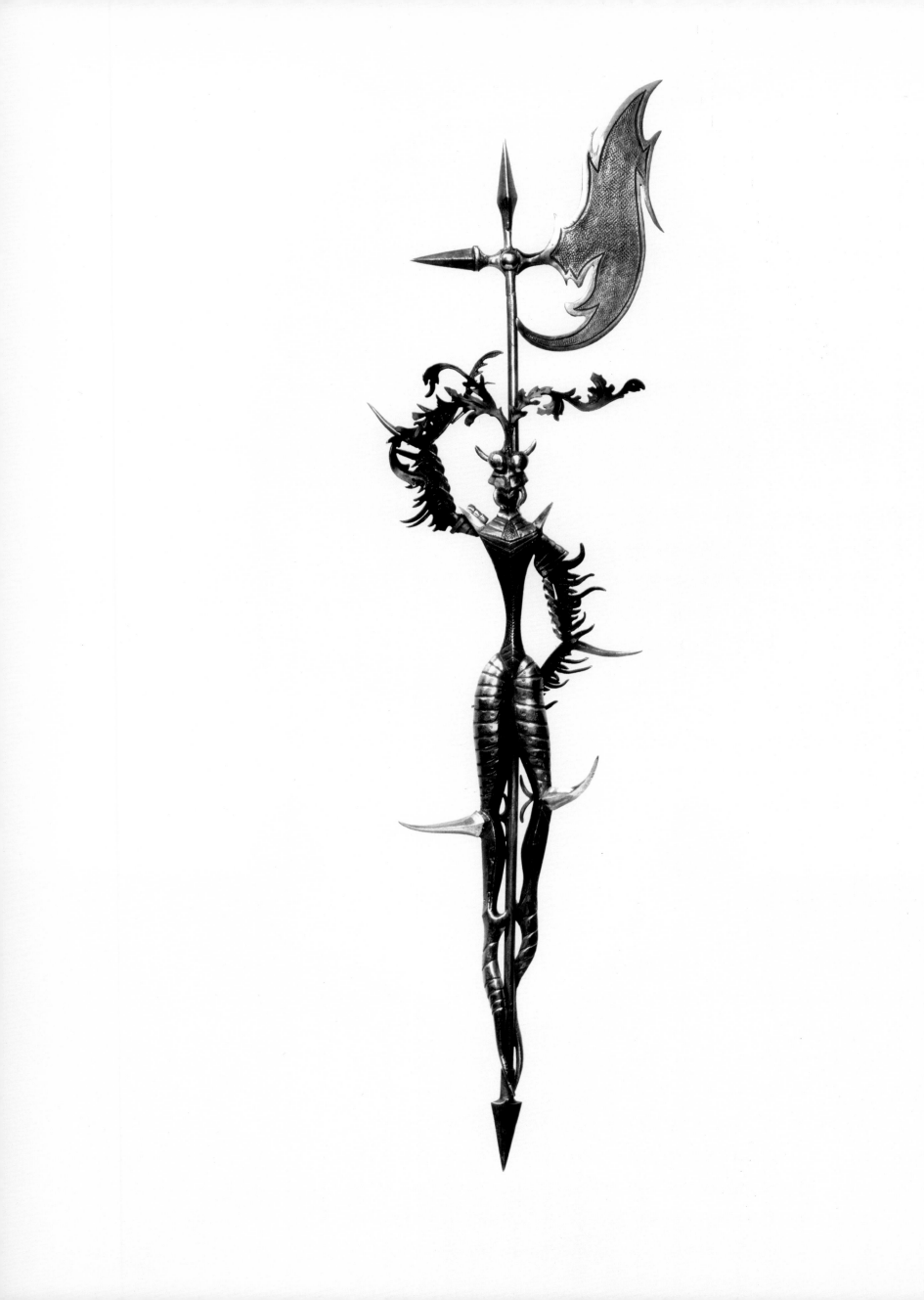

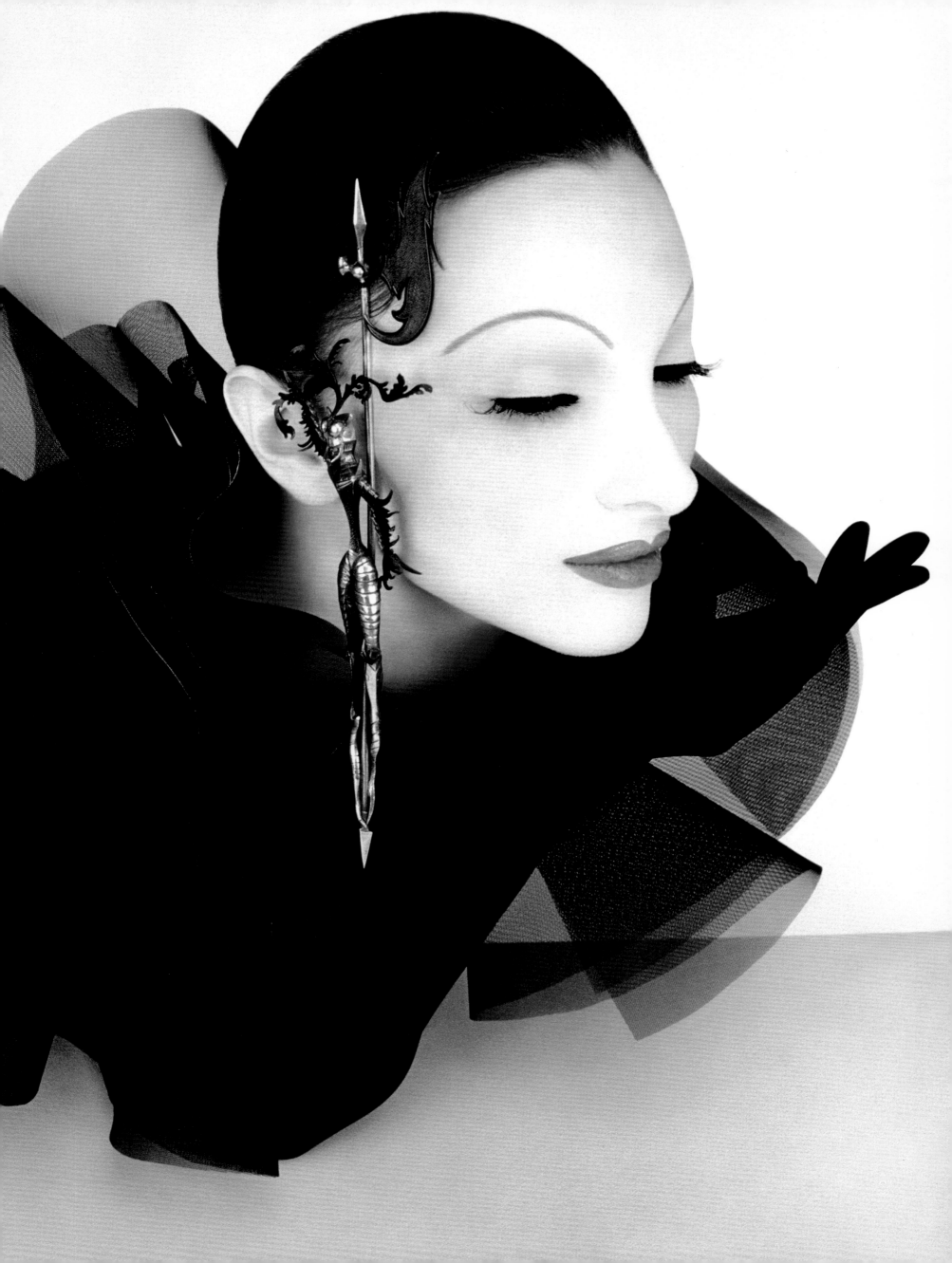

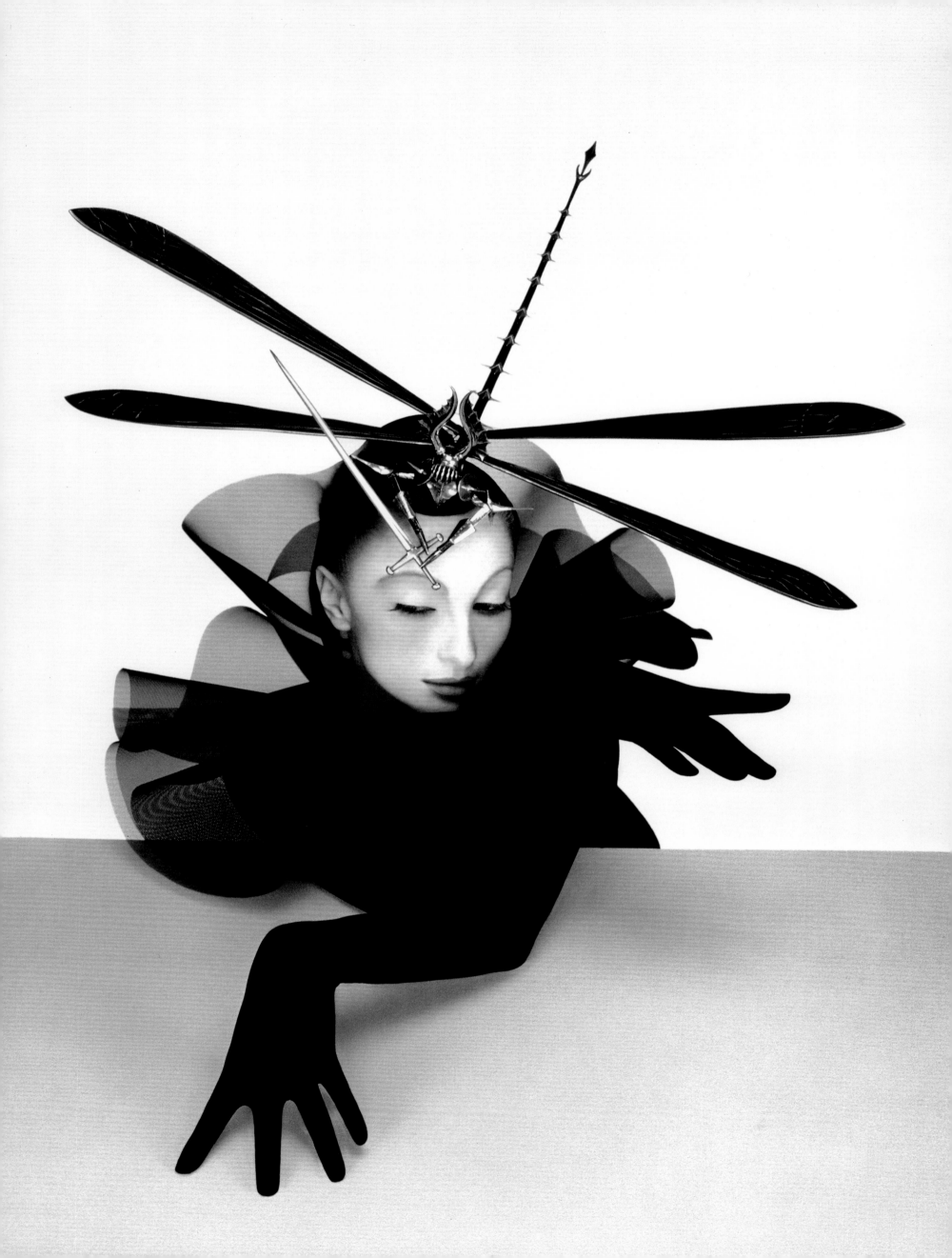

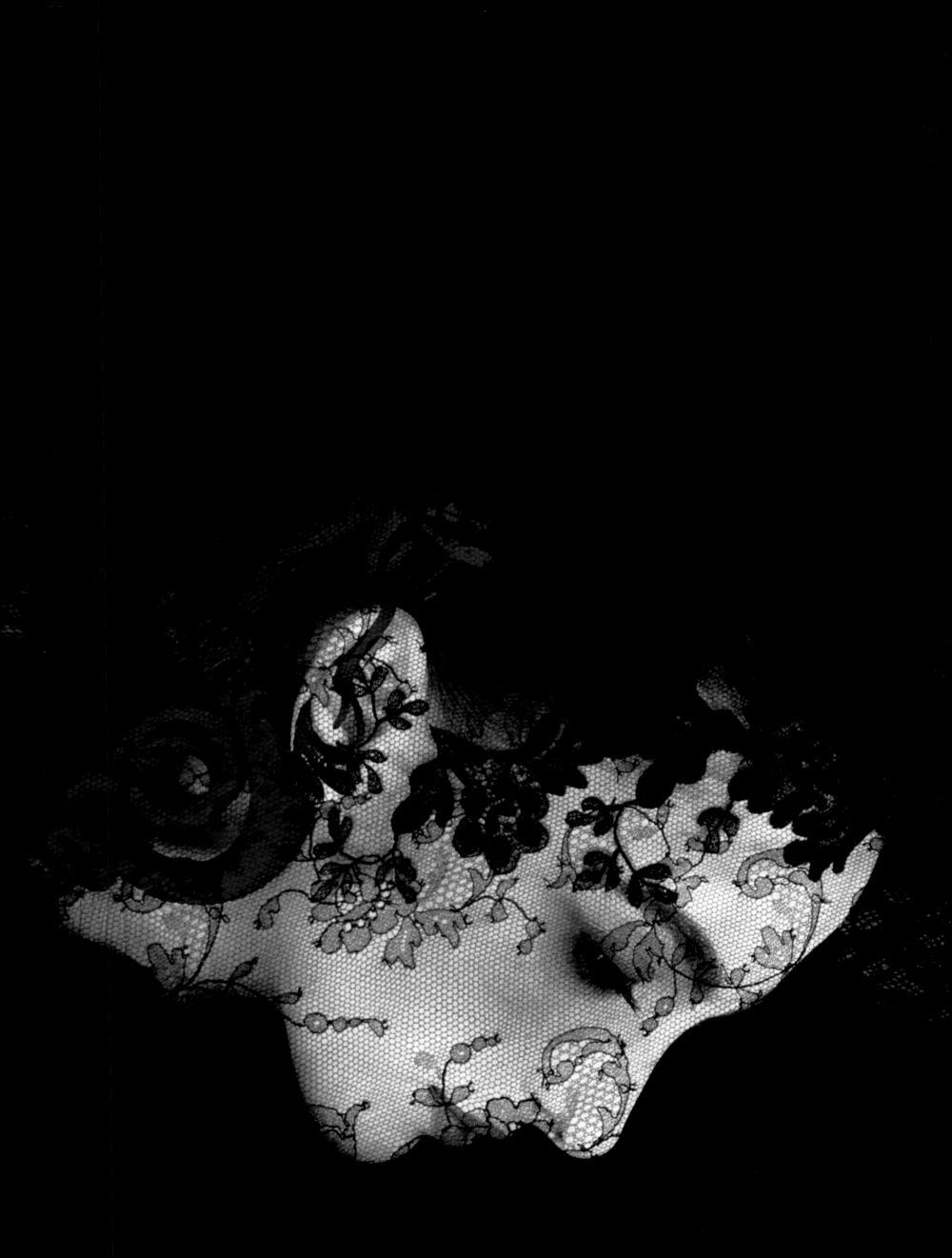

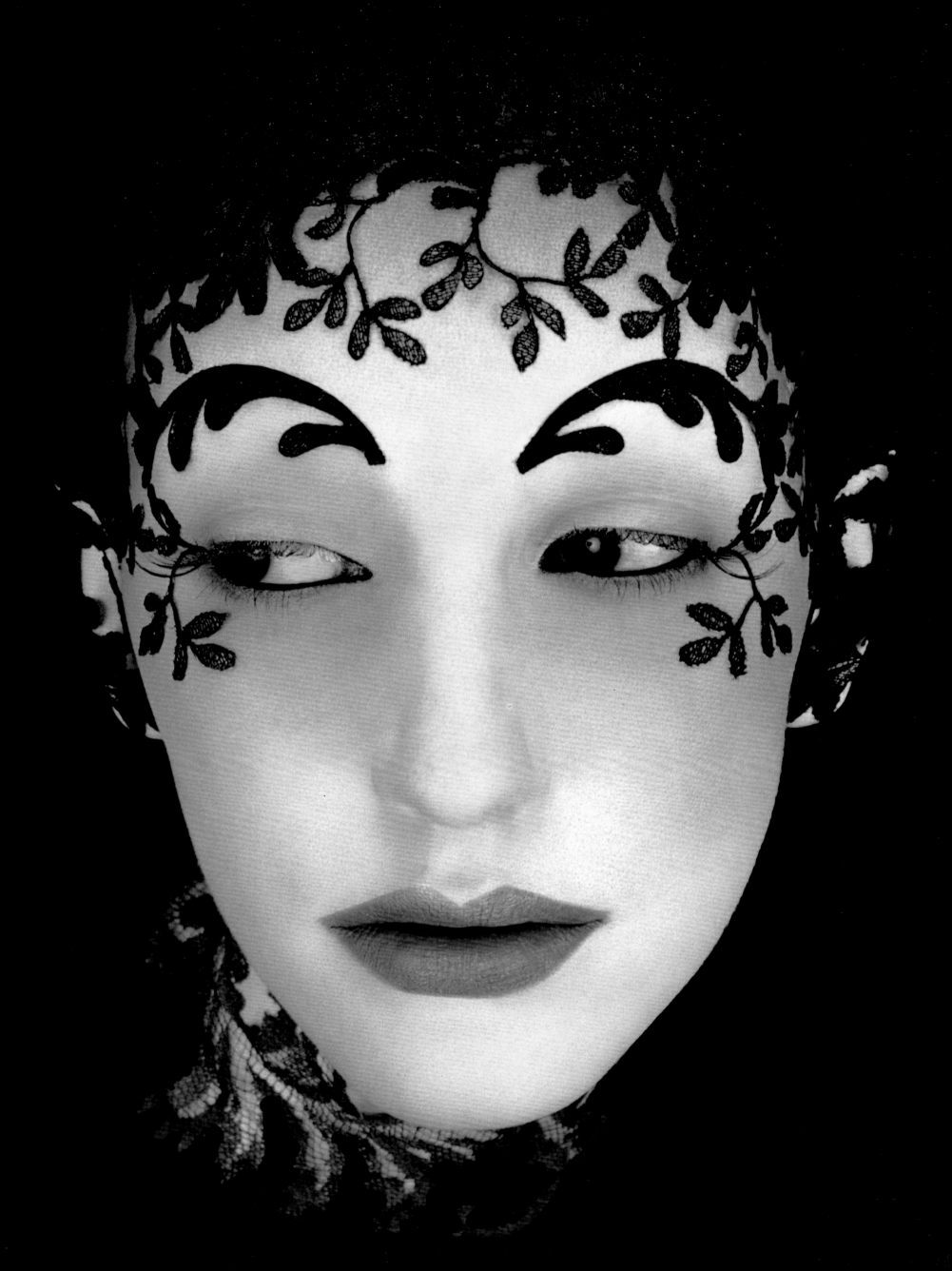

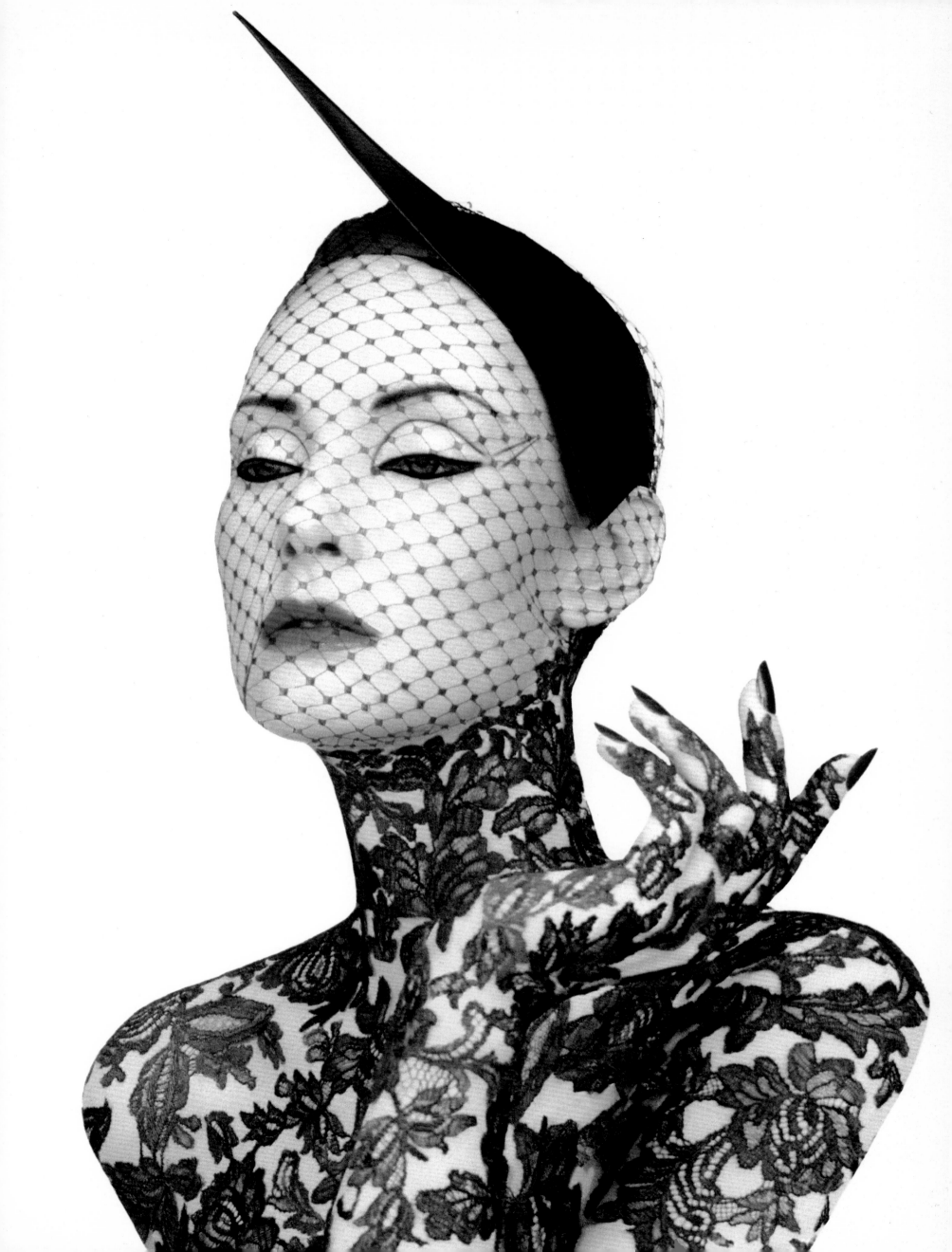

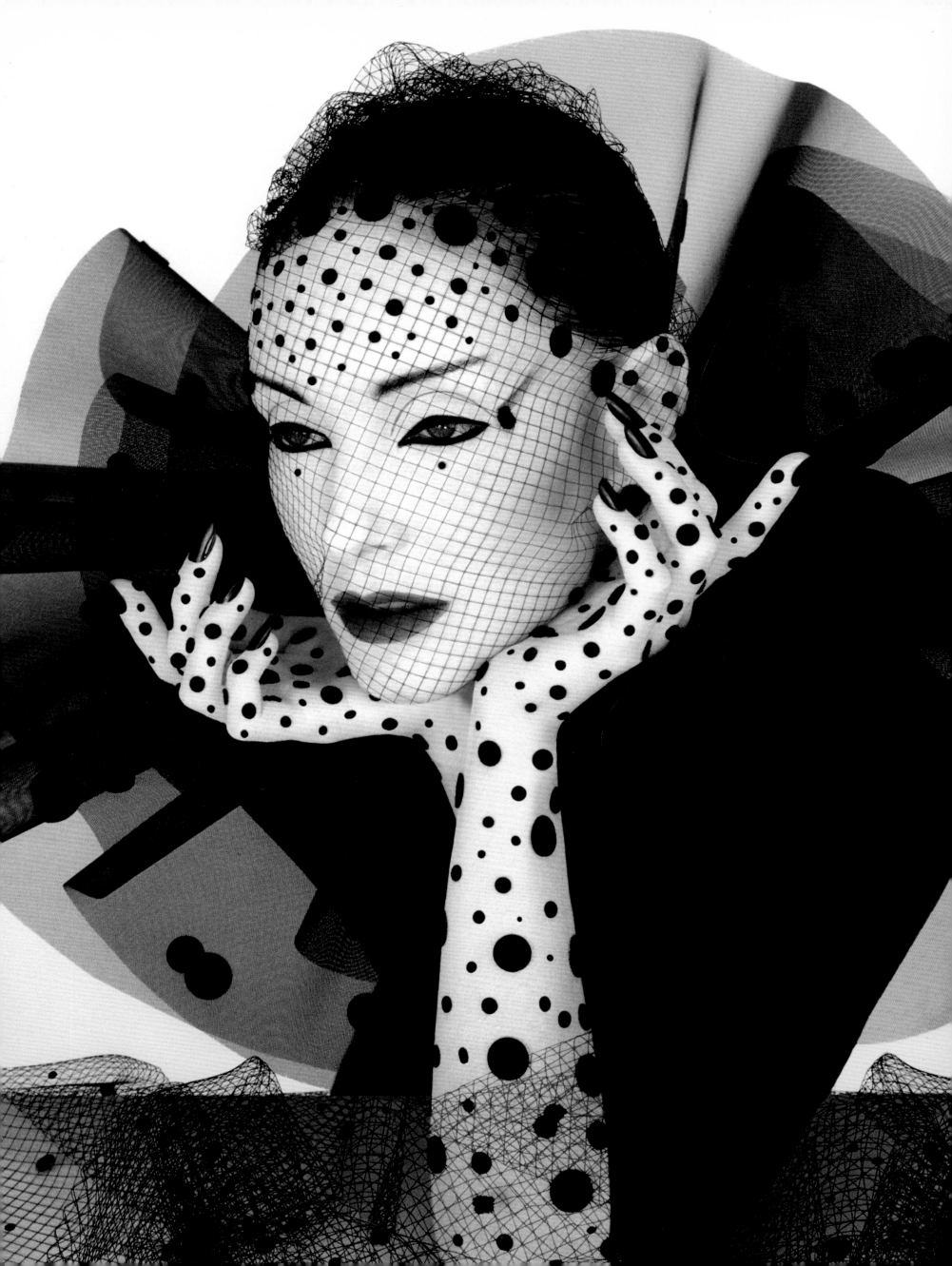

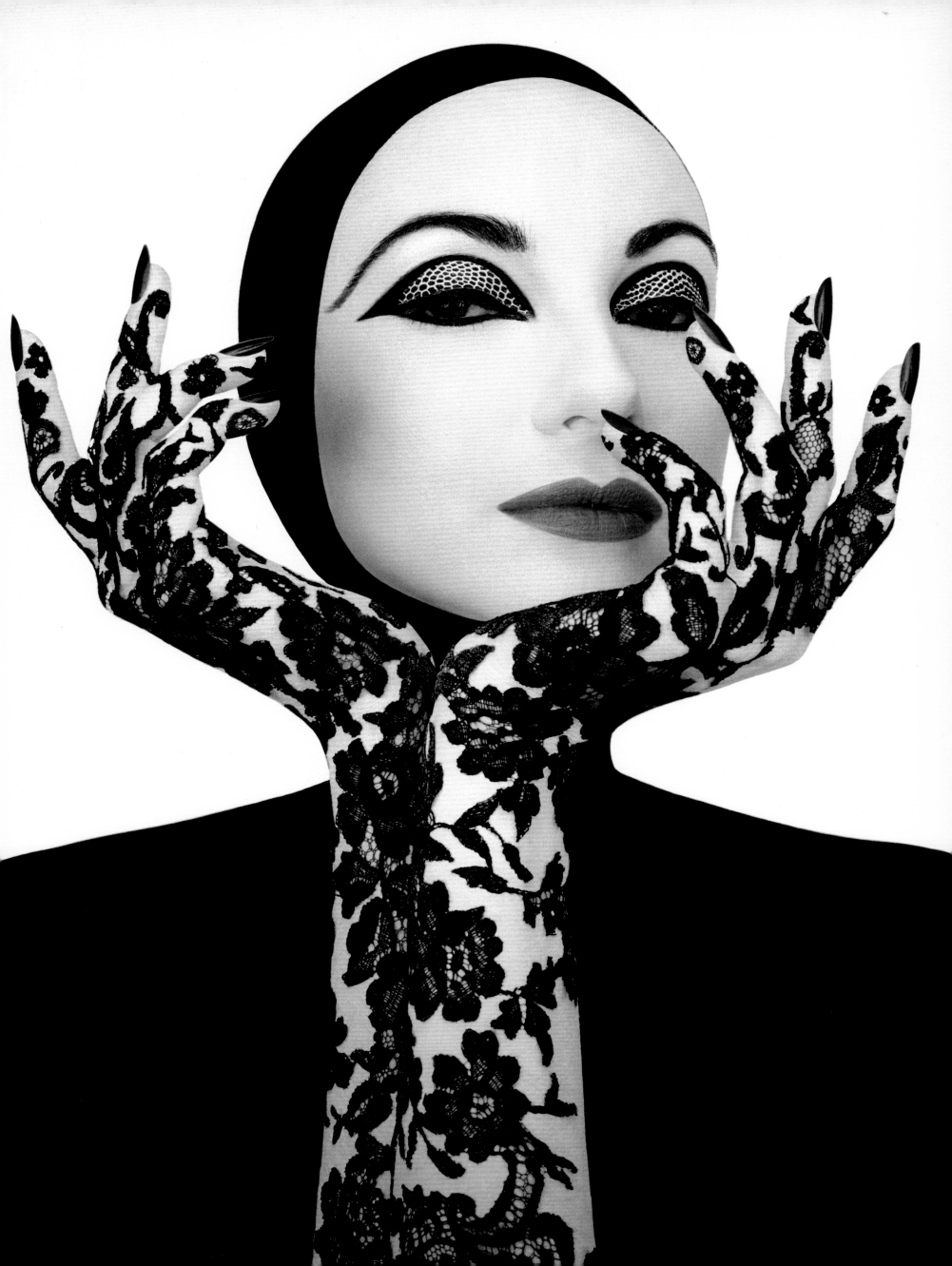

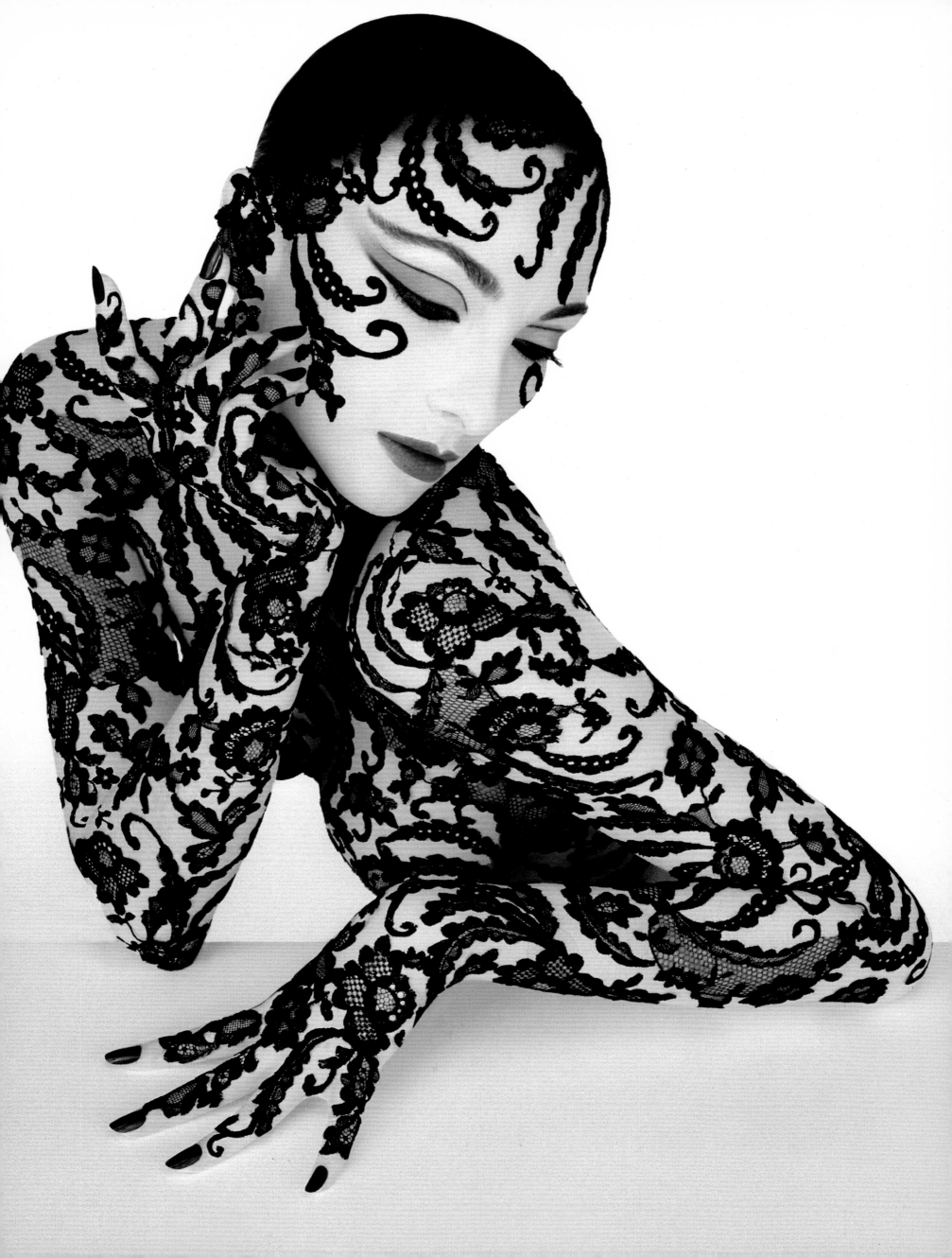

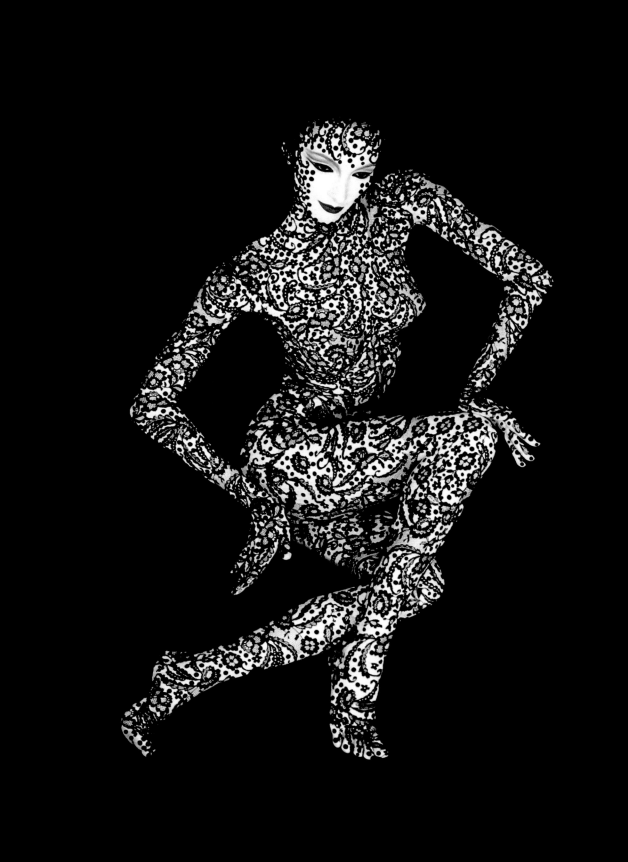

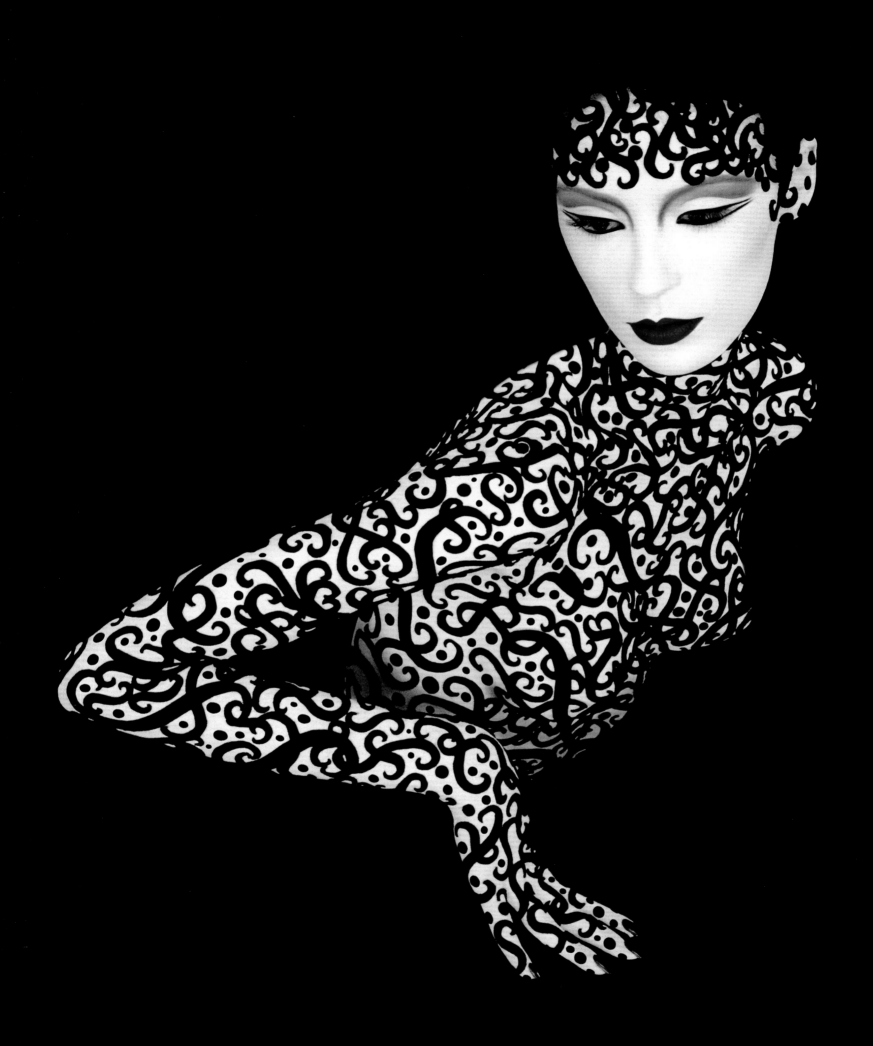

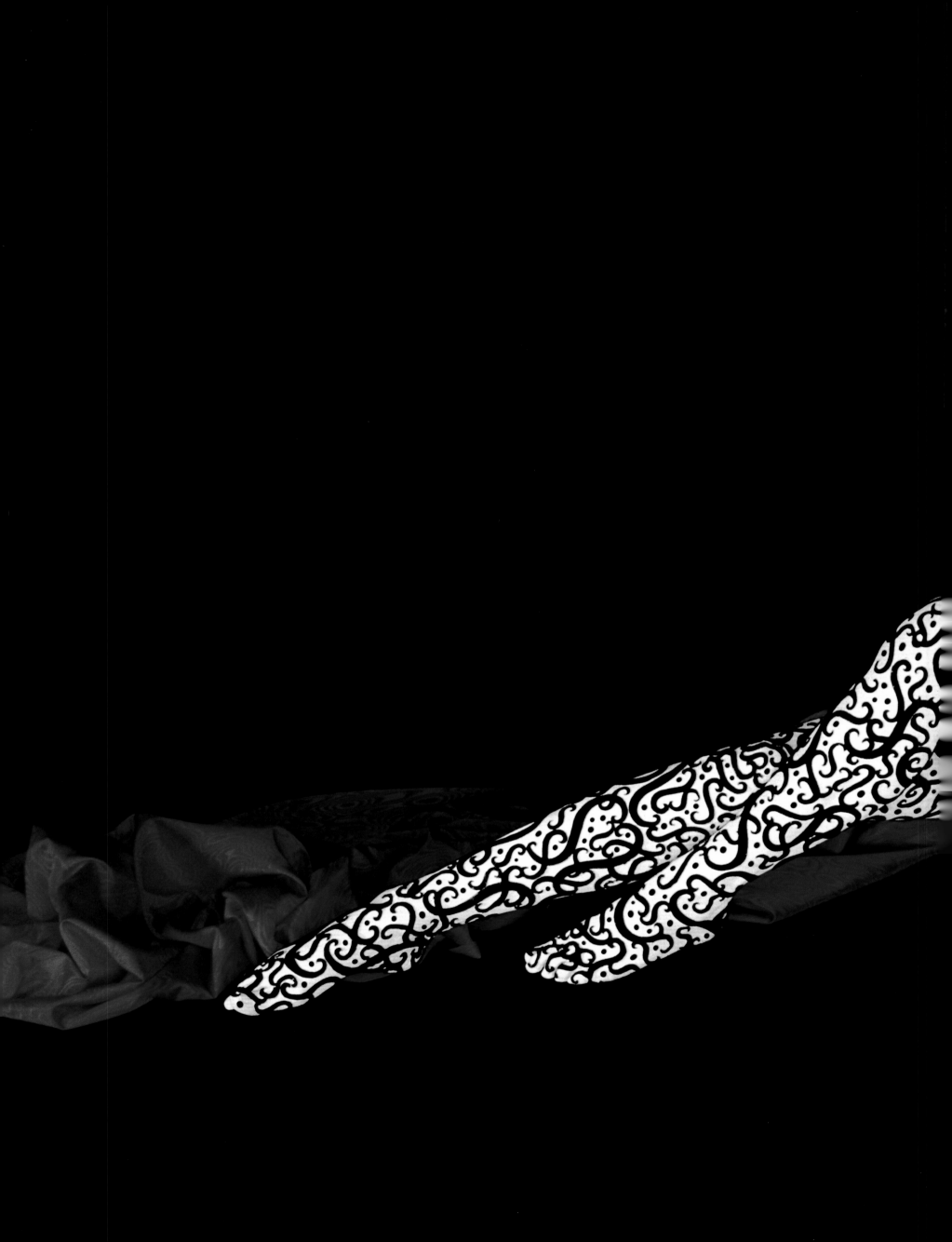

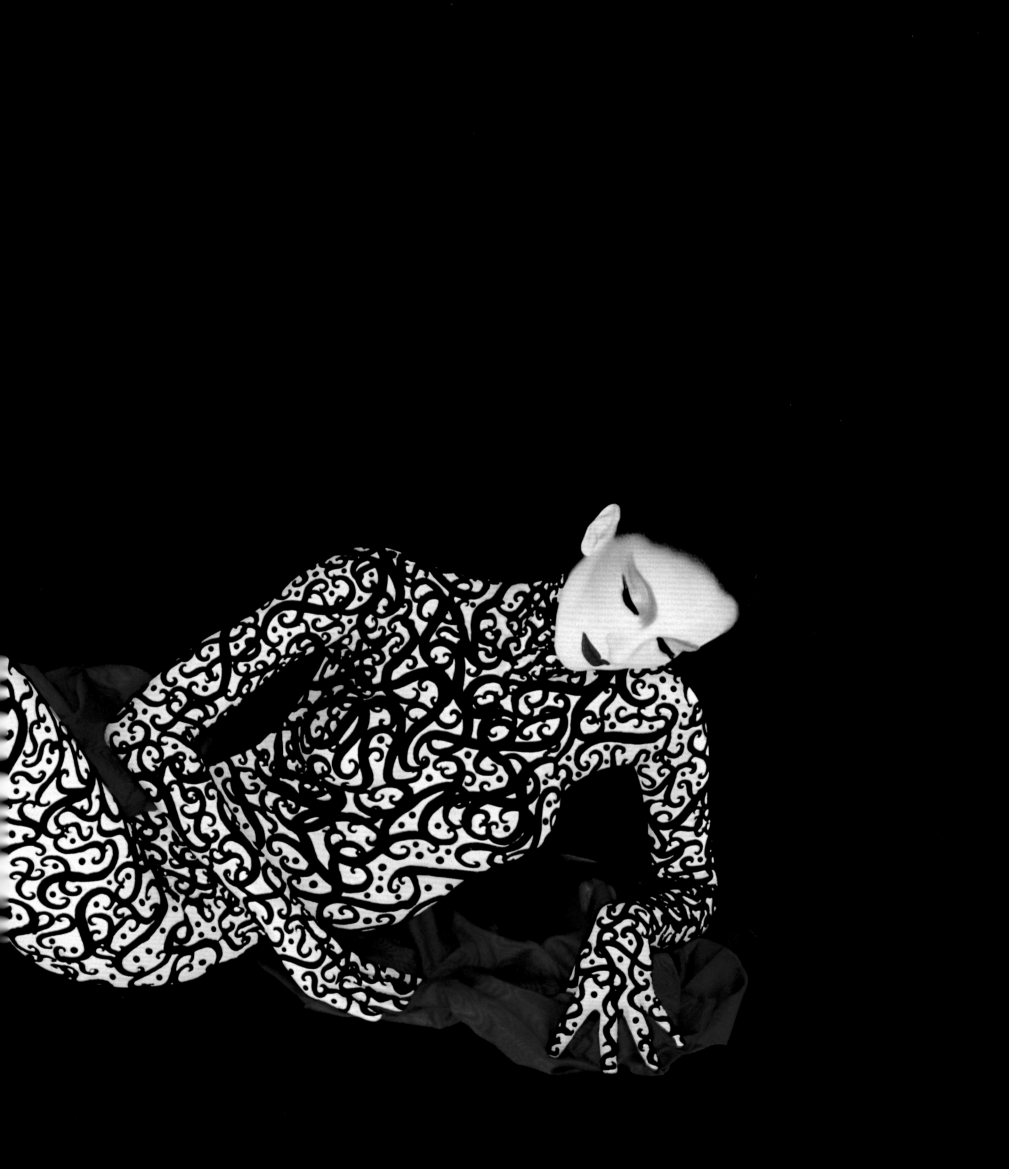

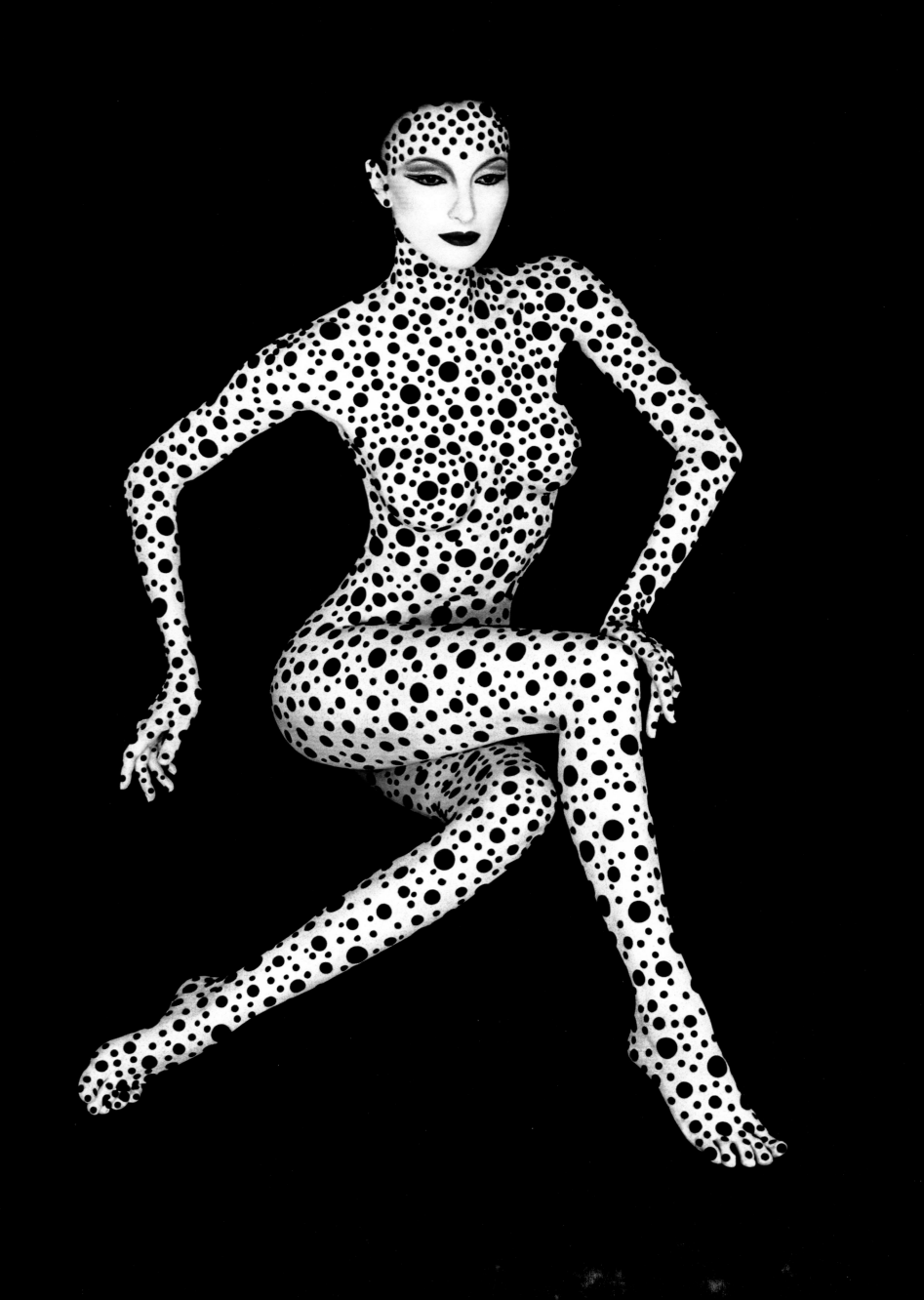

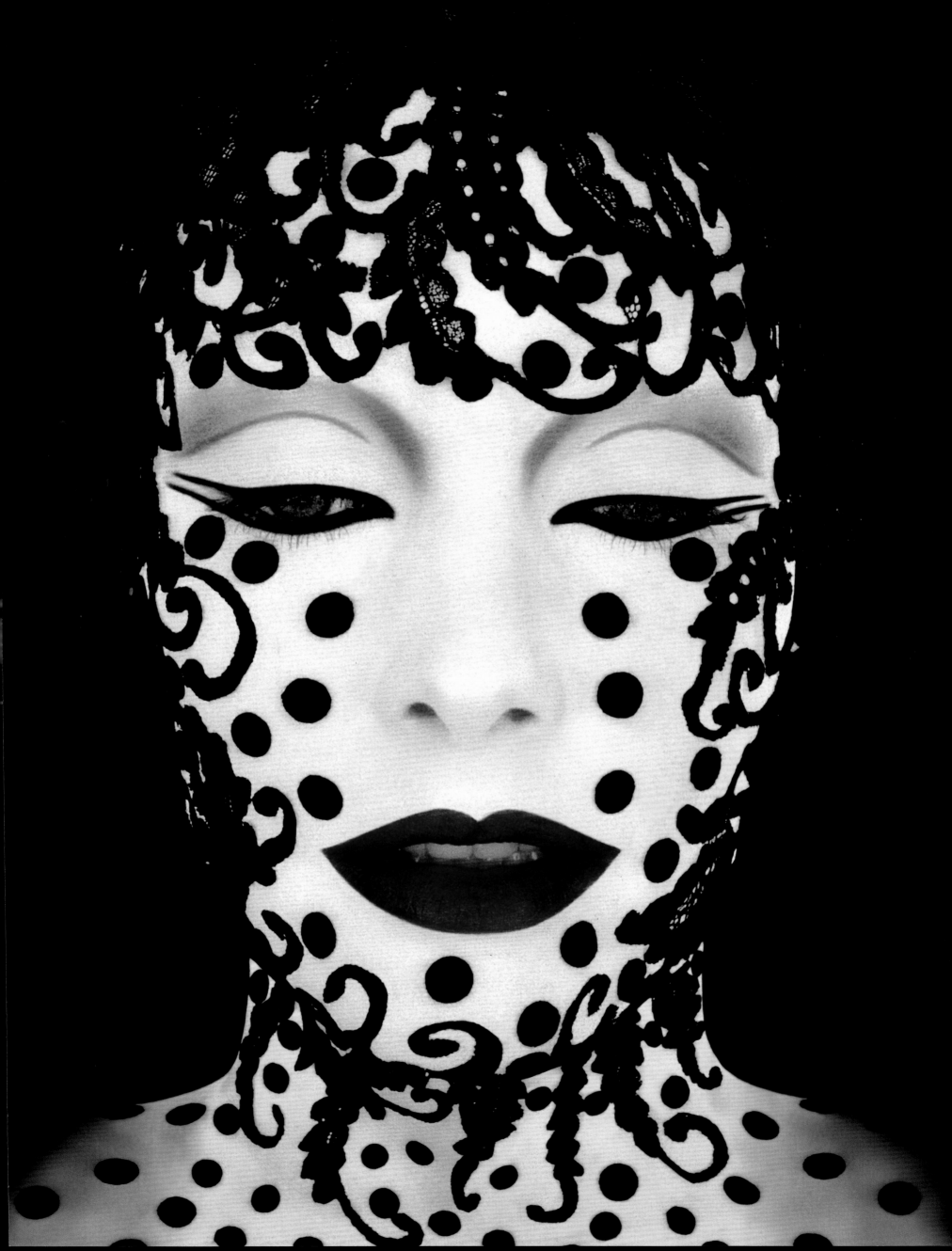

This book is composed of images inhabited by fairytale characters.
Objects, jewelry, ornaments, sets, coiffures and make-up were conceived and realized for the sole purpose of taking their place in the composition of an image and contributing to the desired expression.

These imaginary portraits have no other role, no other ambition. They are not designed to be identified with, even if our society prizes identification. They are not fashion photographs. And they are not to be confused with the seasonal faces, extreme or otherwise, that mark the beauty year.

These images, composed and *mises en scène*, have, as their sole reason for being, the model: my way of envisaging my ideal in the instant.

Here, quite simply, it is merely a question of looking.

Serge Lutens

I recall each of my working sessions through my models; women who, indubitably, arouse in me the same emotion.

Preparation—the mise en place in the studio of ornaments, jewelry, objects—is a delicate step-by-step process at once precise, uncertain and certain. These are shared moments punctuated by crazy laughter ... and amazement.

Osmosis is perhaps the right word to describe the phenomenon that occurs during the short time when the photographs are actually taken. The moments I share with my models are privileged and unforgettable.

Louise Bertaux

A miniscule pale pink flower blossoming on a small branch at the tip of a black tree. Louise is very thin, graceful, decided, fragile. She leaves you wondering about a certain wistfulness. Her long black hair frames the delicate oval of her face, lit up by the smile of a child.

Louise Despointes

Louise pushes her character to the extreme, entering her role as one enters a religious order. To me she is the embodiment of all that is extreme and pure. Her talent is passion. She gives everything to each new image. What does she express? ... perhaps, in the end, despair.

Cathy Gallagher

Cathy is very beautiful, very, very beautiful.
A perfectly oval face, a neck that renders everything prestigious, eyes the color of sapphire and lapis and aquamarine, a precisely drawn mouth and the ghost of a smile. But Cathy is also decisive.
Her beauty deserves to be transformed into cinema; with Cathy it couldn't be any other way.

Janine Giddings

Janine is a Tanagra, fragile, beautiful, delicate. Even the word "fine" is too heavy to describe her, a China girl, an amulet of white jade, dark as jet. God, is she pretty! One protects her for fear that she will break.

Michele Hicks

Quicksilver, spontaneous, fine, impulsive, fragile, electric, elegant, Michele enters an image gently.
Imperceptibly she pushes herself to the extreme, she is already ...

Elena Koudoura

Elena is a Cadillac, veering slowly. She is also the panther nonchalantly stretched out across the back seat. At once dancer and choreographer of her own self. "Control" isn't the right word to describe her. Elena flows from a spring, everything about her seeming simultaneously obvious, natural, impossible. Her imprint is supple and musical. She cleaves the air without ever cutting it. The personification of elegance.

Susan Moncur

Susan is the actress.
Her ability to interiorize is such that the slightest frown, an imperceptible movement of the eyelids, totally changes her expression.
The sudden movement of a body hastily sketched, the gesture of a hand revealing a character at once expected and unexpected. Tragedienne, mime, Susan holds back, distills more than she reveals. Subtly she evokes the invisible facets of her multiple repertoire, displaying the stuff of the screen giants of whom she is one of the direct descendants.

Isabelle Weingarten

Milky skin, a strange and beautiful face, an elegant and perfect body that she controls to perfection. Fascinating, she has a wide repertoire of characters. Each reveals her talent for interpretation and far-reaching mimicry.

ITINERARY

14 March 1942

Serge Lutens is born in Lille, France.

A shy and reserved child, he embodies the expression "in the clouds."

1956-1960

He makes up and coifs his friends, dressing them in clothes and accessories of his own design. A short time after he also photographs them.

Late 1960

Introduction to Madeleine Levy, a dealer in contemporary furniture. A year later, in Paris, they launch an atelier, or "test salon," devoted to make-up, hairdressing, jewelry and extraordinary objects.

1963

Armed with huge portraits he took of his friends/models, he pays his first visit to Vogue, where the editor in chief in charge of beauty, Françoise Mohrt, invites him to collaborate on the makeup, coiffures and accessories for the Christmas 1963 issue. Five years of creation follow for the most prestigious women's magazines, including Paris Vogue, Jardin des Modes, American Vogue and Harper's Bazaar. At this time he and Madeleine Levy also design a collection of jewelry for Italy.

1968

At the crossroads of a crucial year, Serge Lutens is hired by the house of Christian Dior to assume full responsibility for its beauty image and to design its make-up line. A year later he begins taking his first studio advertising photographs. At the same time he is dazzled by his discovery of Marrakech.

1970

First trip to Tokyo for the house of Christian Dior.

1972

A new and important personal voyage takes him all over Morocco, whose south he finds most enchanting of all. In homage to the masters of modern painting, he produces a celebrated series of photographs, exhibited in prestigious venues worldwide, including the Guggenheim, New York, and the Van Gogh Museum, Amsterdam.

1974-1976

He makes his first films, "Les Stars" and "Suaire." They are presented at the Cannes, Berlin and Venice film festivals.

1976

Serge Lutens travels with increasing frequency to Marrakech, residing in the city's oldest quarter, near the Madrasa Ben Youssef.

1980

Serge Lutens closes the book on more than 12 years of creation for Christian Dior when, in spring 1980, he is hired by Shiseido and given international responsibility for the company's image and make-up lines, including creation of the products themselves, colors and packaging.
Creatively he experiences renewed development.

1981-1988

Eight films conceived and produced for Shiseido garner numerous awards, including two Lions d'Or at the Cannes festival and a Clio Award in the United States. In 1990 the ensemble of films receive the "Grand Prix de la Qualité de l'Image" at UNESCO's International Art Film Festival.

1989

Conception of the new Shiseido make-up line.

1991-1992

Feeling that the arcades of the Palais Royal in the heart of Paris symbolize an ideal beauty, Serge Lutens invites Shiseido to create a new, unique and prestigious space, "Les Salons du Palais Royal." He conceives the original decoration down to the last detail.

1992-1998

While working prolifically as a photographer, he also creates two new fragrances every year, thus conceiving a universe of perfume that ignores convention and explores territories that have been forgotten or abandoned by contemporary perfumery.
On a personal level, the Art of Serge Lutens turns evermore towards a world of dreams, imagination and the profound study of beauty traditions throughout the world.

INDEX

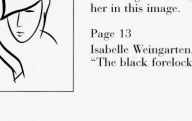

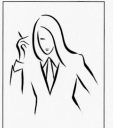
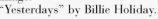

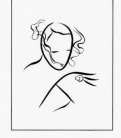

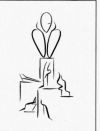

INDEX

INDEX

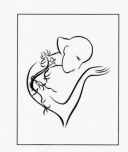
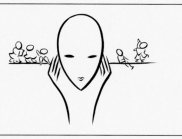

INDEX

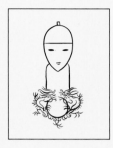

Page 79
Janine Giddings
Chinese boy, hanging dragon bag, accessories and image realized in July 1993.
Music by Duke Ellington.

Pages 90/91
Elena Koudoura, April 1996
Her body an ink-drawn outline.
Calligraphy.
Elena, to a soundtrack of Miles Davis, contemplates her reflection.

Page 80
Elena Koudoura, July 1993
Chaste, gracious, sophisticated. Chinese boys in sculpted wood attached to the end of her braid. Yellow make-up.

Page 81
July 1993
The few shootings I did with Eleonor could not have been more eloquent.
Yellow make-up, faux dragon tattoos, claw nails.
China, beautiful and fascinating.

Page 93
Elena Koudoura, March 1996
China girl in lacquer and stones.
Miles Davis guides us.

Page 83
Susanne Aichinger, April 1996
The Little Princess of the Pagodas.
This and the following image were commissioned by Angelica Steudel-Strub for Madame Figaro to celebrate the Year of Japan in France.
Accompanied by Maurice Ravel.

Pages 94/95
Elena Koudoura, April 1996
Black speed.
I love these images without accessories, without clothes. They're like outlines.
To a rapid rhythm of the Jazz Messengers.

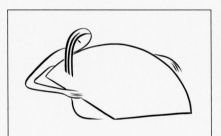

Pages 84/85
April 1966
Chrystele Saint Augustin loves to play, to gambol. Once upon a time she dreamed of long straight hair ...

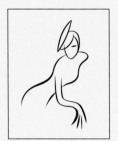

Page 97
Elena Koudoura, Mach 1996
Black swan.
A coiffure of tulle and sapphires.
This photograph would become an illustration for Shiseido.
Music by Miles Davis.

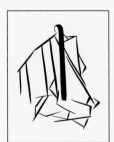

Page 87
Michele Hicks, March 1998
The past is one of the places where I live, a place where I unfold. A sumptuous outfit, hair without end. She doesn't walk, she glides, disappearing slowly.
The women of the Court of Heian in Japan allowed me this very personal transposition.
This photograph would become an illustration for Shiseido. Bewitched by "The Death of Isolde" by Richard Wagner.

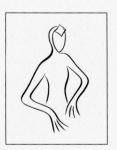

Page 99
March 1966
Turkish tango, Elena, tiny hat and body stocking scattered with multicolored stones.

Page 89
Cathy Gallagher, March 1988
Cut-out, folded and arranged, origami, like a jewelry box, frames only the face of the model, celebrating what I love: absolute beauty.
Accompanied by the last lieder of Richard Strauss.

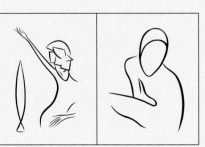

Page 100
Lisa Fallon, November 1985
Silver-propellor earrings, lacquered tulle hat.
To "Rhapsody in Blue" by George Gershwin.

Page 101
June 1995
Composition of black tulle cut out around Elena.

INDEX

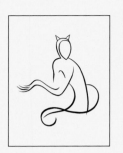
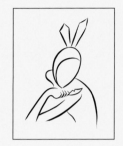

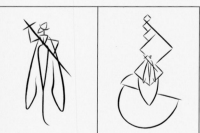

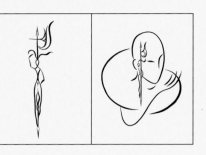

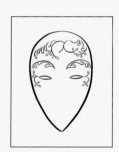
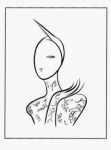
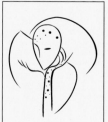

INDEX

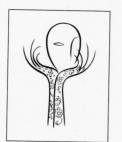
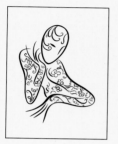
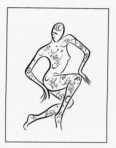
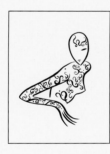
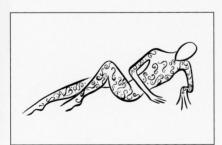
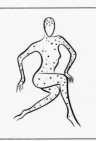
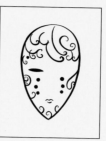

ACKNOWLEDGMENTS

To all those who, by their constant assistance, patience and generosity, helped make this book possible:

For his unflagging enthusiasm in publishing this work, Prosper Assouline.

For his precious assistance and collaboration, Gautier Harleyr.

Linked to so many marvelous moments, everyone who assisted me so perfectly in the preparation of my models and in the taking of photographs in the studio: Kimiko Oshiro, Nathalie Paillon, Victoria Pjebyska, Masako Takano, Noriko Okubo, Wahida Kebbab, Mike Robinson, Jean-Marc Dhelens.

For their skills in the graphic arts: Christine Jean, Chantal Picardat, Alexandre Rotsztein.

For having loyally orchestrated each of my productions, photographs and films, and for having initiated this book, Patrice Lerat-Nagel.

My appreciation is extended to those who opened the pages of their magazines to me and allowed me to realize certain photographs reproduced in this book, images which, without these individuals' trust, would not have existed: Regis Pagniez, who personally oversaw the layouts of my photographic essays in Elle USA, and Melka Treanton, who produced them; Angelica Steudel-Strub, who gave me carte blanche when working for Figaro magazine; Joan Juliet Buck, who commissioned me to participate in the 75th anniversary issue of Paris Vogue. There could be no greater mark of their friendship.

For his inestimable support throughout these last years, thanks are extended to Yoshiharu Fukuhara.

Very special thanks to Shiseido.

Without the remarkable and rare savoir-faire of innumerable artisans, many of these images would never have been born. These craftsmen are warmly thanked.

Until his passing this year, Fernand Cohen helped me enormously with his discerning advice and irreplaceable friendship. I pay homage to his memory here.

Finally, my gratitude to all those who supported me on or since the publication of my first book. Fervent or subtle, this support was infinitely helpful and encouraged me to pursue my graphic oeuvre. It is to these individuals that this second book is owed.